THE SALVATOR MUNDI OF
LEONARDO DA VINCI

THE SALVATOR MUNDI OF
LEONARDO DA VINCI

Joanne Snow-Smith

Henry Art Gallery
University of Washington | **Seattle**

in memory of **Ludwig Heinrich Heydenreich**

Copyright ©1982 by the Henry Gallery Association.

Text copyright ©1982 by Joanne Snow-Smith.

This publication has been supported by the Henry Gallery Association Publication Fund and a grant from PONCHO, Seattle.

Library of Congress Catalog Card Number: 82-21190

ISBN: 0-935558-11-X

front cover
Leonardo da Vinci, *Salvator Mundi* (detail). c. 1510-13. Oil on panel. Collection of the Marquis de Ganay, Paris.

back cover
School of Leonardo da Vinci, *Knot Design.* c. 1510. Engraving. Courtesy of the Trustees of the British Museum.

FOREWORD

One of the most meaningful roles the Henry Art Gallery has as a part of the University of Washington and as a public art museum is that of supporting art history research. The University's art gallery constantly strives to blend the aesthetic and intellectual aspects of the enjoyment and study of art, and this book is an example of our commitment to expand the knowledge and vision of art history at the University and in the region. The Gallery feels privileged to have this opportunity to present Professor Joanne Snow-Smith's extensive research findings on Leonardo da Vinci's *Salvator Mundi* painting in the collection of the Marquis de Ganay. As a member of the University of Washington's faculty, Dr. Snow-Smith enjoys a special relationship with the Gallery and receives our complete support in the publication of her research. The significance and serious nature of such an attribution have, of course, been carefully considered by all involved with this book and have engendered an enthusiasm for the painting and its study that it has not enjoyed since it was initially purchased by the Comtesse de Béhague at the turn of the century.

The ways and means for the Henry Art Gallery to undertake such publications come solely through the Henry Gallery Association, its trustees and its patrons. The dedicated efforts of the Association's President, Mrs. William H. Hoppin, Jr., the Chairman of the Ways and Means Committee, Mr. H. Raymond Cairncross, and the Association's Director, Mrs. John E. Z. Caner, have enabled us to produce the book you now hold in your hand. Seattle's PONCHO (Patron of Northwest Cultural Organizations) and private and corporate patrons have given generously to the Association for its production.

In addition to expressing my appreciation to Dr. Snow-Smith for the pleasure of working with her on this project, I wish to extend a special note of gratitude to the Marquis and the Marquise de Ganay for their generosity in permitting their collection to be exhibited at the University. The *Salvator Mundi* painting was included in the exhibition "Leonardo's Return to Vinci; The Collection of the Countess de Béhague," that was first seen at Vinci, Italy, April-July 1980, and which toured North America under the auspices of the Italian Cultural Institute, San Francisco, and the University Art Museum of the University of California, Berkeley. The collection was displayed at the Henry Art Gallery from November 6, 1982 through January 16, 1983. My deeply felt appreciation goes to the tour's organizing committee of Carlo Pedretti, University of California at Los Angeles, Honorary Chair; Francesca Valente, Italian Cultural Institute, San Francisco, Co-Chair; James Elliott, University Art Museum, Berkeley, Co-Chair; Alessandro Vezzosi, Design Consultant, and Giovanna Zamboni, Editorial Consultant.

On behalf of the Henry Art Gallery and the University of Washington, it is my pleasure to present to you Professor Joanne Snow-Smith's research.

Harvey West
Director
Henry Art Gallery

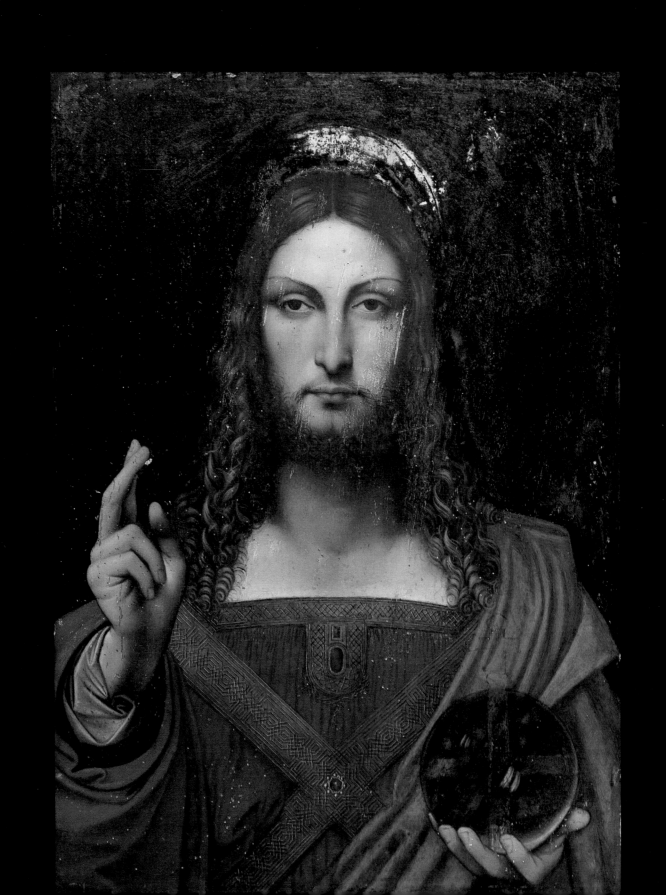

TABLE OF CONTENTS

Leonardo da Vinci, *Salvator Mundi.*
c. 1510-13. Oil on panel, 26⅞ x 19⅛ in
(68.3 x 48.6 cm). Collection of the
Marquis de Ganay, Paris.

INTRODUCTION

It had been planned that upon the publication of my complete research findings on Leonardo's *Salvator Mundi,* now in the private collection of the Marquis de Ganay in Paris, Professor Dr. Ludwig H. Heydenreich of Munich should write the Introduction to the book, setting forth aspects of the study unique from his viewpoint as a world-renowned expert on Leonardo da Vinci. As a result of the death of this great scholar and academician in September 1978, the task has now fallen to me.

It would be presumptuous for me to pretend to the vast scope of the knowledge of Leonardiana possessed by Professor Heydenreich. During my association with him, I realized, as I do now, that in my research on the *Salvator Mundi* I was working in the shadow of an intellectual giant, and that whatever I have achieved has been due to his never-ending and most generous assistance in every aspect of the work.

Professor Heydenreich, prior to his awareness of the existence of the de Ganay painting, had published in *Raccolta Vinciana* in 1964 his analysis of the extant copies of Leonardo's *Salvator Mundi* then known to him and his proposal of the nature of Leonardo's autograph prototype. After I had written to him in 1974 presenting for his consideration my initial research on the Paris *Salvator Mundi,* his immediate response was "My congratulations on this very important discovery of yours!" When, in the course of our correspondence in the following year, I suggested that we share equally in the authorship of my findings inasmuch as my original research was ultimately based on his 1964 article and on his continuing assistance, his generous and modest reply was: "Concerning the Ganay 'Salvator Mundi' I want to say first of all and very clearly, that I consider it entirely *your* mental property! Of course, I'm very willing to continue helping you as well as I can." To that end, in March of 1976, he graciously consented to meet with me in Paris where he not only examined the painting at the home of the Marquis de Ganay but also accompanied me to the Laboratory of the Louvre and evaluated their evidence definitively linking the de Ganay *Salvator Mundi* with the *Saint John the Baptist* in that museum. As a result of this examination and evaluation of the scientific analysis of the painting, he confirmed my conclusion that the *Salvator Mundi* was painted by the hand of Leonardo. In the spring of 1977, while Professor Heydenreich was in the United States serving as Kress Professor-in-Residence at the National Gallery of Art in Washington, D.C., he visited with me, my husband and family to discuss and offer suggestions regarding the final form of the initial article on the de Ganay painting which I had in preparation for publication in *Arte Lombarda,* an article which he graciously hand-carried back to Europe and ultimately saw through the press.

From its inception, my attempt, later augmented by Professor Heydenreich's advice and assistance, to dissipate the veils of mystery which have heretofore shrouded the original painting of the *Salvator Mundi* by Leonardo da Vinci has been a most challenging and rewarding endeavor. Throughout all of my research, Leonardo's own words seemed to come to mind: "Truth alone is the daughter of time" (M 58 verso).

The Paris painting was acquired in 1939 by the Marquis Hubert de Ganay by inheritance from his aunt, the Comtesse de Béhague, who had purchased it in 1902 through the Parisian art dealer Bourdariat from the Baron de Lareinty, who had acquired it from a convent in Nantes. Although at the time of her purchase the Comtesse considered the painting to be a work of Leonardo himself and maintained this opinion throughout her lifetime, no serious effort was made by the family at any time to seek authentication of the work. In January of 1972, at the suggestion of Professor Carlo Pedretti of the University of California, Los Angeles, I began the present research. The dearth of interest on the part of the de Ganay family in seeking an authentication despite the strong feelings of the Comtesse was explained to me by the late Marquis Hubert de Ganay, father of the present owner of the painting, who wrote in a letter of 11 February 1972 that the family accepted Bernard Berenson's appraisal when, while a house guest, he glanced at the painting on the wall and assessed it as a "poor copy by an inferior pupil of Leonardo."

The de Ganay and de Béhague families share a long tradition of devotion to the arts. The present Marquis' grandfather, Charles-Alexandre de Ganay, was a noted collector whose interests, and in particular his penchant for Leonardiana, were carried on by his son Hubert, who was a patron of *L'association Léonard de Vinci* and the Vice President of *Les amis du Louvre.* The father of the Comtesse was the collector Comte Octave de Béhague, whose holdings included many etchings by Wenceslaus Hollar who, in 1650, etched a plate after a painting which he knew as Leonardo's original *Salvator Mundi.* The Comtesse was a lifelong *aficionada* of Leonardo da Vinci, and in addition to Leonardo's *Salvator Mundi* was the owner of four splendid drapery studies by the artist, as well as two manuscripts related to Leonardo's *Treatise on Painting,* one associated with Nicolas Poussin and the other with Peter Paul Rubens. In the spring of 1980 Professor Pedretti arranged for the Leonardo collection of the late Countess to be exhibited publicly for the first time in the museum in Leonardo's birthplace of Vinci, an endeavor in which he was strongly supported by the late Dr. Elmer Belt of Los Angeles, an honorary citizen of Vinci. The following year, due to the generosity of the Marquis, the exhibition began a tour of the United States under the auspices of the University of California, Berkeley, and the Italian Cultural Institute, San Francisco. Regretfully, Professor Heydenreich is not here now to join in this celebration of the works of Leonardo.

ACKNOWLEDGMENTS

It is with deep gratitude to Professor Heydenreich for the essential role he played in bringing my research on the *Salvator Mundi* of Leonardo da Vinci to fruition and for the great privilege and honor he afforded me by allowing me to work with him that, with all humility and respect, I dedicate this book to his memory, and hope that in some small aspect it may approach his standards of scholarship.

Joanne Snow-Smith September 14, 1982

University of Washington
Seattle

In the preparation of this book I was most fortunate in having the able assistance and gracious cooperation of many people and institutions without whom publication would not have been possible. It is my great pleasure and privilege to express my sincere appreciation and gratitude for their efforts on my behalf.

First among them is the Marquis Jean Louis de Ganay of Paris, owner of the *Salvator Mundi,* who graciously and promptly acceded to all of my requests for photographic materials and information relevant to the painting, in addition to granting me permission to publish both. His generous cooperation and that of his late father, the Marquis Hubert de Ganay, through the long duration of my research on the *Salvator Mundi* has been of the utmost importance to this publication.

Some of the material in this book was previously published in a different form in *Arte Lombarda,* and I am indebted to the Director, Professoressa Maria Luisa Gatti Perer, for permitting me to include it here. My thanks are due to the many museums, libraries, institutions and individuals whose courteous provision of photographic materials and permission to reproduce them have been of paramount importance to this book, and to those who have given permission to reprint published material, and who are listed individually elsewhere.

It is with a deep sense of gratitude that I wish to thank Harvey West, director of the Henry Art Gallery at the University of Washington, Seattle, for his unlimited support and assistance, in addition to his much appreciated encouragement and enthusiasm. To his splendid staff, I am also most grateful for their indispensable help. I owe a special debt of gratitude to Joseph N. Newland, editor of publications at the Henry Art Gallery, for his untiring patience, dedication and meticulous care in the preparation of this book that is in keeping with the tradition of excellence of their publications. My thanks are also due to his superb editorial staff, to Paul J. Brown for typing the manuscript and preparing the index, Karen Broenneke for assistance with obtaining photographs, Elaine Schmidt for her careful proofing, and especially to Roberta Schneider, who scrupulously edited the notes and obtained necessary reference materials for me. My appreciation is due also to Douglas Wadden for his lucid and beautiful book design.

I also have the pleasure of acknowledging a research grant from the Graduate School Research Fund at the University of Washington.

Finally, I should like to thank my husband, Porter, for his continued enthusiastic support, assistance and thoughtfulness.

J.S.-S.

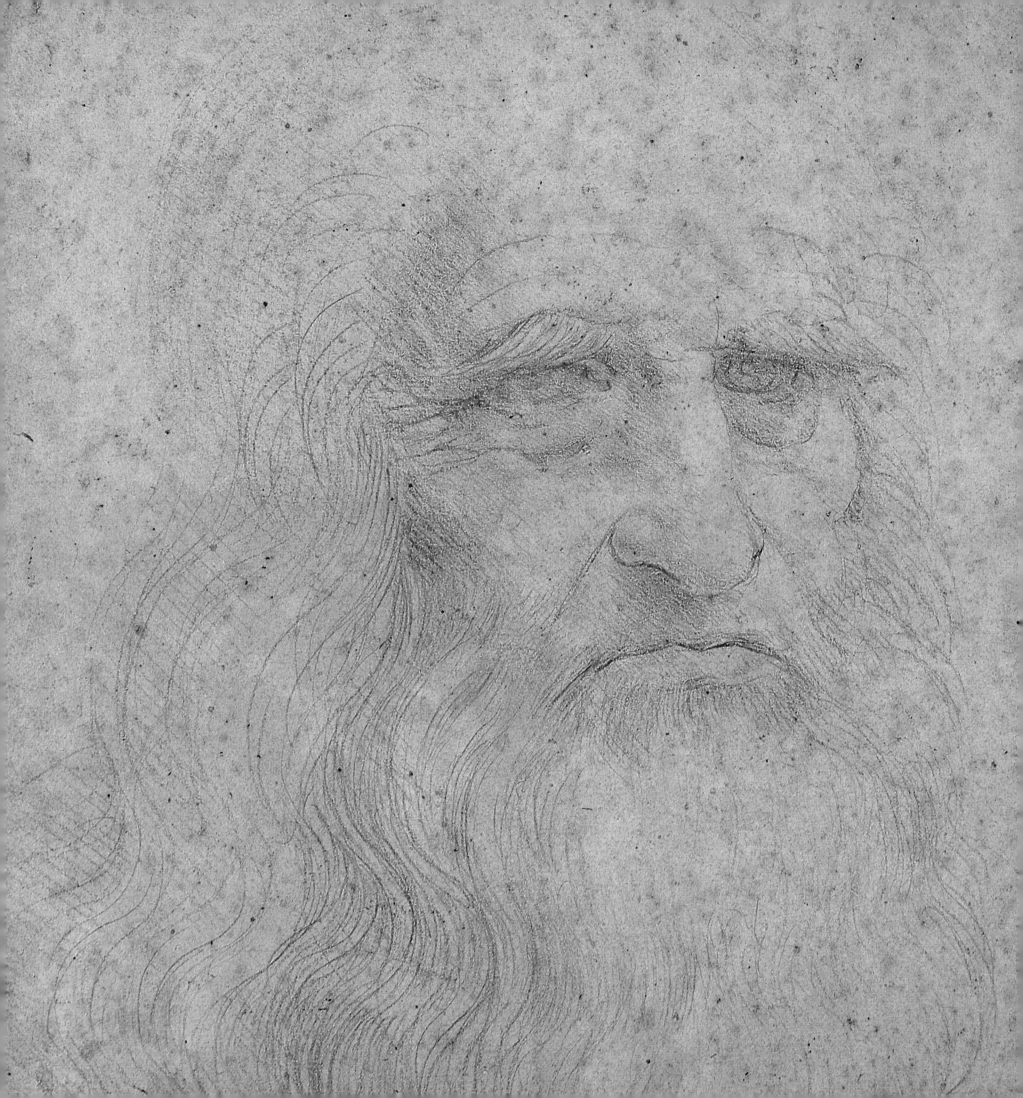

LEONARDO AND THE KING

Suppose that one of the world's masterpieces were to disappear, leaving no trace behind it, not even a reproduction; even the completest knowledge of its maker's other works would not enable the next generation to visualize it. All the rest of Leonardo's *oeuvre* would not enable us to visualize the *Mona Lisa* ...

André Malraux*

**The Voices of Silence,* trans. Stuart Gilbert, Princeton, 1978, p. 455.

After first having etched and printed a series of uninscribed proof copies of a 22 x 17 cm etching of a *Salvator Mundi* (Savior of the World), Wenceslaus Hollar, the Bohemian artist, in order to assert both his artistic indebtedness and the conditions under which he had labored, took the plate in hand and wrote upon it *"Leonardus da Vinci pinxit; Wenceslaus Hollar fecit Aqua forti, secundum Originale, A° 1650"* (fig. 2). After reproducing prints with this modification, he made yet a further addition to the plate, *"Venite ad me ... Joh. 14, v. 6,"* and again had prints made from it.[1]

That there once must have existed a Leonardo painting of a *Salvator Mundi* which Hollar might have copied "after the original" is apparent from the large number of extant representations of the theme which have been attributed to members of Leonardo's circle. From the generally broad accord visible among the Leonardesque paintings of a *Salvator Mundi* to be found in England (figs. 4 and 7), Warsaw (fig. 5), Detroit (fig. 6), Zürich (fig. 8), Milan (fig. 9), and Arcore (fig. 10), *inter se* and between them and the Hollar etching, there may be postulated a prototype which is common to all.[2] The painting of a *Salvator Mundi* from the private collection of the late Comtesse de Béhague of Paris and now belonging to the Marquis de Ganay (fig. 3) is here identified as that prototype.

The copy in the Detroit Institute of Arts (fig. 6) shows a strong affinity with Hollar's etching, and, at first glance, might seem to have provided Hollar's prototype, an idea which, however, is immediately negated by the difference in the treatment of the crossed stole and neckband adorning the figure of Christ. In all of the extant copies after Leonardo's *Salvator Mundi*, with the exception of the one formerly in the Cook Collection in England, which will be discussed below, the differences in the treatment of this embroidery pattern preclude their being the original on which Hollar's etching was based.

Mention should be made here of *"un Christ à demi corps"* which is mentioned by Père Dan as being by Leonardo in *Le Trésor des merveilles de Fontainebleau* (Paris, 1642) and which has at times been identified with the Detroit copy.[3] The painting at Fontainebleau has however been traced to Nancy by Eugène Müntz who states that *[the] half-length of Christ, Père Dan mentions among the pictures of Leonardo preserved at Fontainebleau, a Christ a mi-corps ...which has nothing to do with Leonardo, is now in the Museum at Nancy (engraved in the Magasin pittoresque for 1848, p. 288, with a commentary by the Marquis de Chennevières). According to M. Durand-Gréville it is a Flemish picture of the sixteenth century.*[4]

Today the early attribution of the Detroit painting by Berenson to Giampietrino has found some confirmation[5] despite earlier attributions to Salai[6] and to Marco d'Oggiono.[7] If indeed it is by Giampietrino,[8] it is suggested that it was painted by him around 1511, at the same time that he executed the copy of Leonardo's lost *Madonna of the Cherries*, formerly in the collection of Marcel von Nemes, Munich. It is further suggested that both copies by

2. Wenceslaus Hollar, *Salvator Mundi*,
after Leonardo da Vinci. 1650.
Etching, 8¾ x 6¾ in (22.2 x 17.1 cm).
Royal Library, Windsor Castle.
Reproduced by gracious permission of
Her Majesty Queen Elizabeth II.

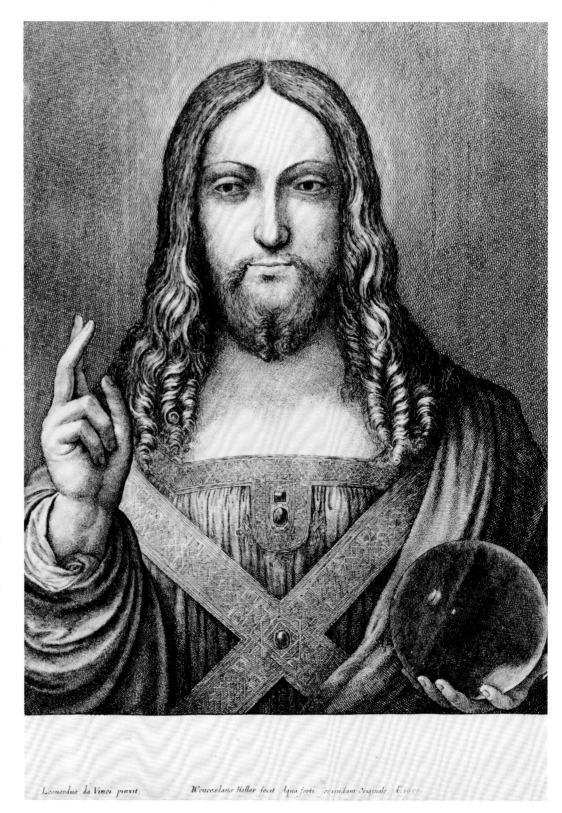

Giampietrino were commissioned by Leonardo's patron, King Louis XII of France, who would have wished to have copies of the paintings he had ordered; the desire of the French kings for copies of the masterpieces they owned is well known. The wish for a personal copy of Leonardo's *Salvator Mundi* by members of the King's entourage is suggested by the copy that was in the Trivulzio Collection in Milan (fig. 9), which may have been commissioned by Gian Giacomo around 1509-13 while Leonardo was working on the general's monument and the original *Salvator Mundi* was still in the artist's studio.[9]

It is suggested that these artists copied the same painting as Hollar but in different stages of its execution, and that Hollar in 1650 faithfully duplicated an embroidery pattern which had been completed on the painting while the other artists had been forced to improvise their own decorations for the stole and neckband (or in the case of the Warsaw copy leave them off entirely) because, at that time, this area of the original was either blank or at best merely roughed in.

However, the copy formerly in the Cook Collection (fig. 7), the whereabouts of which are presently unknown, does include the same pattern in the crossed stole that is found in the Hollar etching and the de Ganay *Salvator Mundi* (figs. 2 and 3). In the 1913 catalogue of paintings formerly in Doughty House, Richmond, in the collection of Sir Frederick Cook, the entry for this painting (which had been purchased in 1900 from Sir J. C. Robinson as attributed to Luini) states "Free copy after Boltraffio." Inasmuch as Boltraffio (Giovanni Antonio, 1467-1516), Leonardo's finest pupil and devoted disciple, is reported to have lived with his master in Milan, was placed in charge of Leonardo's workshop when he was forced to leave that city in 1499, and had his presence noted in Leonardo's journal on 26 September 1510 during his second Milanese sojourn, he would have been uniquely placed to make a copy of Leonardo's *Salvator Mundi* just before the painting was sent to Louis XII sometime in 1513, the circumstances of which will be discussed below. That the Cook painting could not have been the prototype of Hollar's etching is evidenced, however, by the fact that there is no jewel in the center of the stole nor an accommodation in the orphrey for the insertion of one; the embroidery merely continues the hexagonal pattern without interruption whereas Hollar includes a change in the pattern around a mounted jewel. Moreover, the Cook copy includes only cross-hatching in the neckband while Hollar makes the embroidery of continuous filaments, as does the de Ganay *Salvator Mundi*. The obvious differences in the face of the Cook copy, which is lacking a beard, has eyes light in color and looking in the opposite direction, and lacks the pencil-thin eyebrows found in both the etching and the de Ganay painting, further mitigate against it being Hollar's model.

Leonardus da Vinci pinxit. *Wenceslaus Hollar fecit Aqua forti secundam Originale A 1650*

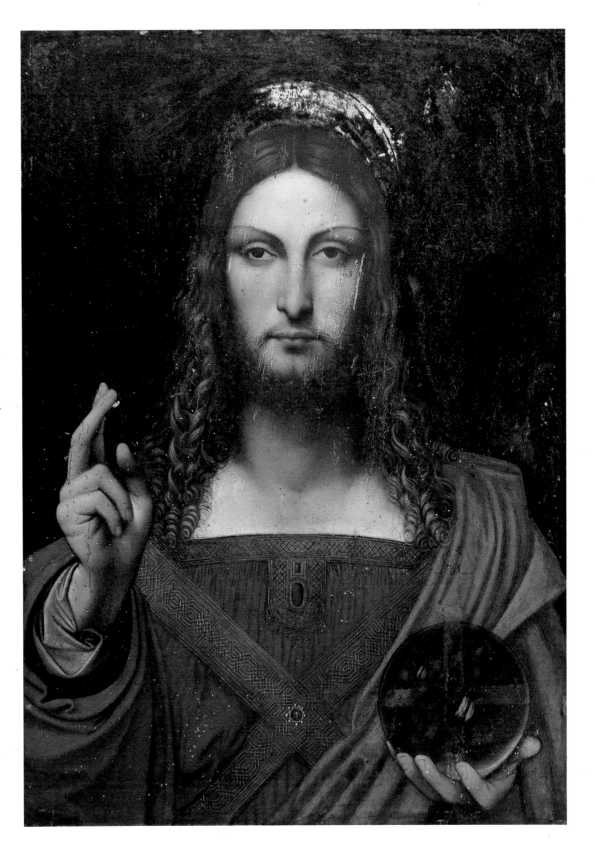

3. Leonardo da Vinci, *Salvator Mundi*.
c. 1510-13. Oil on panel, 26⅞ x 19⅛ in
(68.3 x 48.6 cm). Collection of the
Marquis de Ganay, Paris.

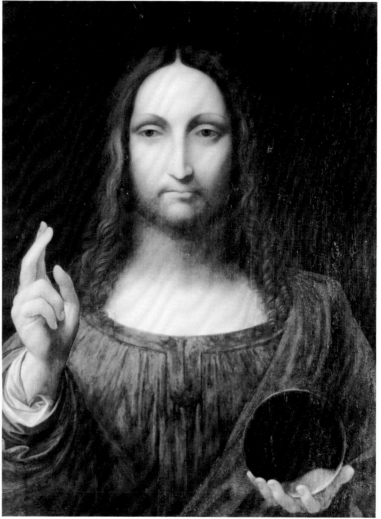

4. After Leonardo da Vinci, *Salvator Mundi.* 24⅜ x 19¼ in (62.5 x 48.8 cm). Formerly in the Worsey and Yarborough Collections, England; whereabouts unknown.

5. Cesare da Sesto, *Salvator Mundi,* after Leonardo da Vinci. 24¾ x 19⅝ in (63 x 50 cm). National Museum, Warsaw.

6. Giampietrino, *Salvator Mundi*, after Leonardo da Vinci. c. 1511. 26 x 19 in (66 x 48.3 cm). Detroit Institute of the Arts, Gift of James E. Scripps.

7. After Giovanni Antonio Boltraffio, *Salvator Mundi*, after Leonardo da Vinci. 24⅜ x 17½ in (63.2 x 44.5 cm). Formerly in the Cook Collection, Richmond; whereabouts unknown.

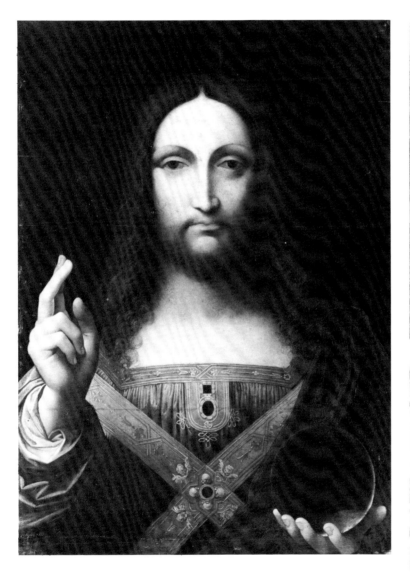

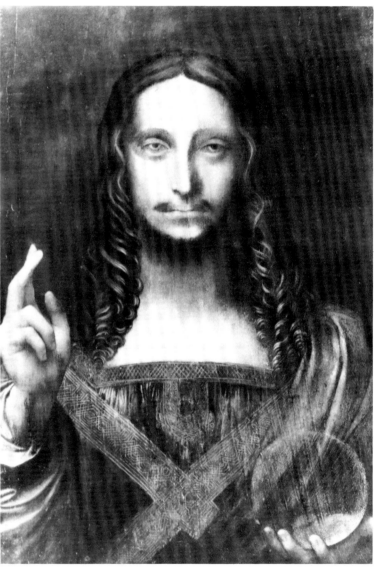

In addition to the extant copies of Leonardo's *Salvator Mundi,* another version of a *Salvator Mundi* may be postulated from a comparison between Windsor drawing 12524 (fig. 11), which Lord Clark has identified as a preliminary drawing for a *Salvator Mundi,*[10] and the copy of a *Salvator Mundi* after Leonardo formerly in the Worsey Collection (fig. 4) in England.[11] Ludwig Heydenreich has pointed out the exact similarity of two details between the Worsey painting and the Windsor drawing, saying, "The sleeve styles of the blessing hand in both the painting and in the drawing are in accord with each other even in the details [such as] the bunches and folds of the undergarment, [and] the s-shaped loop, as well as the flaps doubled on the right and tripled on the left of the overgarment;"[12] and concluding, "[Although] the really clumsy manner of painting marks the painting as a copy, nevertheless it becomes certain from this that *two* versions of Leonardo's *Salvator Mundi* must have existed…(A) that for which the Windsor drawings laid the foundation, and a second (B) which we might denote as the Wenceslaus Hollar style."[13]

It should be mentioned that the only other Leonardo drawing identified by Lord Clark as being associated with a *Salvator Mundi,* Windsor 12525[14] (fig. 12), contains in the lower left hand corner an omega-shaped tuck in Christ's vestment (the iconological significance of which will be discussed later) which is found duplicated only in the Paris and Worsey paintings, and seemingly in the Cook example, although it is difficult to be absolutely certain on the basis of the existing photograph and without being able to inspect the painting. While the presence of the omega tuck in the Paris painting links it directly with Leonardo's drawing, in addition, the overall similarity of other details between it and the Hollar etching mandates that it be accepted as the Hollar prototype. The only discrepancies apparent to me between the Paris painting and the Hollar etching are (1) different anatomical proportions in the etching, in which the head is larger relative to the body, resulting in some cropping at the bottom; (2) the omega tuck incorporated in the painting and absent from the etching; (3) traces of the remains of an overpainted cross on the globe and a section of a gold halo in the painting which were not revealed until after the painting was cleaned, neither of which is duplicated in the etching; (4) the lack of nobility in the face of Christ so apparent in the painting; and (5) eight obviously overpainted pearls which surround the central jewel of the stole in the painting but do not appear in the etching. There are logical explanations for all of these: (1) the change in size and scale in the translation of the painting (68.3 x 48.6 cm) to the etching (22.2 x 17.1 cm); (2) an omission on the part of the etcher in view of the reduced amount of space towards the bottom of the etching, and, not understanding the iconological significance of the tuck, Hollar did not include it; (3) neither of these would have been visible to the etcher, because they had not yet been applied; (4) Sir Ernst Gombrich has pointed out the one thing that is most difficult, if not

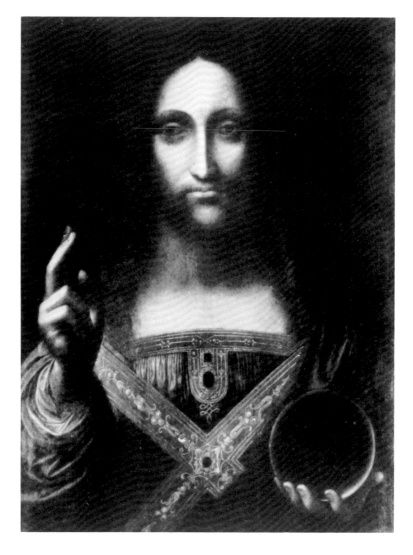

9. After Leonardo da Vinci, *Salvator Mundi.* 1511. Formerly in the Trivulzio Collection, Milan. (Copied from *Raccolta Vinciana* 20.)

10. After Leonardo da Vinci, *Salvator Mundi.* Formerly in the Vittadini Collection, Arcore. (Copied from *Raccolta Vinciana* 20.)

11. Leonardo da Vinci, Study for a *Salvator Mundi.* Windsor 12524. c. 1510-15. Red chalk with touches of white, 8⅝ x 5½ in (22 x 13.9 cm). Royal Library, Windsor Castle. Reproduced by gracious permission of Her Majesty Queen Elizabeth II.

12. Leonardo da Vinci, Study for a *Salvator Mundi.* Windsor 12525. c. 1510-15. Red and white chalks, with pen and ink, 6½ x 6¼ in (16.4 x 15.8 cm). Royal Library, Windsor Castle. Reproduced by gracious permission of Her Majesty Queen Elizabeth II.

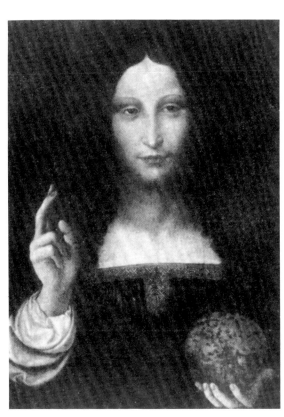

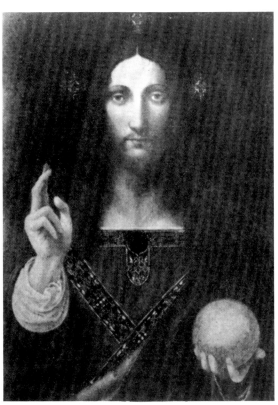

impossible, for the copyist, however skilled, to imitate is the human face; and (5) the overpainting of these pearls around the central jewel was executed subsequent to the date of Hollar's etching and may have been added as a part of armorial bearings.[15]

Mention should also be made here of the painting of *The Twelve-Year-Old Jesus in the Temple* requested of Leonardo in 1504 by Isabella d'Este which is known by the Luini copy in the National Gallery in London. It should be stressed that this work was entirely different in conception and iconography from a *Salvator Mundi*. While Professor Heydenreich in 1964 could only suggest that the Windsor drawings for a *Salvator Mundi* were in no way connected with the d'Este request of 1504, I am indebted to Professor Carlo Pedretti for putting this question completely at rest by providing me with the information that, on the basis of his recent examination of their reverse sides, the drawings must now be dated between 1510 and 1515, long after Isabella d'Este's plea.

It now becomes necessary to investigate Hollar's statement that he etched his copy "after an original" which "Leonardo da Vinci painted." The research *desiderata* are: (1) a plausible history for Leonardo's original *Salvator Mundi* painting from its inception until the year 1650 which includes the name of the original patron and the interim depository of the painting, (2) an analysis of the activities of Hollar during the year 1650 which would not only indicate that he had access to the proposed location of the painting in that year but also provide an explanation of the etiology of his etching which would include the source of his commission, and (3) a suggested history of the painting from 1650 until the present; while the *sine qua non* are: (1) a scientific analysis of the de Ganay painting and (2) a stylistic analysis of it, both of which tend to confirm and, most importantly, do nothing to negate its being an original work by Leonardo.

Inasmuch as all of the copies of Leonardo's *Salvator Mundi* as set forth by Heydenreich in his previously cited study of 1964 were so patently different in both technical and artistic merit as to preclude any suggestion of the autograph of Leonardo, there was no equal impetus to establish a similar historical and etiological linkage between da Vinci and these works. Similarly, no purpose would be served by submitting them to detailed scientific and stylistic analyses. However, it would be improper to summarily dismiss these copies as unimportant since they do establish the existence of an original painting by Leonardo, provide clues as to some of its details and, on stylistic and historical grounds, provide valuable dating tools from which inferences may be drawn leading to the conclusion that the original, while it was probably started earlier, was well along by 1511, even if not completed prior to 1513.[16]

Evidence of an early interest by Louis XII in the subject matter of Leonardo's painting may be found in his important coronation manuscript which shows the French King being presented by his patron, Saint Louis, to Christ, who is represented in the role of a *Salvator Mundi* (fig. 16).[17] Louis XII prided himself on his sense of fairness and justice and liked to think of himself as the "father" rather than the "king" of his people.[18] He reorganized the law courts and introduced a new system of justice,[19] and may have hoped that his efforts reflected the divine justice inherent in a *Salvator Mundi*. This idea is borne out by the representation of this theme in a full-length statue that the King had placed on the trumeau of the second level of Sainte-Chapelle in Paris (fig. 15), the holy chapel of the Law Courts remodelled under his edict.[20] This same theme is repeated there in the painting on the interior of the central tympanum beneath *La Grande Rose de la Façade*.[21]

Further proof of the King's particular religious devotion to Christ may be found in his cenobian pursuits. In 1502 Louis XII reformed the Order of the Cordelier,[22] a Christ-centered lay Order whose name recalled and gave honor to the cords that bound Jesus at the time of His Passion, and a few years later his wife, Anne of Brittany, introduced to the French Court the female branch of the same Order, which had been founded by her father's first wife.[23]

So important was the Order of the Cordelière to Anne and her husband that she incorporated its device into her own coat-of-arms (fig. 13),[24] and it was installed on and above the mantelpiece of *La Cheminée des Cordelières* at the château at Amboise and on both *La Cheminée "au Porc-épic"* and the ceiling of the chapel of the château at Blois. In addition, Anne fitted out and presented to her husband a warship christened *"La Cordelière"* which was designed and built for war against the Saracen pirates in the Mediterranean.[25] Upon her death, the first mass at her funeral was said by the Cordeliers, and the device of that order not only was prominent in the funeral decorations while she lay in state[26] (see fig. 14), but also was inscribed on the gold reliquary in which her heart was encased when it was interred in Nantes in the tomb of her father, François, Duke of Brittany.[27]

Another close connection of the French Royal Family to the theme of a Blessing Christ is to be found in the so-called *Main de Justice* which also is portrayed in figure 14 at the left hand of Anne in her obsequies.[28] This Hand of Justice, one of the crown jewels of France, consists of a gold staff surmounted by an ivory hand in which the fingers assume the same blessing position as in a *Salvator Mundi*. The source of the ivory in the original *Main de Justice* was traditionally held to have been the horn of a unicorn,[29] an animal that was so imbued with a Christological identification by the medieval exegetes as to make this choice of material singularly appropriate.[30] Although the original has been lost, its general form is apparent in a replica made for Napoleon I now in the Louvre.[31]

13. Detail from Frontispiece of *le Trepas de l'Hermine regrettee*. c. 1514. Ms. Dutuit B. 665, fol. 1r. Petit Palais, Paris.

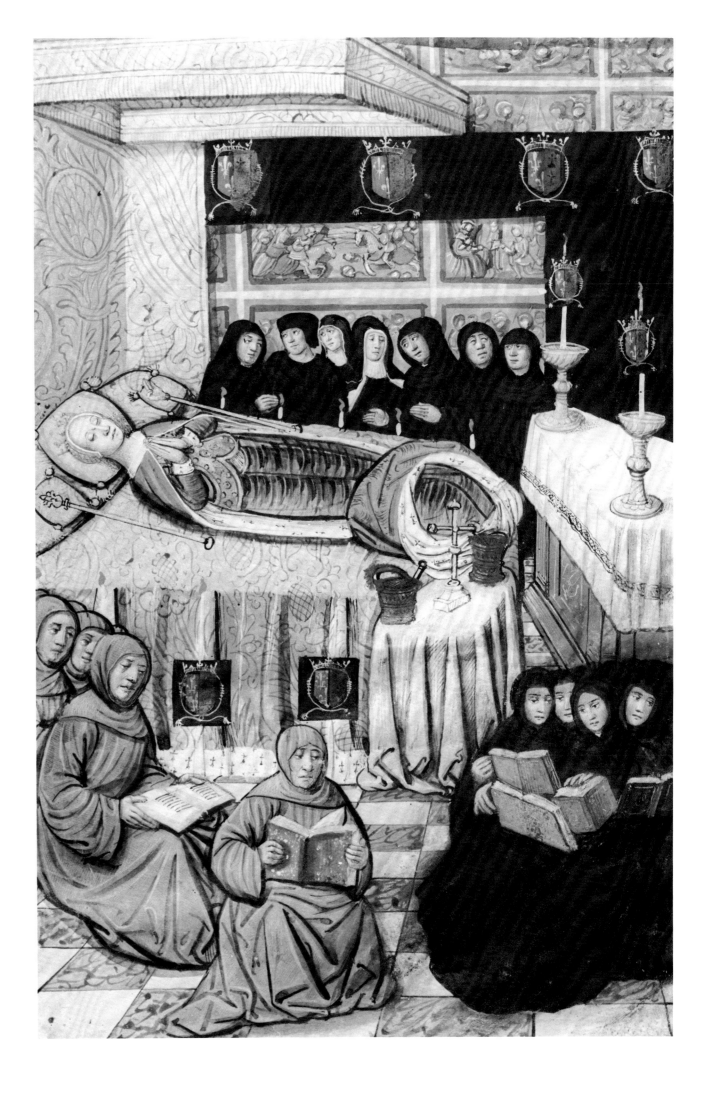

14. "Anne of Brittany Lying in State,"
from *le Trepas de l'Hermine regrettee*.
c. 1514. Ms. Dutuit B. 665, fol. 5v. Petit
Palais, Paris.

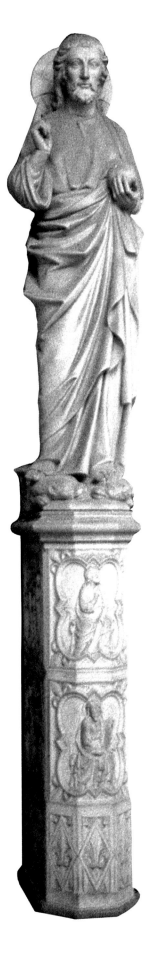

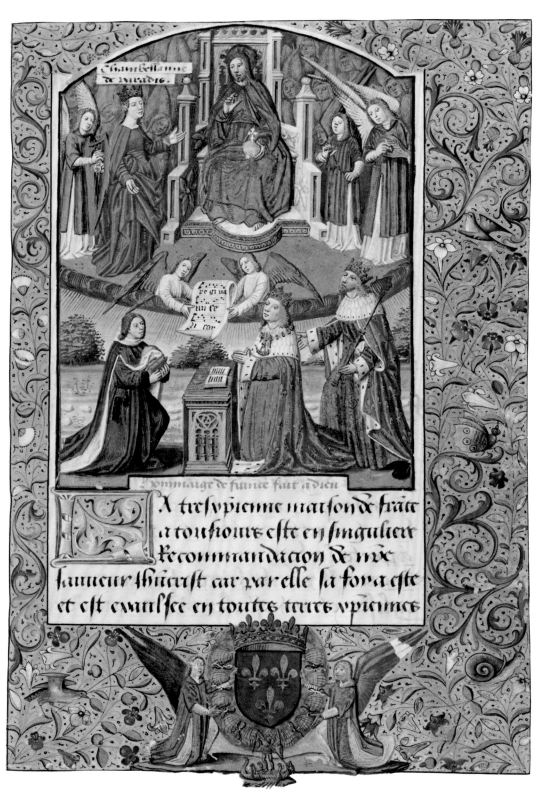

15. Statue of a *Salvator Mundi* in *la Sainte-Chapelle de Paris*, modern copy by Geoffrey Dechaume after an early 16th century original.

16. "Louis XII before his Patron Saint, Saint Louis," from *Les services et devotions fait par les rois de France à l'eglise Saint-Denis, avec les enseignements de Saint Louis et son fils.* 1498. Ms. Fr. 5869, fol. 1. Bibliotheque National, Paris.

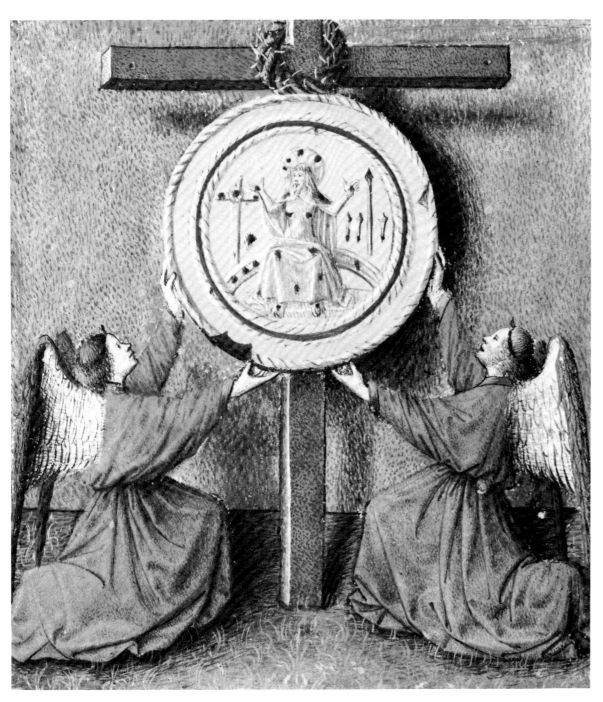

Despite the early and continued interest of the King and his wife in the *Salvator Mundi* theme and in separately sponsored Christocentric Orders, the true impetus for Louis' commissioning of a painting of a *Salvator Mundi* may best be attributed to a series of events which commenced early in 1505, the seventh year of his reign, when the King was struck down by an illness of such severity that his own physicians had given him up for dead. At this point, prayers were constantly offered for his recovery by the priests at la Sainte-Chapelle de Dijon before the *Holy Host* —bearing the image of Christ seated on a sprung rainbow with both hands raised displaying His wounds—which was much revered for its miraculous qualities (fig. 17). Louis began to recover and, feeling that his life had been miraculously preserved by the intervention of the Host, on the 25th of April following his recovery, the King presented as a votive offering the crown with which he had been invested to adorn the monstrance in which this Sacred Host was displayed.[32] The significance of the King's recovery cannot be overstated. At the time of his illness, his only then-living child, "*Madame Claude de France*," was affianced to the Duke of Luxembourg, the future Charles V, and in the normal course of events would have become his bride and France as her dower right would have been absorbed into the Hapsburg Empire, thereby losing its character as a separate nation. Louis, realizing the danger in which his nation had been placed, met in royal audience on 14 May 1506 with

à dextre d'un costé de Monsieur le Legat d'Amboise, du Cardinal de Norbonne [Guillaume Briconnet] du Chancelier & grand quantité d'Archevesques & Évesques: & de l'autre costé de Monsieur le Duc de Valois, & de tous les Princes du sang, & autres Seigneurs & Barons dudit Royaume en grand nombre aussy du premier Président de la Court de Parlement [C'étoit Jean de Gannay lequel a été depuis Chancelier de France] & plusieurs Conseillers, donna audience publique aux Deputez des États du Royaume[33]

in order to reaffiance his daughter to the future Francis I of France and assure a French succession even in the event, which indeed proved to be the case, that he, Louis, was not later provided with a male heir.[34]

While Heydenreich has pointed out in regard to the type of *Salvator Mundi* portrayed by the Hollar etching that it represents an amalgamation of the *vera effigies (Vera Icon)* and the Christ in Majesty of the Netherlandish painters of the fifteenth century,[35] this theme was, of course, as well known in France as it was in the Netherlands. In addition to the previously mentioned representations, it is portrayed in many manuscripts and repeated several times in *Les Très Riches Heures de Jean, duc de Berry.*[36] Particular note may be made of a *Salvator Mundi* which appeared in *L'art de bien mourir* published by Antoine Vérard in Paris in 1492 under the title of *"Les élus du paradis"* (fig. 18). This portrayal of Christ—in which He is seated on a sprung rainbow, clad in a voluminous overgarment and wearing an undergarment decorated with a crossed stole, and holding a globe surmounted by a cross in His left hand and blessing with His right—appears to stand transitionally between the depiction of the Savior which appeared on the *Holy Host* revered by Louis XII and the final version executed by Leonardo, and may well have been suggested by the King to the artist as a starting point for the latter figure. In any event "the art of dying well" must have been much on Louis' mind during his near-fatal illness, and a portrayal of a beneficent Christ presiding over the saved in Paradise would have had a particular poignancy for him, a poignancy which he would have recalled when, scarcely six months after making arrangements for his own succession, the King sought to avail himself of Leonardo's services.

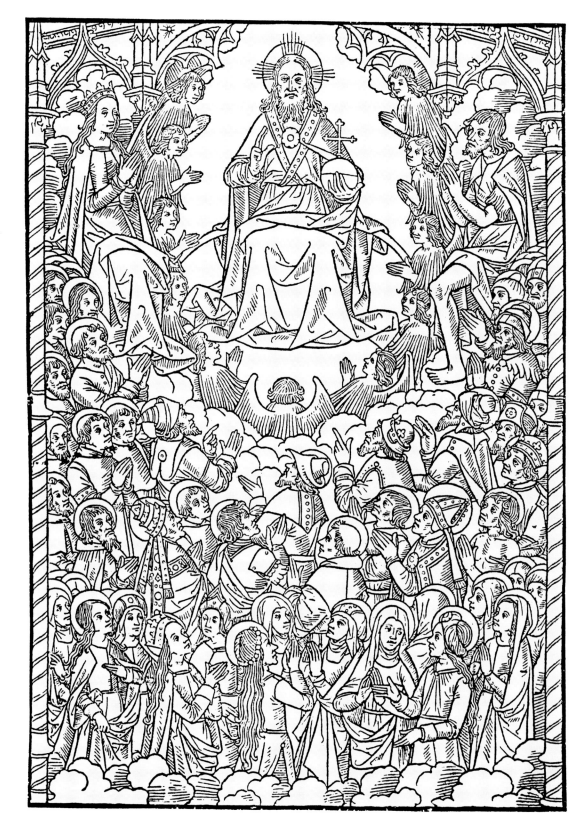

The interest of Louis XII in the art of Leonardo da Vinci could have commenced as early as 1499 when the King had the opportunity while in Milan to view the full-sized clay model of the enormous horse which Leonardo, during his first Milanese period of 1483-99, had executed at the request of Ludovico Sforza.[37] About the same time, according to an apocryphal story, the King is said to have strongly expressed his admiration for the *Last Supper* in the refectory of Sta. Maria delle Grazie and his hope to transport the mural to France.[38]

That Leonardo was actually employed by Louis and his secretary prior to 4 April 1501 is confirmed by a letter of this date mentioning "his [Leonardo's] engagement with the King of France" at that time and the artist's earlier completion of a "small picture [the *Madonna of the Spindle*] which he had executed for one Robertet, a favourite of the King of France…."[39] However, for the next five years Leonardo was to become occupied in areas distant from Milan, and over this period the King's direct connection with the artist was to lapse, not to be resumed until 1506.[40] In this regard may be mentioned the letter which Francesco Pandolfini, the Florentine Ambassador, wrote from Blois on 22 January 1507 at Louis' request asking that the Signoria of Florence allow Leonardo to remain in Milan as the King had expressed the desire for "certain small pictures of Our Lady and others, according as the idea occurs to me: perhaps I shall get him to paint my portrait."[41] Also, cognizance should be taken of the two letters written by Louis' secretary Robertet and signed by the King himself. In the first of these, dated 14 January 1507, the King indicates that he desires Leonardo to be allowed to remain in Milan as the King wished to make use of the artist's services.[42] In the other, dated 26 July of the same year, Louis requests the Signoria to expedite a lawsuit in which Leonardo was then engaged so that the artist might sooner return to the King's services.[43] In the same year Leonardo was appointed painter and engineer to the King.[44]

The artist, writing in acknowledgement from Florence about 1508, indicates his intention to return to Milan and to continue to "please our most Christian king."[45] Leonardo mentions in a note the salary that he was awarded by Louis XII to cover the period from July 1508 to April 1509.[46] The budget for the Duchy of Milan for the year 1510, item 436, approved by Louis XII, mentions a payment "*A m^e Leonnard, painctre*" of four hundred *livres,* and the budget for the following year, item 126, calls for a payment of the same amount "*A M^e Leonnard Vincy, florentin.*"[47] That Leonardo's emoluments from Louis XII were not restricted to the monetary payments received in these four years and continued even after the King's death is apparent from the painter's own testamentary disposition of 23 April 1518 in which he bequeaths the rights to "twelve ounces of water" from the canal of S. Cristoforo which he had received from the King in 1509.[48]

While Leonardo's indebtedness to the King both for the monetary benefits received from 1508 to 1511 and for the valuable water rights accorded him in 1509 is evident, his own personal interest in the subject of a *Salvator Mundi* for a painting does not seem to have arisen before his meeting with Louis at the time of the latter's triumphal entry into the city of Milan on 24 May 1507.[49]

As previously mentioned, Windsor 12524 (fig. 11) and 12525 (fig. 12) have been identified by Lord Clark as associated with a *Salvator Mundi* painting by Leonardo, and there is strong stylistic evidence that these drawings should be dated subsequent to the King's entry into Milan in 1507. Their newly assigned date of between 1510 and 1515 would make them coetaneous with the proposed date for the evolution of Leonardo's *Salvator Mundi*. In view of these facts and of Louis XII's demonstrable interest in the *Salvator Mundi* theme, especially after his unexpected recovery, it seems reasonable to propose that Leonardo's *Salvator Mundi* was the result of a direct commission by the King of France given in person to the artist in 1507 and that the payments made by Louis to Leonardo between that year and 1511 reflect, at least in part, payment on this work.

The schema of Leonardo's *Salvator Mundi* may have been suggested to Louis by a painting, possibly by Quentin Massys, that was once in the possession of James IV, King of Scotland. Although this latter work has now been lost, its existence is known to us from the Scottish King's *Book of Hours* of about 1505[50] in which James is shown in private devotions before a small altar that is surmounted by a triptych, the central panel of which contains a portrayal of Christ in the role of Savior of the World, *Salvator Mundi* (fig. 19), identical in composition to that of Leonardo's own work (fig. 3).[51]

The closeness of the ties, both social and political, between the Scottish and the French thrones at this time would have virtually assured Louis' cognizance of the items in James' collection. The intimate relationship between James IV and both Louis XII and his wife is demonstrated by the fact that when Henry VIII of England invaded France in 1513, James, perhaps in response to an appeal from Anne of Brittany who referred to him as "Her Knight," made an abortive invasion of England that resulted in his death at Flodden Field in Northumberland on 9 September of that year. Anne may have felt that James was indebted to her by ties of blood inasmuch as her father's first wife had been the great aunt of the Scottish King.[52]

If he were to desire a votive painting for his own private devotions, which would be quite likely, especially after recovering from his near-fatal illness, it seems in keeping with the French King's long-standing devotion to the *Salvator Mundi* theme that he would have wished to emulate the Jamesian work, and, appropriate to the French King's superior role and with his unique access to Leonardo, such a painting would undoubtedly be able to surpass the Flemish work of Louis' royal relative.

It is suggested that Leonardo commenced and worked on the *Salvator Mundi* during his second Milanese period (1506-13), a time when his pupils would have had access to the painting in progress

in the artist's studio and executed copies of the picture in various stages of completion, as evidenced by the seven now extant (figs. 4-10). It is also suggested that, concurrently with work on the *Salvator Mundi,* Leonardo was also concerned with the *Saint John the Baptist* in the Louvre, the commencement of which I assign to this same period, in addition to commissions for Charles d'Amboise, the French governor of Milan up until his death, work on two paintings of the Madonna for the King, work on the Trivulzio Monument, and on various engineering projects for the French, as well as painting the *Leda*.

Because of these many enterprises in which Leonardo was engaged and his known aversion to completing any painting, it would not be surprising if the *Salvator Mundi,* even if begun as a direct commission from Louis XII received in 1507, were not brought to conclusion by 1513.

The hypothesis is here put forward that between the pyrrhic victory of the French at Ravenna in 1512 and their defeat at the Battle of Novara in 1513, sensing the immediate loss of Lombardy and fearing for the safety of his painting,[53] Louis XII demanded that the *Salvator Mundi* which he had commissioned more than five years earlier be completed at once and turned over to his representative. At the time of the King's order, the picture would have been complete except for the final ornamentation of the neckband and the crossed stole and the background. Leonardo complied with the King's order to the extent of completing the ornamentation and painting in a solid background, and some time in the spring of 1513, just prior to the Battle of Novara, turned the picture over to Trivulzio, who was Louis' Captain of the Horse and still in Milan. The painting probably remained with the French army until the peace treaty with the Swiss made in late September in which the French General Tremoille, then in command of the French forces but acting without approval of the King, was blackmailed, in order to prevent the sack of Dijon, into forfeiting the rights of the French to the Duchy of Milan and at the same time was forced to agree to the payment of a large ransom to save the city. It is probable that Leonardo followed these events with more than passing interest and hoped for a French resurgence. But this was not to be during Louis' lifetime; the treaty in which the French abandoned the Milanese was implemented on 14 September 1513,[54] and Leonardo left Milan ten days later while his patron, Louis XII, was still in the north facing the English near Amiens.[55]

The next month found the King at Blois, Leonardo in Florence, and the painting in transit between Dijon and Blois, where it arrived toward the first of November. However, it was to provide little pleasure to the King, for only a few months later he suffered the greatest loss of his life—that of his wife Anne, who died at his side in Blois on 9 January 1514.[56]

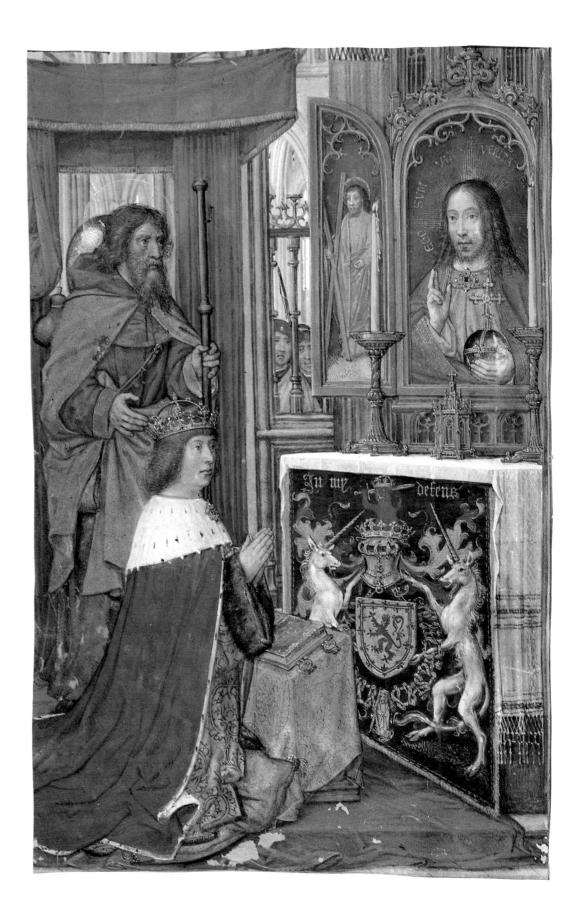

It is here proposed that shortly subsequent to her death, and possibly in compliance with her dying wish, Louis XII donated the *Salvator Mundi* that he had so recently acquired to the Franciscan convent connected with the Order of the Cordelière which his wife had introduced into the French court and that the convent in which the *Salvator Mundi* was placed may be identified with that of the Order of Saint Claire, which was founded in Nantes in 1457 by Françoise d'Amboise,[57] the wife of Pierre II, who had been Duke of Brittany from 1450 to 1457 and was first cousin to Anne's father.

The importance of Nantes itself in the life of Anne is indisputable. It was the capital of the Duchy of Brittany, which was her birthright; she was born there 20 January 1476,[58] married Louis XII there on 8 January 1488 in the chapel of the château,[59] and perhaps most significant of all, after her death her heart was buried there in the Cathedral of Nantes although her body was interred at St. Denis, the customary resting place of the kings and queens of France.[60] In regard to the disposition of Leonardo's *Salvator Mundi,* it seems particularly pertinent that on the day following the formal interment of the Queen's heart, the brothers of the Confraternity of the Veronica, an Order of which she was the sole female member, repeated the same service as that of the day before save that as they marched, they bore torches "decorated by a Veronica and the face of Jesus Christ, and emblazoned with the armorial bearings…" of Anne of Brittany.[61]

Therefore it would seem only appropriate for her husband the King to present as his personal votive funerary offering to the convent founded by the female side of her family, which was located in what was in truth her city, Leonardo's *Salvator Mundi*, which harked back to the original *vera effigies* in its rigid hieratic frontality. There it would have remained, protected from natural light and sequestered from public consciousness (except for the copy executed in 1650 under circumstances which will be discussed in the following chapter), until the turn of this century when the convents and monasteries were suppressed.

The foregoing hypotheses would completely explain the dearth of early references to its existence, the brilliance of the colors which we see today in the de Ganay *Salvator Mundi,* the discrepancy between the treatment of the embroidery on the stole and neckband to be found in that work and all but one of the known copies, the Paris painting's affinity with the Hollar etching, and the fact that no other painting has been found which possesses the same overall similarity.

The suggestion has been made that the painting which Hollar copied may once have been in the Arundel Collection and that he copied it while he was in the service of the Countess Alathea of Arundel in Antwerp.[62] While acceptance of this would eliminate the necessity of attempting to document a heretofore unmentioned trip to Paris and Nantes by Hollar, it seems untenable as it leaves the following questions unanswered: (1) If the painting were in the Arundel Collection, why did he not inscribe the etching *"ex collectione Arundeliana"* as he did on a total of sixty-five etchings—including two groups of heads after Leonardo[63] dated 1646 and one anatomical drawing[64] dated 1651 —coming from it? (2) Does it seem probable that the Leonardo painting could have been in the Arundel Collection and no mention of it passed down to us in the writings of his contemporaries or of his descendants? (3) If the painting were in the Arundel Collection, how can we explain its subsequent history and the dearth of any copies other than that of Hollar? (4) Finally and most difficult to answer, why is it not listed in the household inventory of the probate estate of the Countess Alathea filed in Amsterdam and dated 10 April 1655, some time after her death in 1654? While it is true that her son Lord Stafford sold some of the items from her estate and sequestered others before probate, it does not seem feasible that a Leonardo painting could have been among them and not become an issue in the lawsuit brought against him by his brother's children which arose out of the dispute surrounding the estate.[65]

Inasmuch as our investigation so far has been to establish the fact that the de Ganay painting of Leonardo's *Salvator Mundi* was the prototype of Hollar's etching in 1650, the identification of Louis XII as the patron of the original commission to the artist, and the presence of the painting in Nantes following its placement there by the French King, it now becomes necessary to establish a nexus between the Bohemian etcher and that city.

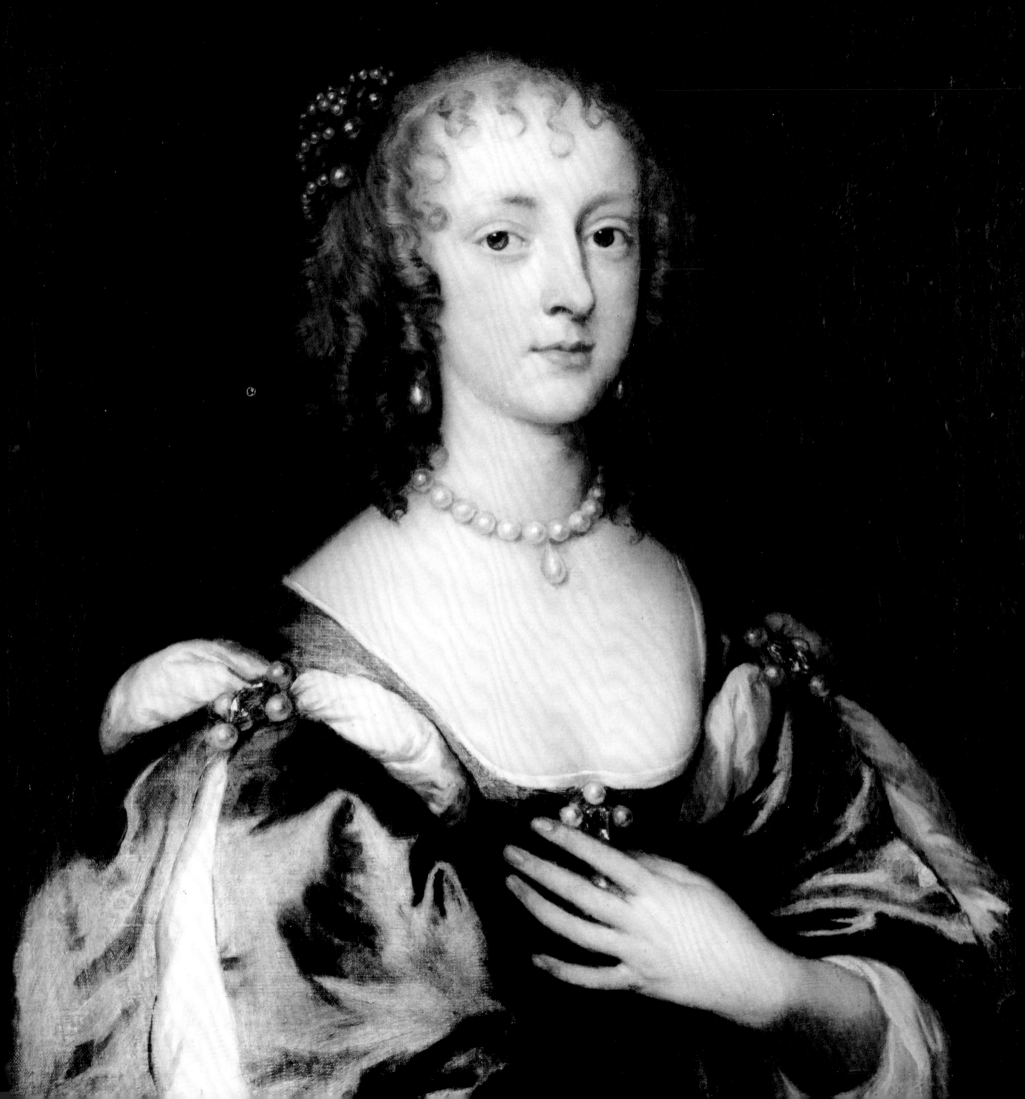

21. Wenceslaus Hollar, *Portrait of Princess Elizabeth, Daughter of King Charles I.* 1650. Etching, 5½ x 3⅝ in (14 x 9.2 cm). British Museum, London.

Leonardus da Vinci pinxit; Wenceslaus Hollar fecit Aqua forti, Secundum originale A° 1650.*

*Leonardo da Vinci painted the original from which Wenceslaus Hollar etched [this copy] in 1650 *Anno Domini.*

The provenance of Hollar's etching (fig. 2) copied in 1650 from Leonardo's *Salvator Mundi* is based on the following facts and the conclusions drawn from them: (1) the close, even personal, relationship between Hollar and the family of Charles I of England that lasted from 1637-73; (2) Hollar's coming to Antwerp from England about 1644, his conversion there to Catholicism, and his departure from Antwerp in 1649 and ultimate return to England by 1652; and (3) the internal evidence to be found in Hollar's etchings and the external evidence of the present disposition of Hollar's plates as catalogued by Gustav Parthey, which provide an abundance of information indicating Hollar's presence in Paris during this period as well as strongly suggesting that while he was absent from the Netherlands he also travelled through southern France and on into Italy.[1]

This research shows the probability that Henrietta Maria de' Medici, the widow of Charles I, martyred King of England, was the patron and the recipient of the proof copies of Hollar's etching after Leonardo's *Salvator Mundi*. Hollar's long history in the service of the English Royal House, dating back at least to his employment as etcher to the King and art tutor to the young Charles and his brother, combined with the evidence of Hollar's stay in Paris and three etchings of the young Charles II which are ascribable to the years 1649-1650 suggest that while in Paris he was subject at least in part to the commands of the Dowager Queen.

"Mr. Hollar went into ye Lowe Countries where he stayed till about 1649."[2] Thus wrote John Aubrey, contemporary and confidant of the Bohemian etcher. Until recently Hollar's *locus vivendi* from the year 1649 until his return to England in 1652 has been of no particular concern to the majority of his biographers, but the present research on Leonardo's *Salvator Mundi* painting has focused attention on this relatively unknown period of the etcher's life and necessitated a more thorough investigation of his activities between 1649 and 1651. Katherine Van Eerde has suggested a close tie between Hollar and Charles II during this period,[3] while Keith Brown has attributed to Hollar the original drawing for the engraved cover page of Thomas Hobbes' *Leviathan*, a drawing which was included in Hobbes' presentation copy given to the young King in Paris.[4] Although Brown does not insist on a Paris provenance for this drawing, his exposition of the necessarily close cooperation between the artist and Hobbes, who was in that city, militates in favor of this view. This drawing must have had a date close to and a *terminus ante quem* of 1651, the date of publication of the *Leviathan* in England.

In any attempt to fill in the *lacunae* in the etcher's activities during the "lost years" of 1649-51 by making an historiographical investigation of his life on the basis of contemporary material, one is eventually brought face to face with the dearth of available sources. Other than his opening quotation, Aubrey makes no further reference to Hollar's continental stay except for

mentioning his subsequent return to England.[5] The only other accounts of Hollar's activities by his contemporaries that include this period provide even fewer particulars.

Although John Evelyn was personally acquainted with Hollar, he makes no mention whatsoever in his publication *Sculptura; or, the History and Art of Chalcography, and Engraving in Copper*[6] of the Bohemian's trip to the Netherlands. However, he does mention Hollar's stay in Antwerp in his *De Vita Propriae*, a passage which has been incorporated in a footnote in his *Diary*,[7] but limits his comments to the fact that Hollar was converted there to Catholicism by the Jesuits and ultimately returned to England. Samuel Pepys, the only other contemporary source who discusses Hollar, provides no information on the subject years.[8]

Subsequent to these remarks by Hollar's contemporaries is the study of the etcher and his *oeuvre* made by George Vertue (1684-1756) which was first published in 1745 and reprinted in a second edition in 1759.[9] In this study Vertue not only lists all of Hollar's etchings known to him but also appends both a description of his technique of engraving purportedly by Hollar himself and a biography of the Bohemian which seems to be based partly on Evelyn's *Sculptura*, on conversations with Hollar's still-surviving contemporaries and on an analysis of Hollar's *oeuvre* itself and the subscriptions thereon.

Vertue provides the following information concerning the years under discussion:

In this Year [1647], and following Years 1648, —49, 1650, —51, he grav'd many Heads, Portraits, Landscapes after Breughil, Elsheimer, Teniers, *the* Triumphs of Death, &c. *and some of the most valuable Part of his Works from famous Paintings.*[10]

To this he adds mention of the etching by Hollar after a portrait drawing made of him by Johanne Meyssens, an engraver and print seller of Antwerp, to which was appended a short biography of the Bohemian in French, an etching which Vertue has dated 1648.[11]

Regarding the next year, Vertue supports the close connection between Hollar and the Royal Family in stating:

After the Death of King Charles *the First, he immediately grav'd his Picture, and several Loyalists; the King*[g] *and the Duke of* York *his Master coming into* Flanders, Teniers *drew the Duke's Picture, and* Hollar *engraved a Plate after it, which is scarce, being done in 1651, AEtat. 18.*[12]

Horace Walpole first began publishing in 1762 a multi-volume encyclopedia of English artists in which he included a catalogue of engravers based on the notes of Vertue, who had died six years previously.[13] However, perhaps in deference to the monograph on Hollar by Vertue which had already been published in two editions, one before and one three years subsequent to Vertue's death in 1756, Walpole did not include any reference to the artist in this or any later edition of this work. Walpole's encyclopedia was reissued in 1849 in a three-volume edition which included an entry on Hollar by the Rev. James Dallaway in which the biography of Hollar by Aubrey was incorporated, but the year 1649, which

Aubrey himself had given as the date of Hollar's departure from the Netherlands, regrettably, was mistakenly given as 1652.[14] Coupling this error with the adequately documented fact that Hollar had returned to England sometime in 1652 might explain why there has been little reason for most of Hollar's subsequent biographers to conclude that he had absented himself from the Netherlands prior to his return to England.

Four years after this publication Gustav Parthey completed his monograph cataloguing, describing, indexing, giving the inscriptions on, and cross-referencing to Vertue where possible all of the Hollar etchings known to him, totaling over two thousand seven hundred. Nevertheless, Parthey, not wishing to duplicate the efforts of another scholar, chose not to prepare a complete biography of his subject and merely brushed in Hollar's life with the broadest strokes, stating *"Da eine ausführliche Lebensbeschreibung Hollars demnächst aus einer Kundigen Feder zu erwarten steht."* As a result, Parthey has limited his comments on Hollar's sojourn in the Netherlands to the notation, *"[Hollar] ging über See nach Antwerpen im Jahre 1644. Hier verweilt er acht Jahre bis 1652".*[15]

Because of the scarcity of biographical evidence pertaining to Hollar's activities during the years 1649-50, a period of paramount importance to this study of Leonardo's original *Salvator Mundi*, it now becomes necessary to investigate Hollar's own works dated during those years for evidence of his *locus vivendi*. It is significant to note that many etchings were printed and published in Paris, suggesting his presence there.

F. L. D. Ciartres printed in Paris not only a series of the etchings by Hollar dedicated to the *Four Seasons*[16] but also the *Death of the Archbishop of Canterbury*, which is of interest in the context of Hollar's suggested stay in Rome.[17] Van Merle of Paris printed a later state of a series of twelve prints after Peeter van Avont, seven of which were originally signed by Hollar, four dated 1646 and two dated 1647.[18] The etcher, after the original printing in Antwerp, might have reclaimed the plates and taken them to Paris four years later for subsequent printing. Odieuvre, also in Paris, published three etchings by Hollar, one of which was a copy of Aretino's portrait by Titian which in the first state bore a lengthy Italian subscription that was later excised from the plates and replaced by one in French for the Paris print market.[19] The other two prints published by Odieuvre, consisting of Hollar's copy of Hans Holbein the Younger's portrait and his own self-portrait, both with French subscriptions,[20] must inevitably be linked with the publication by the Parisian N. Pitau of Hollar's thirty plates after Holbein's *Dance of Death*, for which Abraham van Diepenbeeck had drawn the borders and may be dated 1650.[21] This completes the list of all Hollar etchings known by either Parthey or Vertue to have been published in Paris; however, it does not conclude the evidence of Hollar's presence in the city in that year.

22. Wenceslaus Hollar, *Portrait of King
Charles II*, after Van Dyke. 1649.
Etching, 9⅝ x 6⅞ in (24.4 x 17.7 cm).
British Museum, London.

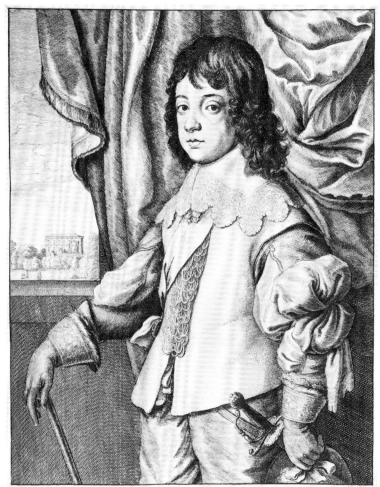

CAROLVS II. D.G. MAGNA. BRITTANIÆ. FRAN. et HIBERNIÆ. REX

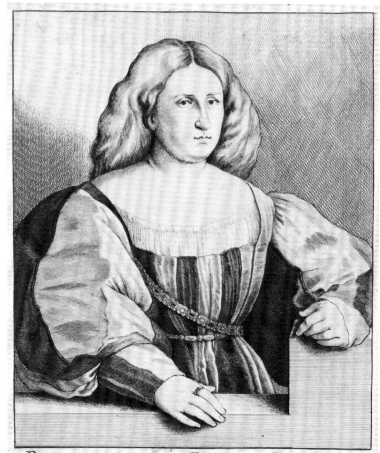

RITRATTO DELLA REGINA CATARINA
CORNARA.

24. Wenceslaus Hollar, *Portrait of Bonamico Buffalmacco*, after Giorgione. 1650. Etching, 9⅝ x 6¾ in (24.9 x 17.1 cm). British Museum, London.

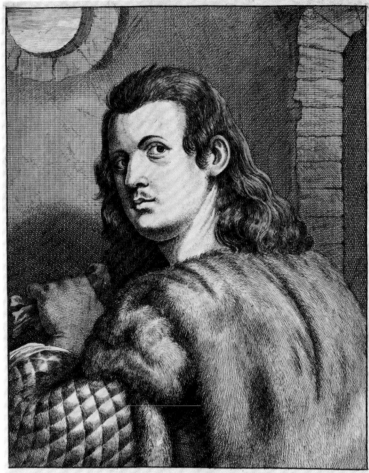

RETRATTI DE BONAMICO BVFFALMACCO
PITORI IN VENETIA.

Georgione da Castel Franco pinxit, W. Hollar fecit, ex Collectione Ioannis et Iacobi van Verle, 1650. F. van den Wyngarde exc.

25. Wenceslaus Hollar, *Self-Portrait of Giorgione as David with the Head of Goliath*, after Giorgione. 1650. Etching, 9¾ x 7 in (24.8 x 17.8 cm). British Museum, London.

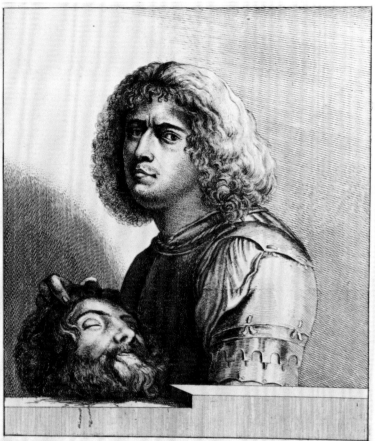

VERO RITRATTO DE GIORGONE DE CASTEL FRANCO
da luy fatto come lo celebra il libro del VASARI.

W. Hollar fecit ex Collectione Iohannis et Iacobi van Verle. 1650. F. van den Wyngarde excudit.

Further proof is suggested by six of Hollar's etching plates which are today held by the Chalcographie du Louvre,[22] and in a sense their present *locus* has even more significance than that of the printer's marks. Of the plates at the Louvre, three (figs. 23, 24 and 25) are dated 1650 and have as their subject matter Italian paintings in the collection of Johanne and Jacob van Veerle, who themselves may well have been in Paris in 1650 along with Frans van den Wyngarde, who is listed as printer.[23] The plate of Charles II after Anthony van Dyck (fig. 22)[24] which Hollar prepared and himself had printed in 1649 at his own expense completes the catalogue of the four plates at the Louvre which can be directly dated 1649-1650. One of the remaining two plates is a conversion, an etching of Hollar's sponsor the Countess Alathea of Arundel into that of Matthew of Arundel. The original state is dated in 1647 at Antwerp, but there is no date on the second, and the only safe conclusion is that the plate was altered sometime later at her request.[25] The last of the Louvre holdings of Hollar plates, dated at Antwerp in 1645, is after van Dyck's portrait of John Malderus, the one-time Bishop of Antwerp and a noted Thomist scholar.[26]

These six copper plates in the Chalcographie du Louvre appear to be the only ones extant from the 2,733 etchings catalogued by Parthey other than five at the Bodleian Library, his cat. nos. 1327-31, etchings of religious dissidents which Parthey refers to as *"Fünf bestrafte englische Kontroversisten."* In view of the established practice of melting down plates and reusing the copper, it can only be assumed that Hollar and the van Veerles gave those plates now at the Louvre to the English Dowager Queen herself or to a member of her Court while it was at the Louvre, and that they were subsequently lost in an out-of-the-way corner, only to be found later and placed in the Chalcographie for preservation. That they came into the Louvre collection via Henrietta Maria or her Court rather than through the French Royal Family seems assured by the fact that the latter had been forced by the Fronde to flee Paris during the subject years.

Although it was neither printed in Paris nor the plate preserved at the Louvre, there is an etching of the young Princess Elizabeth, second daughter of Charles I and Henrietta Maria, which is dated 1650 (fig. 21).[27] The young Princess is shown in mourning dress, a garb which she continually wore from the date of her father's execution on 30 January 1649 until her own death at Carisbrooke Castle on the afternoon of 8 September 1650.[28] The fourteen-year-old girl did not enjoy a single moment of calm from the time of her father's death,[29] and, in fact, it has been said that the child wept her life away.[30] The plate was probably prepared after her death.

I have been unable to find a direct source of the original from which this etching was copied and none is given on the print. It is of interest to note that it bears no printer's identification, only Hollar's notation *"W Hollar fecit"* and the date 1650. The oval format of the etching suggests that it might have been modelled on a miniature portrait of the Princess kept in a locket of that same shape which the Queen Mother may have had in her possession while she was in exile in Paris at this time. In view of the fact that it was necessary for her to leave her daughter behind in England when she fled the country, it would, of course, be natural for her to have a likeness of Elizabeth with her. I believe that this was the case and that the miniature had been made from the beautiful portrait of Princess Elizabeth in Syon House painted by Sir Peter Lely (fig. 20).[31] It would not have been difficult for Hollar to modify the elegant wearing apparel of the Princess shown in the portrait to the appropriate mourning clothes while still retaining, on the whole, the original pose and features. In any event, it seems probable that the etching arose out of a direct commission by Henrietta Maria as a memorial for her deceased daughter and in fact may have served as part of a death announcement. It is likely that Hollar etched this portrait while in the *ménage* of the Dowager Queen in Paris in 1650.

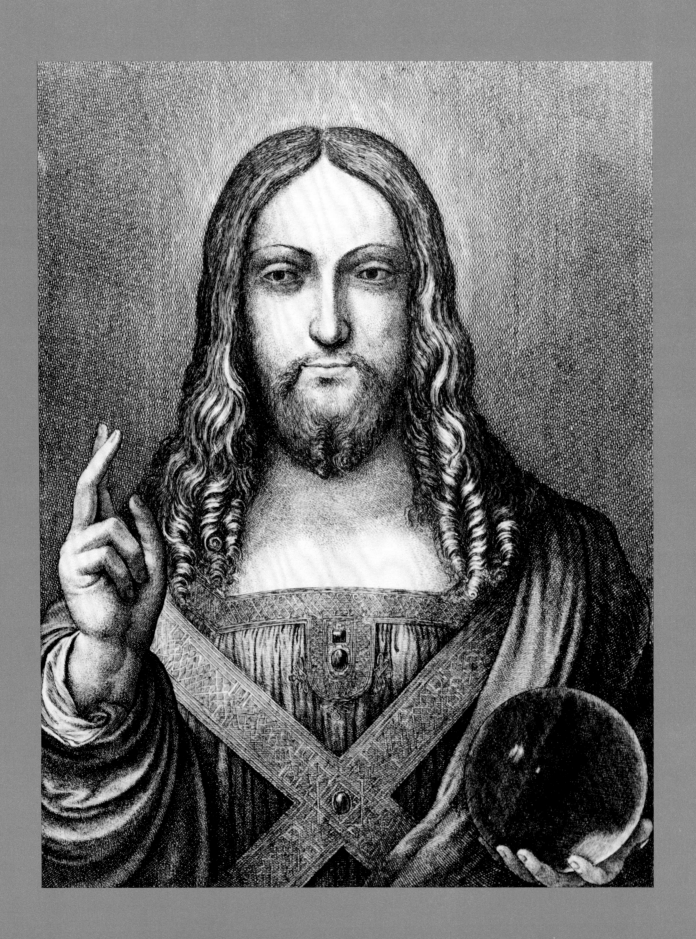

But the Queen was to suffer yet another loss as her daughter Mary's husband, the Prince of Orange, was to follow Elizabeth to the grave on the 6th of November that same year, an occasion which seemed to have upset her as much as did the death of her own daughter due to the fact that the British Royalist Cause was so intimately bound up with the fortunes of the House of Orange.[32]

Burdened down with her personal losses, it is certainly likely that Henrietta Maria would have desired a respite from the strictures of Paris brought on by the War of the Fronde. The choice of a journey along the Loire to Nantes would have been a natural one for her because of her close association with the Order of the Visitation Sainte-Marie.

The Order of the Visitation was founded in 1610 by Saint Francis de Sales and grew rapidly, with there being over thirty houses by 1650. Immediately following her husband's death, Henrietta Maria had gone into retirement for a period of six months in the second convent of that Order in the Faubourg Saint-Jacques. Then, in 1651, she herself was active in the founding of and "*fréquenta très assidûment, sans y être religieuse, le troisième monastère de Paris, à Chaillot.*"[33]

There were along the course of the Loire convents of the Order at Neveas, Orléans, Blois, and Nantes,[34] and making such a trip may well have been suggested to Henrietta Maria by Mme. de Montmorency, the Mother Superior of the Visitation at Moulins,[35] who was related to her by marriage. In any case, further impetus for a journey to Nantes would have been supplied by the fact that her mother, Marie de' Medici, had in 1626 laid the cornerstone of the convent of Notre Dame du Calvarie there.[36] It is suggested that Henrietta Maria requested Hollar to accompany her in the role of court etcher. There is no question but that his sense of duty to the family he loved so well would have induced his acceptance.

Whether they stayed in Nantes in the convent of the Visitation or of the Calvairiennes need not concern us. Suffice it to say that in either place she would have heard of the *Salvator Mundi* by Leonardo da Vinci cloistered in the Clairician convent in that city.[37]

It seems certain that the "*demi-religieuse*" status of Henrietta Maria combined with the prestige attached to her position as Dowager Queen of England and sister of the King of France would have afforded entrée within a convent's walls to her and to her etcher-companion,[38] and it certainly would be understandable that she, devastated by the tragedy of her husband's execution, the vicissitudes which her son, the young Charles II, was undergoing and the recent deaths of both her daughter and her son-in-law, would have wished Hollar to copy for her a painting in which the kindness and love of the ultimate justice were expressed with such strength, tenderness, and pathos. It seems probable that it was there in the convent of the Sisters of Saint Claire that Wenceslaus Hollar in "*A° 1650*," after the death of Elizabeth, etched his *Salvator Mundi* "*secundum originale*" after the painting "*Leonardus da Vinci pinxit,*" placed there by Louis XII for the soul of his wife Anne of Brittany and which today may be found in the collection of the Marquis de Ganay, descendant of Jean de Ganay, presiding officer of the Parliament of Paris and Chancellor of France under Louis XII.

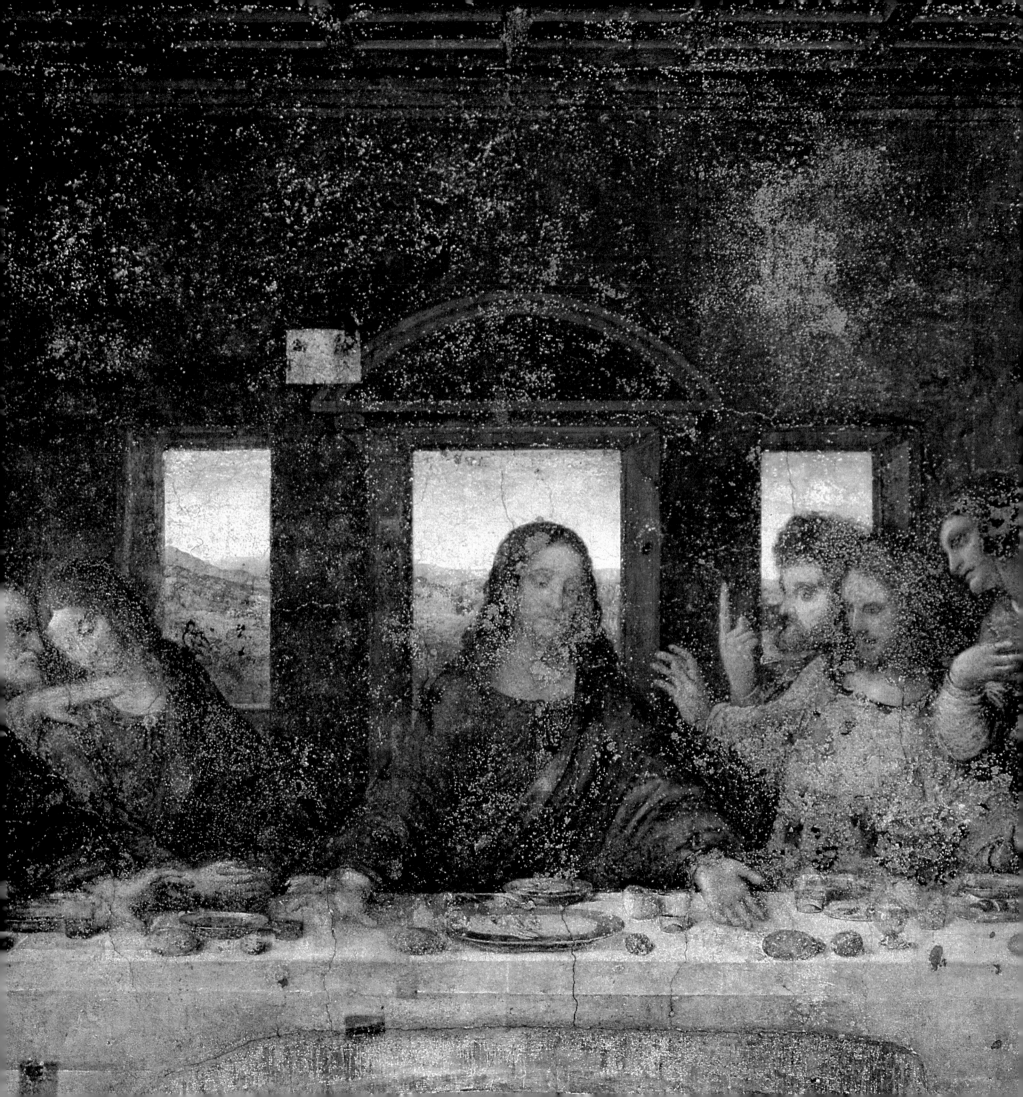

IN PURSUIT OF THE SEEN AND UNSEEN

27. Leonardo da Vinci, *Last Supper* (detail). 1495-97. Oil-tempera mixture on wall. Refectory, Sta. Maria delle Grazie, Milan.

That art, which Leonardo took so far that analysis of materials alone is enough to set his work apart from that of pupils or imitators.*

Up to this point a suggested historical background to Leonardo da Vinci's original *Salvator Mundi,* Hollar's etching, and the de Ganay painting that unites the three in a convent in Nantes has been put forward. It now becomes necessary to employ scientific methods to compare the Paris painting itself in its physical and stylistic characteristics with unquestioned works by Leonardo.

In an examination of a painting under the rays of natural light, our observations are, of necessity, limited to what appears on the surface layer. However, by studying a painting under other types of rays, our vision is enhanced, and thus we are enabled not only to penetrate through the obscuring surface layers of grime and varnish but, in certain cases, to see through the actual layers of pigment and to analyze the materials used, as well as to discern different stages of the painting's construction.

To this end, on 21 and 27 April 1972, Leonardo's *Salvator Mundi* was submitted for study under four different types of radiation, those of monochromatic sodium light, ultraviolet, infrared and X-rays, by Madame Madeleine Hours, Director of the Laboratory of the Louvre Museum, Chief Curator of the National Museums of France and Master of Research at the National Center for Scientific Research, who graciously allowed me to participate in these observations and shared with me the conclusions that she had drawn from them.[1]

Monochromatic sodium light suppressed the color and revealed not only the appearance of the painting during the preliminary stages of the work by the artist but also its appearance if cleansed of the heavy coat of varnish which then overlay it.[2] This evidenced the need for a thorough cleaning before the quality of the painting could be properly evaluated under normal lighting conditions. In addition, the appearance of the *Salvator Mundi* under this light revealed that the black background of the painting was a later accretion, as were the pearls surrounding the jewel in the center of the crossed stole and the addition and subsequent removal of a cross upon the crystal globe. One of the benefits of this type of examination is that it can be carried out by the naked eye without the necessity of a camera.

Under ultraviolet rays, again without need of a camera, the previous findings of earlier attempts at retouching, additions and removal were confirmed. Inasmuch as the use of ultraviolet light is most valuable as a tool in determining the state of preservation of a painting, its role in conservation is of paramount importance. "Earlier over-zealous restorations can be remedied, for nowadays the restorer's chief aim is fidelity to the original; he respects the creative artist's work and regards his own job as being the prolongation of the painting's life by appropriate treatment…"[3]

* Madeleine Hours, *The Secrets of the Great Masters,* Paris, 1964, p. 203.

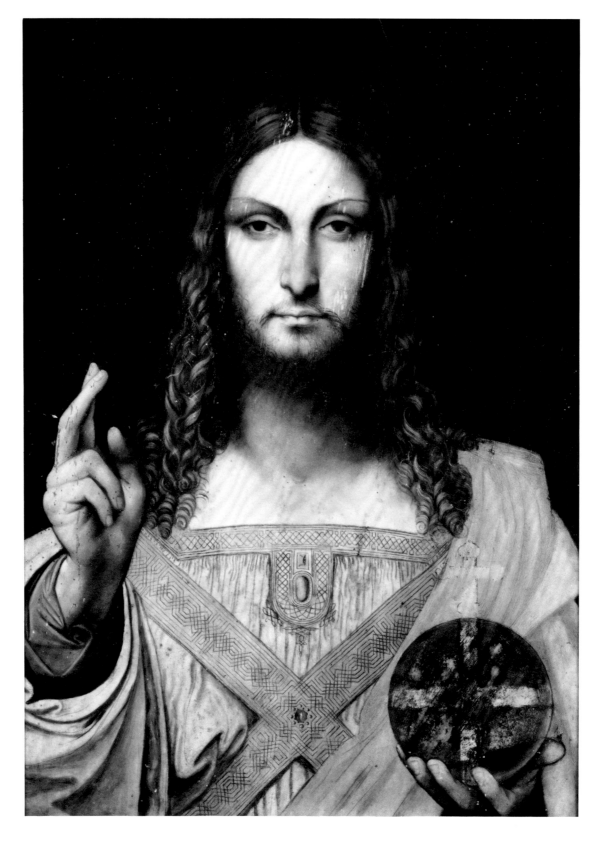

29. Infrared photograph of
Leonardo's *Salvator Mundi* (detail).

30. Infrared photograph of
Leonardo's *Salvator Mundi* (detail).

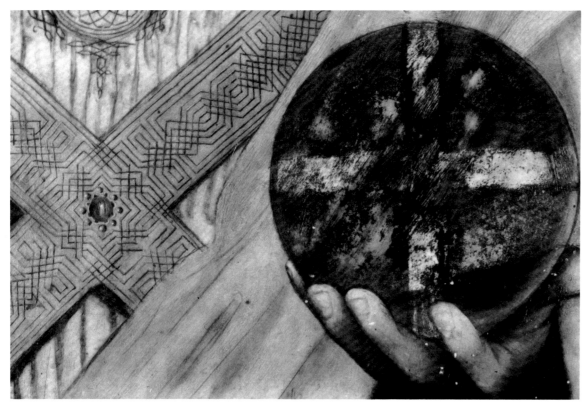

A series of photographs was then taken of the *Salvator Mundi* under the penetrating power of infrared radiation (figs. 28, 29 and 30). The importance of the infrared examination is that the various stages and technique of construction are exposed and it is possible to see the appearance of the painting before the artist had completed it—in some cases, even the underlying sketch will appear, as it does in the infrared photographs of the *Salvator Mundi.* This preliminary drawing reveals Leonardo's meticulous workmanship; particularly notable are the drawings of the orphreys of the yoke and the crossed stole (fig. 29). As these rays penetrate the outer layers of the paint, they produce a photograph which shows the painting as if unfinished and in the course of construction. Sometimes, as in the case of Leonardo's *Salvator Mundi,* his *Saint John the Baptist* at the Louvre (fig. 33), the Louvre *Virgin of the Rocks,* the *Mona Lisa* and other paintings by him, infrared rays will only produce a slightly sharper image than normal light, the outlines being very little altered,[4] indicating that once Leonardo had thought out his *concetto* and drawn a careful preliminary sketch, his subsequent revisions were minimal. It should be mentioned here that in neither the visual nor scientific evaluation of the *Salvator Mundi* did there appear any indication of *pentimento* whatsoever, nor of any overpainting other than that previously noted; the remains of the cross mentioned above were visible under all lights but did not appear in the X-radiograph.

Finally, examination under X-rays—probably the most important and useful tool for studying the support on which the work was done, the condition of the painting and the technique of the artist—was conducted on the *Salvator Mundi.*[5] This test was the most conclusive in terms of a confirmation of Leonardo's autograph. During the last years of his life, Leonardo painted with low density organic materials and built up the color with very thin layers of paint of low atomic weight, and, as a result, X-rays are uninhibited in their passage through the paint and clearly reveal the wood support underneath, as is the case with the *Salvator Mundi,* which Madame Hours said was "typical of the last five years of Leonardo's life."

In the Laboratory of the Louvre, I was able to make a visual comparison of X-radiographs of the de Ganay *Salvator Mundi* and Leonardo's *Saint John the Baptist* (figs. 31 and 32). The graining of the wood panels beneath was equally visible in both X-radiographs, and it became immediately apparent that the wood of both panels was identical and that each of these panels was mono-unitary. Madame Hours said it was a kind of "nut wood,"[6] previously known to have been used by Leonardo *only* for the *Saint John.* His other paintings had been done on poplar.[7] The use of a nut wood or *"bois fruitier"* by Leonardo was restricted in his *oeuvre* to the *Saint John* and the *Salvator Mundi.*[8]

It is documented that when Louis XII met with Leonardo in Milan in 1507 he was accompanied by his court painter, Jean Perréal, and that the two artists undoubtedly met and compared notes on painting technique.[9] It is suggested that at this time, Perréal, at Louis' request, induced Leonardo to employ in the King's service panels supplied by the French artist, and that Leonardo did so, completing the *Salvator Mundi* for the King around 1513 while working in the same year upon the *Saint John the Baptist,* which he continued while in Rome from that year until 1516 and which he subsequently took with him to France, where it was ultimately found in his studio at Cloux near Amboise at his death on 2 May 1519.[10] If indeed the *Saint John* were part of Louis XII's commission to Leonardo in 1507, it would have been impossible for the artist to have delivered it to his patron as the King died on 1 January 1515, before the *Saint John* was finished.[11]

The similarity in the height of the supports for the de Ganay *Salvator Mundi* and the *Saint John*[12] strengthens the hypothesis of a common source for the two panels: 68.3 cm for the former vis-à-vis 69 cm for the latter, but the *Saint John* is broader by 8.4 cm, 57 cm as opposed to 48.6 cm for the *Salvator Mundi.* It should be pointed out here that the copies of Leonardo's *Salvator Mundi* catalogued by Heydenreich maintain the same average width as the de Ganay painting but, on the whole, reflect a cropping of 2.3 to 5.3 cm in height above the head of Christ.[13]

Additional analyses of the X-radiograph of the *Salvator Mundi* conducted by Madame Hours revealed shadow patterns which she interpreted for me as indicating that the priming, the preparation of the ground, the pigments employed and the technique of building up the color by the use of very thin layers of paint were identical in the *Saint John* and the Paris *Salvator Mundi* and that both are "typical of the technique used by Leonardo in the latter part of his life." In analyzing the *Saint John,* Madame Hours states that *"la préparation est blanche, mince mais très dure."*[14] In the de Ganay *Salvator Mundi* in areas which have been physically damaged, such as above the head, "exactly the same ground and the same preparation" as that of the *Saint John* is visible, even under regular light.

In both paintings, under natural light and all radiations, no evidence of any brush stroke is visible. This aspect of the *Saint John,* which Madame Hours has commented upon in her detailed examination of that painting,[15] is equally true of the *Salvator Mundi.*

It should be mentioned that in no sense did Madame Hours act as an authenticator of the de Ganay *Salvator Mundi.* She merely conducted the tests and evaluated the results for me in scientific terms. In relation to her comments to me, compare the following quotations from her writings:

The works of some painters defy the power of X-rays. This is because the materials used are transparent to the rays, i.e., of light atomic weight; the works of Leonardo da Vinci are certainly the most famous that come into this category.[16]

Speaking of the *Saint John the Baptist,* she says that

The painting density is so low that to achieve this image, special equipment is required...It is the most subtle, the most ethereal, indeed, the most inimitable of X-ray photographs ever produced. This elusiveness in the face of radiations is unique to the technique of Leonardo.[17]

Elsewhere, she further states in regard to the X-radiograph of the *Saint John:*

The X-ray study provides us with only a small amount of information: the very slight contrasts between light and shadow are scarcely visible on the radiographic plate.[18]

All that is visible in the Louvre X-radiograph of the *Salvator Mundi* (fig. 31) are vermicular trails, the graining of the wood, the eye sockets and brows, the sketch marks underlying the orphreys on the yoke and crossed stole, a hint of the mouth and nose, the touches of white on the over-painted pearls surrounding the jewel at the crossing of the stole, and the inner edge of the mantle draped over Christ's left shoulder which, as will be shown below, appears to have been a later restoration.

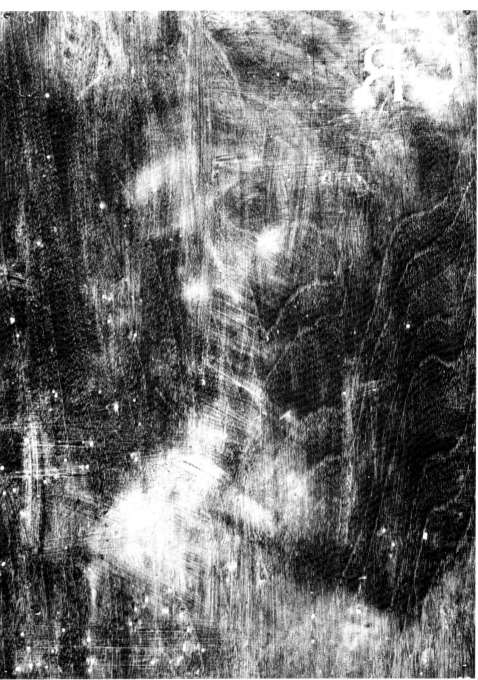

In the spring of 1976 I met Professor Heydenreich in Paris, and after first examining Leonardo's *Salvator Mundi* at the owner's home, we visited the Louvre Laboratory where we compared the X-radiographs of the *Saint John* and the *Salvator Mundi* and examined the infrared photographs of the latter painting. This examination confirmed the results obtained during my earlier visit, but since a complete stylistic evaluation of the painting was made difficult by the heavy overlying coat of poor quality varnish, steps were taken to have it removed.[19] The cleaning was conducted by Sylvaine Brans of Paris, who participates in the restoration work done at the Laboratory of the Louvre. After conducting the requested conservatorial measures, she submitted to the present owner the following:

Sylvaine Brans

Report

Original Condition of the Picture:

Very thick yellow varnish on a panel having worm holes. There are numerous gaps which have been repainted and which could reappear upon the removal of the varnish.

The black background seems to be a restoration over the entire surface. A mishap above the head of Christ could have provided the justification for the black restoration [repainting] of the background. However, one may make out a trace of a gold halo.

The blue vestment [mantle] could perhaps be a restoration; it appears at the very least to post-date the main body of the painting.

Steps of Intervention:

The fixing of the weak parts. The swelling of these fragments has been reduced, but because of a lack of space to replace them edge to edge in a perfectly flat position, we have only been able to fasten them firmly; likewise on the surface there appears in numerous places the ridge of the original pictorial skin. The [underlying] drawing is very visible.

The varnish was removed entirely under microscope. Thus it was possible that none of the original material was disturbed, and we have therefore stopped at the boundary between the yellow varnish and the painting's natural mellowness. Some restorations [repainting], especially that above the head of Christ, have been removed with the cleaning. In order to provide a better view of the pictorial surface, only a retoucher's varnish has been put on after the removal of the old varnish. It can be removed at any moment.[20]

Although this coating, unfortunately but inevitably, gives the painting a certain glossy quality that was not intended by Leonardo, it was a necessary compromise in that it both preserves the painting and, at the same time, allows a close examination of the artist's technique until such time as permanent restoration of the *Salvator Mundi* is desired. Although this reflective surface may come as a surprise to viewers who are expecting the rather dull appearance of a permanent varnish, it was considered important for the sake of scholarship at the present time to leave the *Salvator Mundi* in its original condition insofar as it was possible, so that Leonardo's own work may be most readily studied without the obscuration of a duller finish. With the same objective in mind, all steps in what would be a normal restoration were rejected.

Although the addition and subsequent removal of a gold cross on and above the crystal globe and the overpainting on the mantle have partially damaged this area of the painting, after cleaning the folds of the underlying drapery and the palm of Christ's left hand can be seen appearing through the globe as can the whitish highlights used to express its inner light. It is quite likely that the addition of a cross on the globe and the halo were the work of the same, later hand and damage in their removal occasioned the restorations of the mantle and background.[21] In those places where the black background was lifted during the cleaning, a blue one— similar to that seen in the *Salvator Mundi* in King James IV of Scotland's *Book of Hours* (fig. 19)—was revealed.

Despite the few defects arising out of the passage of time and early retouchers' work evident in the de Ganay *Salvator Mundi*, the original colors seem to have retained their freshness and have suffered only minimal fading. The painting's good state can be attributed to its long placement in a convent far from natural light and the extremely heavy coat of varnish which once covered the entire picture.

33. Infrared photograph of
Leonardo's *Saint John the Baptist*.
The Louvre, Paris.

34. Photograph taken under
monochromatic sodium light of
Leonardo's *Saint John the Baptist*.
The Louvre, Paris.

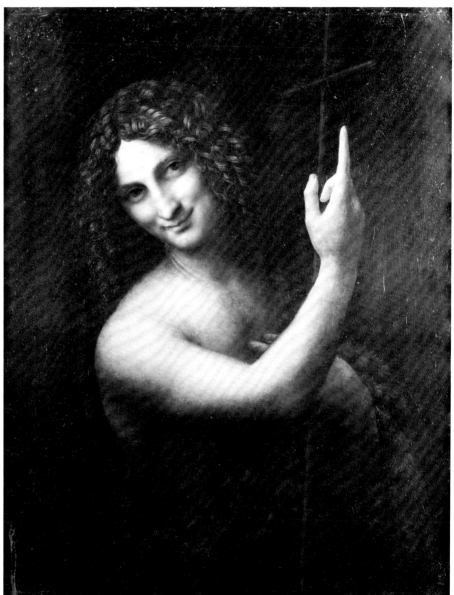

The viewer, who has become accustomed to the almost sombre appearance and the apparent dullness of the palette employed in many of the extant works of the master that have darkened due to the exposure to natural light, is inevitably surprised by the brightness of the colors of Leonardo's *Salvator Mundi*. Especially striking in this regard is the brilliant red of Christ's vestment, a hue which one might tend to disassociate from Leonardo's palette, but for the fact that the 1946-54 restoration of his *Last Supper* revealed that the color used by the artist for Christ's robe, as seen in figure 35, originally had been the same flame-red, traditionally symbolic of the Passion, which appears in the *Salvator Mundi*.[22] In regard to the usage of brilliant colors in the *Last Supper*, Heydenreich notes: "The colours of Christ's garments—red tunic and blue cloak—are both reflected in the pewter plate in front of him; similarly the plate in front of Philip reflects the red of his cloak."[23] Even though "the clear and vivid colors (blues, red, greens and yellows) no longer vibrate in the light"[24] in the *Last Supper*, the little which remains of this great mural's original chromaticism still prevails to substantiate an echo in the *Salvator Mundi*.

It has only been after the restoration of the *Last Supper* that a re-evaluation of Leonardo as a skillful and daring colorist has been mandated.[25] Anna Maria Brizio states that the restoration "reveals the boldness of Leonardo's original colors."[26] This assessment is reflected in the chromatic panorama of the Apostle's garments, such as the green of James the Lesser's, the bright blue of Matthew's, the ochre of Jude's, the mixture of carmine and violet of Simon's, the green cloak over a golden yellow under-vestment of Andrew's, the reddish of James the Greater's and similar schemes for the other Apostles, which are distributed across the painting in a well conceived gradation passing from the pure primary tones in the clothing of Christ into the more subtle blends on each side.[27]

The juxtaposition in the employment and the similarity of geometric placement of the colors in both Leonardo's *Last Supper* and his *Salvator Mundi* should not pass without notice. While the *Salvator Mundi* painting, of necessity, isolates the Savior, much the same sense of spatial aloneness and detachment is to be found in the multi-figural composition of the *Last Supper*. As John Shearman says of the larger work:

The figure of Christ, in the colour composition, is isolated by the simplicity of the colour-shapes—a red diamond and a blue equilateral triangle—and also because these two colours, apparently endlessly echoed and re-echoed in the other figures, are the strongest in the whole painting. Moreover, if we are right in reconstructing the rich green of James' tunic as being about equal in intensity to the blue and rose of John's vestment and robe, there was originally a crescendo toward the center, an organic movement in the colour which continuously focuses, even now, the spectators' attention on the quiet figure of Christ.[28]

The red diamond and blue equilateral triangle in the *Last Supper* are to be seen resounding in the *Salvator Mundi* in the parallelogram formed by the scarlet of Christ's robe and the sleeve of His blessing arm that is juxtaposed to the brilliant blue triangle of His mantle. In addition to these clearly delineated geometrical forms, Leonardo in the *Salvator Mundi* has also created four isosceles triangles in Christ's robe by dividing it with the crossed stole. These angular shapes are reinforced by the triangular aspect of the blessing hand, the apex of which is in the two raised fingers, and are in contrast to the curvilinearity of the crystal globe.

Geometry, the basis of all of Leonardo's paintings, is probably nowhere more pronounced than in the *Salvator Mundi* and the *Last Supper*, in both of which the figures of Christ form a triangular or pyramidal composition, a geometric pictorial form perfected by Leonardo. Its employment is also clearly evidenced in the central group of the *Adoration of the Magi*, in the *Lady with the Ermine*, the *Virgin of the Rocks*, the *Virgin and Child with Saint Anne*, and the *Mona Lisa*.

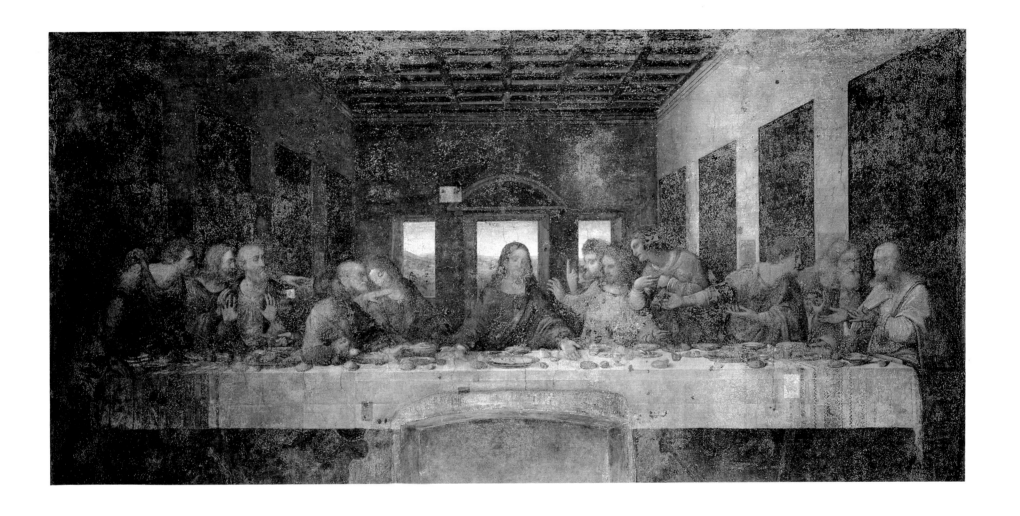

Recent redating of the preliminary drawings for Leonardo's *Salvator Mundi* (Windsor 12524 and 12525, figs. 11 and 12)[29] provides a *terminus post quem* of 1510 to 1515 for the painting itself. The dating of 1511 which appears on the copy in the Galerie Czernin, Vienna, suggests that either the original painting was well along or that a rather complete cartoon was available to the copyist by this time.

The method of execution of hair almost unique to Leonardo's *oeuvre* during the sixteenth century is visible in a detail of the de Ganay *Salvator Mundi* (fig. 38). Heydenreich has pointed out that "the almost stylized spiral lock similar to his water studies is a characteristic *motif* of Leonardesque paintings and drawings after 1500 such as the *Madonna of the Spindle*, the *Angel of the Annunciation* in Basel, and the *St. John the Baptist* in the Louvre."[30] Leonardo himself wrote around 1513 on Windsor 12579 recto:

Observe the motion of the surface of the water which resembles that of hair, and has two motions, of which one goes on with the flow of the surface, the other forms the lines of the eddies; thus the water forms eddying whirlpools one part of which are due to the impetus of the principal current and the other to the incidental motion and return flow.[31]

It is of the utmost importance in this regard to note that in Windsor 12579 recto (fig. 36) as the water passes the interrupting stake, the eddies formed downstream on the left are shown starting in the center with a counter-clockwise motion which is opposed on the right by a clockwise motion. While the left and right circular propensities of the flow of a stream of water faced with a rectangular interruption are somewhat difficult to see clearly in Windsor 12579 recto, on close evaluation they do become visible. These motions become explicit though in Windsor 12660 verso (fig. 37) and in Windsor 12662 (fig. 39). In these drawings, water is represented issuing forth from square or rectangular weirs, and in both it is readily apparent that a counter-clockwise eddy exists on the left of the direction of flow and a clockwise eddy on its right.

Precisely this same representation of the left and right circular motions of water is found duplicated in the hair of Christ in the *Salvator Mundi.* The part in the hair at the top of the head serves as the division, and the hair falls in long spiral locks emulating the currents of water: on Christ's right side, the curls fall in counter-clockwise fashion while those on His left are portrayed clockwise. Thus Leonardo's words "the motion of the surface of the water…resembles that of hair" are perfectly embodied in the representation of Christ's hair.

It is interesting to note that these counter- and clockwise patterns of hair, so visible in the Paris painting, are not duplicated exactly in any of the copies, not even in that which is the most similar, the copy formerly in the Cook Collection (fig. 7). Perhaps it is not too much to say that in the treatment of the hair in the de Ganay *Salvator Mundi,* we may find a unique "signature" of Leonardo's, the significance of which was not recognized and, therefore, was ignored by his copyists.

36. Leonardo da Vinci, Water Studies, detail of Windsor 12579 recto. c. 1513. Pen and brown ink. Royal Library, Windsor Castle. Reproduced by gracious permission of Her Majesty Queen Elizabeth II.

37. Leonardo da Vinci, Water Study, detail of Windsor 12660 verso. c. 1507-09. Pen and ink. Royal Library, Windsor Castle. Reproduced by gracious permission of Her Majesty Queen Elizabeth II.

Now that the painting has been cleaned, the extreme softness of the flesh tones and the subtlety of the modelling of the features of Christ in the *Salvator Mundi* are striking. Equally noteworthy are the depth of the eye sockets and the shadow at Christ's throat, two features which are also prominent in the *Saint John*. This treatment of facial shadows was announced by Leonardo's comments in the Madrid codices, rediscovered in 1965,[32] in which there was demonstrated the varying intensity of light and shadows at different locations in the face (fig. 40) that appears to have formed a canon of Leonardo's later style:

Of spots of shadows that appear on distant bodies. The throat or other straight perpendicular, which has some project above it, will always be darker than the perpendicular face of that projection; this occurs because that body will appear most illuminated which is exposed to the greatest number of rays of the same light.

You see that A is illuminated by no part of the sky F K, and B is illuminated by I K of the sky, and C is illuminated by H K of the sky, and D by G K, and E by the white sky from F to K. Thus, the breast will be of the same brightness as the forehead, nose, and chin.

But what I should remind you of about faces is that you should consider how, at different distances, different kinds of shadow are lost, and there remain only the essential spots, that is, the pits of the eye and places of similar significance. Finally the face remains obscure.

… The length of the above-mentioned light from the sky confined by the edges of roofs and their façades, illuminates almost as far as the beginning of the shadows which are below the projections of the face, gradually changing in brightness, until it terminates over the chin with imperceptible shading on every side.

It is as if the light were A E. The line F E of the light illuminates as far as beneath the nose, and the line C F only illuminates as far as beneath the lip. The line A H extends as far as beneath the chin. Here the nose remains very bright because it faces all the rays of light, A B C D E.[33]

In a stylistic comparison of the usage of light and shadow in the *Salvator Mundi* (fig. 41) and the *Saint John* (fig. 42), one is immediately struck by the similarity of treatment despite the difference in the angle of the light source. In the *Saint John*, the source is approximately 75 to 80 degrees above a line perpendicular to the vertical plane of the picture and off-set to the left of its horizontal plane by about 60 degrees from the point of view of the spectator. In the *Salvator Mundi*, while the source of light is also above and to the left, both angles of incidence of the source of illumination have been brought closer to the perpendicular of the painting so that the angle from the vertical has been reduced to about 20 degrees and that from the horizontal to about 30 degrees. As a result, the source of light in the *Salvator Mundi* has cast a far less extensive and much softer penumbra. Thus, although disparate origins of light are observed in both the *Saint John* and the *Salvator Mundi*, Leonardo has nonetheless meticulously followed the true geometry of shadows in relation to the source of light.

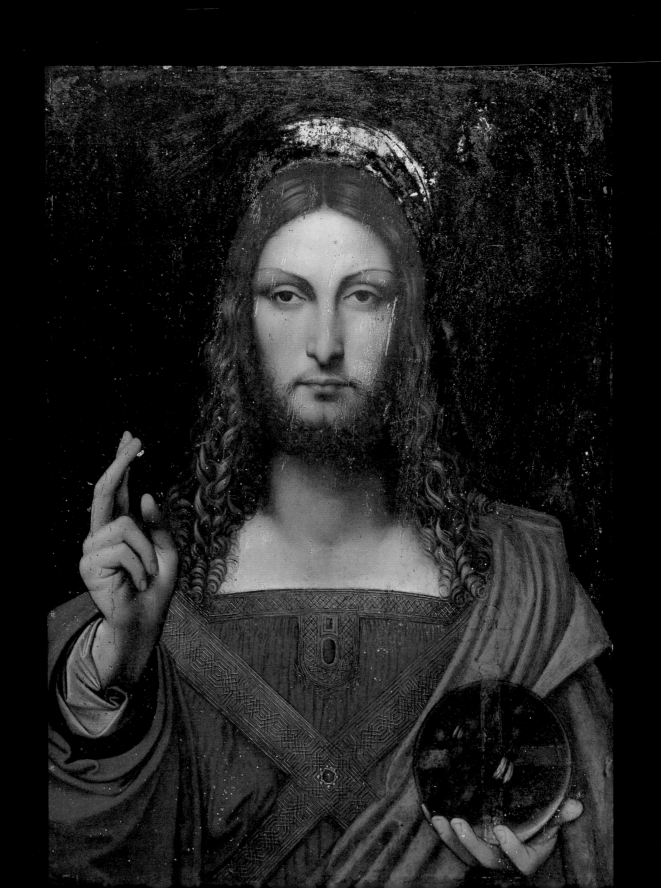

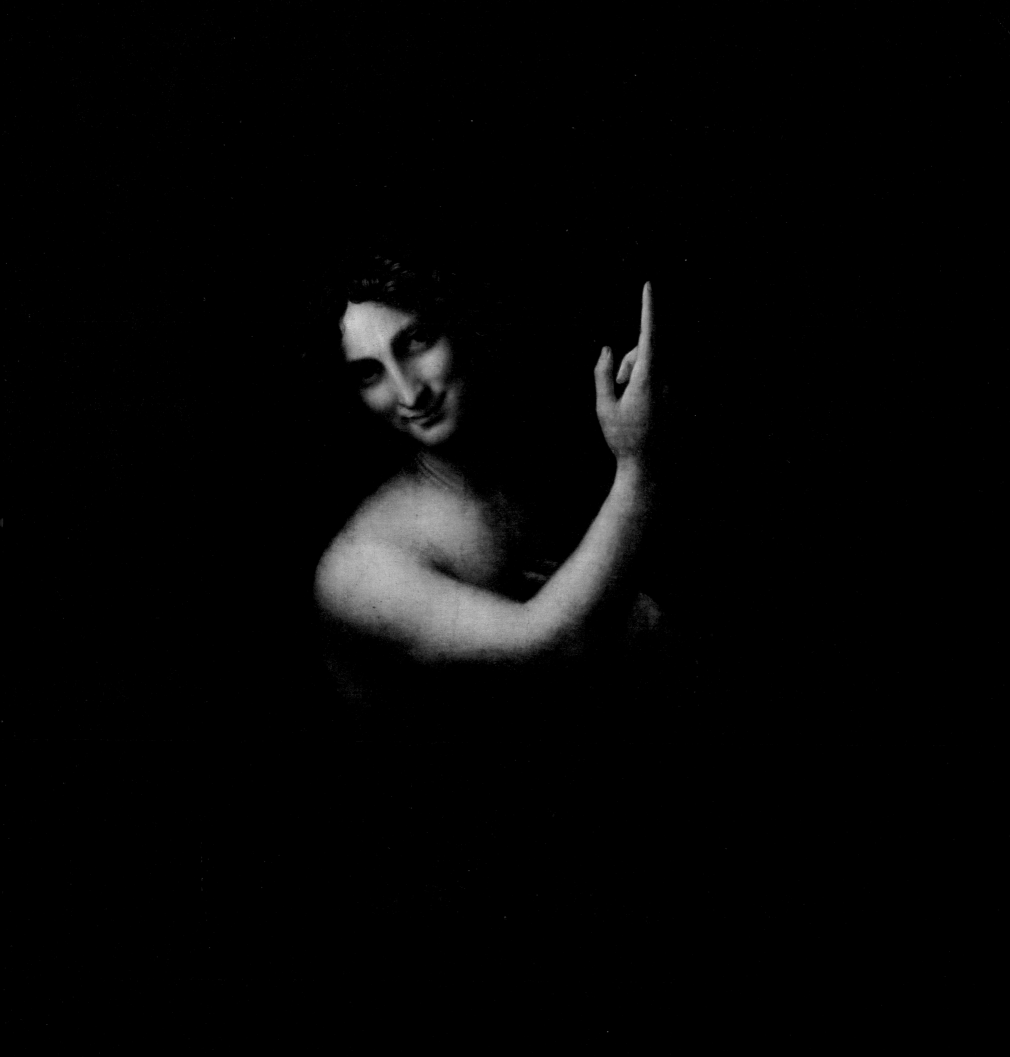

A close observation of the head of Christ in the de Ganay *Salvator Mundi* brings to mind Giorgio Vasari's words in his Life of Leonardo:

In this head, whoever wished to see how closely art could imitate nature, was able to comprehend it with ease; for in it were counterfeited all the minutenesses that with subtlety are able to be painted, seeing that the eyes had that lustre and watery sheen which are always seen in life, and around them were all those rosy and pearly tints, as well as the lashes, which cannot be represented without the greatest subtlety. The eyebrows, through his having shown the manner in which the hairs spring from the flesh, here more close and there more scanty, and curve according to the pores of the skin, could not be more natural. The nose, with its beautiful nostrils, rosy and tender, appeared to be alive. The mouth, with its opening, and with its ends united by the red of the lips to the flesh-tints of the face, seemed, in truth, to be not colours but flesh. In the pit of the throat, if one gazed upon it intently, could be seen the beating of the pulse. And, indeed, it may be said that it was painted in such a manner as to make every valiant craftsman, be he who he may, tremble and lose heart.[34]

While Vasari was describing Leonardo's painting of the *Mona Lisa* as it was known to him and not, unfortunately, as it appears today, his comments seem particularly apposite to the *Salvator Mundi*. Nevertheless, even now it is possible to discern a close correspondence between the two paintings. In the lighting of the *Mona Lisa* can be observed a pattern of shadows similar to that seen in the *Salvator Mundi*, and again, the same predilection of Leonardo for an overhead and off-set light orientation has been maintained.[35]

Although the individual hairs of the eyebrows and lashes of the *Mona Lisa*, as described by Vasari, have disappeared, the manner in which they once must have been portrayed is readily visible in the eyebrows, eyelashes, mustache and beard of the *Salvator Mundi* under natural light, and even more so in an infrared detail (fig. 20). They may be seen with equal clarity in Leonardo's red chalk self-portrait drawn about 1512-15 (fig. 1); in both, the similarity of the rendering of each hair as it issues from the skin beneath the lower lip and at the corners of the mouth is striking. Moreover, the shading strokes on the side of and under the nose evince the same technique despite the different angles of the lighting.

In a comparison of the mouth in the *Mona Lisa* (fig. 45) and in the *Salvator Mundi* (fig. 43), the identical shape of both is readily visible, as are the delicacy of the soft shadowing between the lips and the similarity of the shadows beneath the lower lip and at the corners of the mouth.

It is also of significance on stylistic grounds to compare the physiognomy of the Savior (fig. 43) with that of the head of Saint Anne (fig. 44) in Leonardo's painting of the *Virgin and Child with Saint Anne* in the Louvre dated about 1509-11. Indeed, when these two details are juxtaposed, there appears a remarkable similarity of features. Both share the same ovoidal face, and a long slender nose with similar shape and proportions that is surmounted by the same high arch of the brow. Also of note for comparative purposes is the angle of the bridge of the nose as it turns into these brows. Furthermore, although Saint Anne looks downward, there is still a similarity in the deep shadowing of the eye-sockets which seems to follow the same idiom described by Leonardo in the Codex Madrid II (fig. 40).

preceding pages
page 46

41. Leonardo da Vinci, *Salvator Mundi*. c. 1510-13. Oil on panel, 26⅞ x 19⅛ in (68.3 x 48.6 cm). Collection of the Marquis de Ganay, Paris.

page 47

42. Leonardo da Vinci, *Saint John the Baptist*. c. 1513-16. Oil on panel, 27¼ x 22½ in (69 x 57 cm). The Louvre, Paris.

43. Detail of the head of Christ in Leonardo's *Salvator Mundi.*

45. Leonardo da Vinci, *Mona Lisa.* c. 1503-07. Oil on panel, 30¼ x 20⅞ in (77 x 53 cm). The Louvre, Paris.

44. Detail of the head of Saint Anne in Leonardo's *Virgin and Child with Saint Anne.* The Louvre, Paris.

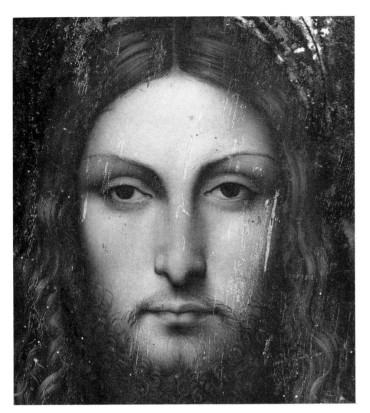

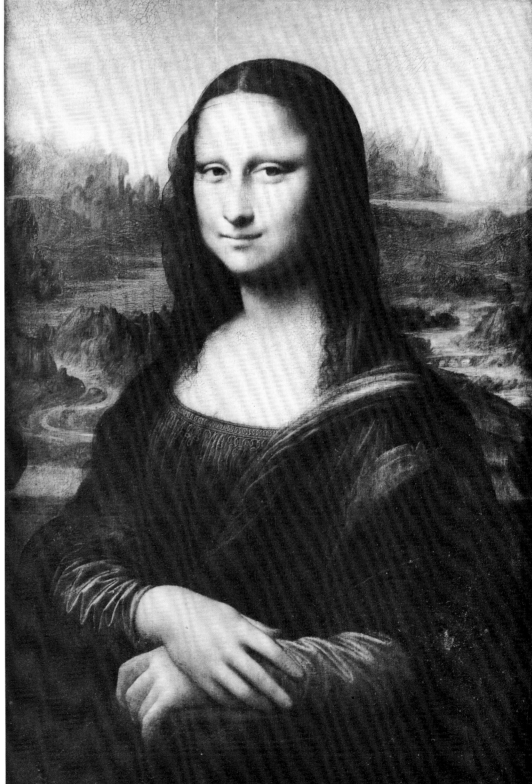

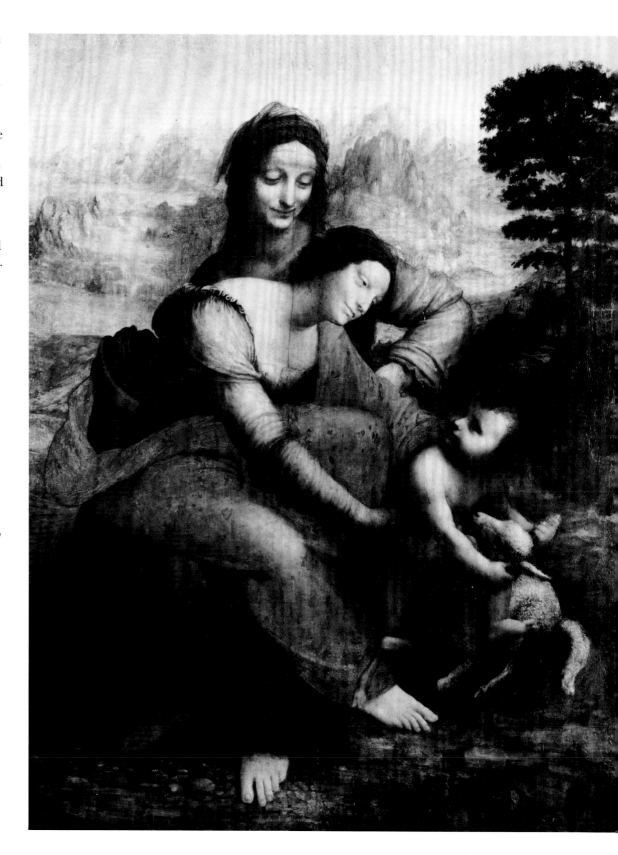

46. Leonardo da Vinci, *Virgin and Child with Saint Anne.* c. 1509-11. Oil on panel, 66⅜ x 51¼ in (168.6 x 130.2 cm). The Louvre, Paris.

The raised hand of the *Salvator Mundi* in the act of benediction finds correspondences in other works by Leonardo. This motif appeared, albeit in a different context, as early as about 1481-82 in the unfinished painting of the *Adoration of the Magi* in which it may be observed in the hand of the young shepherd in the foreground to the right of the tree. Another example of this same idiom is that of the raised hand with pointing finger of Saint Thomas in the *Last Supper* (see fig. 27). Despite the difference of perspective, the second, third and fourth fingers of the hand of the Apostle are folded inward and down, with the long, slender index finger raised in a manner strikingly similar to that of the blessing hand in the *Salvator Mundi.* Equally apropos is the hand in the preliminary drawing of Saint Peter for the *Last Supper* in the Albertina Collection in which the shape and position of the fingers and hand resemble those of Christ in the later painting of the *Salvator Mundi.* A similar configuration also appears in Saint Anne's upraised hand in the *Burlington House Cartoon.*

Ultimately, the inevitable comparison must be made between the blessing hand of Christ in the *Salvator Mundi* and the raised hand of the *Saint John the Baptist*; that of the latter clearly seems to echo that of the former in position and shape, with the obvious difference in the number of fingers raised.

In regard to the position of the two raised fingers of the blessing hand of Christ in the act of bestowing benediction in the Latin idiom of the Roman Church, it has appeared to some that the two fingers are crossed. This is, however, merely a matter of perspective and not really the case, as is easily demonstrable by viewing one's own hand in a mirror held in this position.[36]

As to the left hand of Christ that holds the globe, it finds a prototype not only in the inverted, outstretched hand of Mary in the Louvre *Virgin of the Rocks* (fig. 48), a similarity which extends even to the folds of skin between the thumb and the palm, but also in what is still discernible of the right hand of Christ in the *Last Supper* (fig. 27).

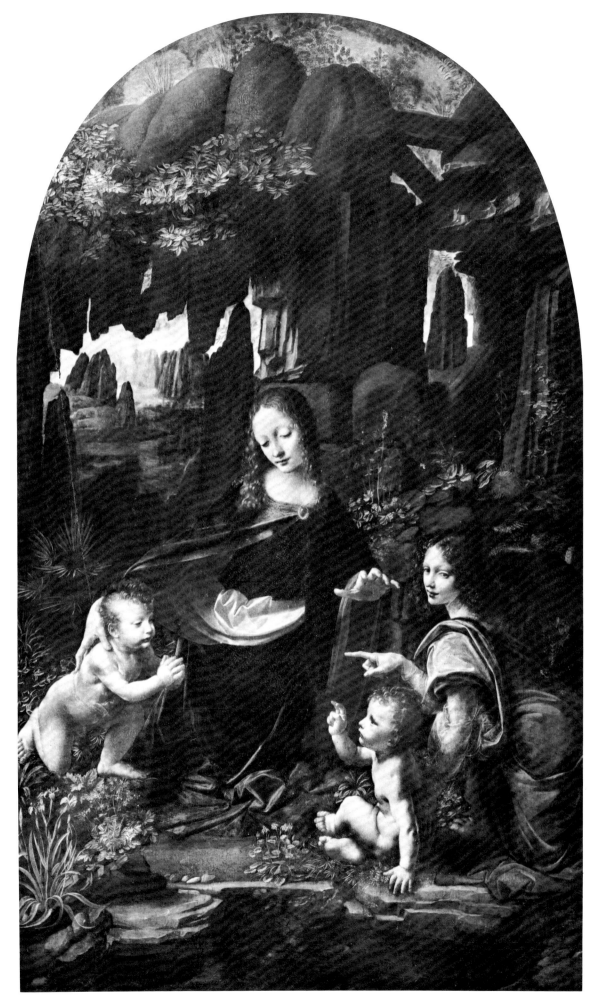

48. Leonardo da Vinci, *Virgin of the Rocks.* c. 1483-85. Oil on canvas (originally panel), 78 x 48½ in (198 x 123 cm). The Louvre, Paris.

47. Detail showing Christ's left hand in Leonardo's *Salvator Mundi.*

49. Detail of crossed stole, neckband, and drapery of right sleeve in Leonardo's *Salvator Mundi*.

50. Leonardo da Vinci, Knot Designs, detail of *Codex Atlanticus*, fol. 68 v-b. Biblioteca Ambrosiana, Milan.

The iconological import of the orphrey patterns on the crossed stole and neckband of the de Ganay *Salvator Mundi* will be discussed in detail in Chapter 5. However, comments on the skill with which they were executed seem more properly to be a matter of style. Figure 49 reveals the almost incredible detailing of the embroidery on the stole and neckband in which the infinite pains taken in the shading make it possible to follow a continuous strand throughout the interweaving pattern, again bringing to mind Vasari's words in his Life of Leonardo. In this instance he says of a now-lost tapestry cartoon, "the brain reels at the mere thought how a man could have such patience…nothing save the patience and intellect of Leonardo could avail to do it."[37] And, inevitable comparison must be made with the famous "*Academia Leonardi Vinci*" knot designs (e.g., fig. 53) of which Vasari says, "He even went so far as to waste his time in drawing knots of cords, made according to an order, that from one end all the rest might follow till the other, so as to fill a round…"[38]

Vasari's description of Leonardo's drawings of "knots of cords" is generally accepted today as encompassing the six knot designs copied by Albrecht Dürer, presumably during his second trip to Italy (1505-07).[39] Of these, the Leonardo original of Dürer's design with a repetitious hexagonal pattern (fig. 54) would bear the closest resemblance to and may have been the starting point for the even more intricate pattern which appears in the de Ganay *Salvator Mundi* and is duplicated in Hollar's etching.

Throughout Leonardo's journals, there is evidence of his continuing interest in and fascination for series of cords, intertwined, but in which any separate strand may be distinguished from one end to the other.[40] It is germane to compare here a folio from the Codex Atlanticus (fig. 50) with a detail from the de Ganay painting.[41]

Around the outside of the lower part of the central continuation of the yoke orphrey in the *Salvator Mundi*, Leonardo has provided further embellishment by the addition of a delicate filigree of *vinci*, or knot designs, the form of which not only finds a quotation in Windsor 12351 verso but also has been employed in a similar decorative manner beneath the narrow embroidered yoke of the dress of *Mona Lisa* (see fig. 45).

Equally informative is the correspondence between the drapery folds on the sleeves of the *Mona Lisa* with their angular pattern and those of the gray inner drapery represented on Christ's raised arm in the *Salvator Mundi* (cf. figs. 49 and 45).

The stylistic portrayal of the drapery in the *Salvator Mundi*, and in particular that of the raised blessing arm, is worthy of close study as it seems to echo Leonardo's own words on his theory of drapery representation:

That part of a fold which is farthest from the ends where it is confined will fall most nearly in its natural form. Everything by nature tends to remain at rest. Drapery, being of equal density and thickness on its wrong side and on its right, has a tendency to lie flat; therefore when you give it a fold or plait forcing it out of its flatness note well the result of the constraint in the part where it is most confined; and the part which is farthest from this constraint you will see relapses most into the natural state; that is to say lies free and flowing.[42]

These comments he augments under the heading of "Small Folds in Draperies":

How figures dressed in a cloak should not show the shape so much as that the cloak looks as if it were next the flesh; since you surely cannot wish the cloak to be next the flesh, for you must suppose that between the flesh and the cloak there are other garments which prevent the forms of the limbs appearing distinctly through the cloak. And those limbs which you allow to be seen you must make thicker so that the other garments may appear to be under the cloak.[43]

In his exposition on the proper manner in which draperies should be drawn from nature, he concludes

and if it is to be silk, or fine cloth or coarse, or of linen or of crepe, vary the folds in each and do not represent dresses, as many do, from models covered with paper or thin leather which will deceive you greatly.[44]

In regard to Leonardo's abjuration of these media, Vasari describes the artist's actual method of working:

…he studied much in drawing after nature, and sometimes in making models of figures in clay, over which he would lay soft pieces of cloth dipped in clay, and then set himself patiently to draw them on a certain kind of very fine Rheims cloth, or prepared linen: and he executed them in black and white with the point of his brush, so that it was a marvel, as some of them by his hand, which I have in our book of drawings, still bear witness…[45]

The drapery studies mentioned by Vasari probably may be identified with those in the collection of the Marquis de Ganay (e.g., figs. 51 and 52).[46]

The treatment of the folds of the outer drapery of the blessing arm of Christ in the *Salvator Mundi* (fig. 49), cascading gracefully from the wrist and framing the angularity of the pattern of the inner sleeve (in itself so like the drapery resting on Mary's lap in the Louvre *Virgin of the Rocks*, fig. 48), finds its similitude within all of Leonardo's *oeuvre*.

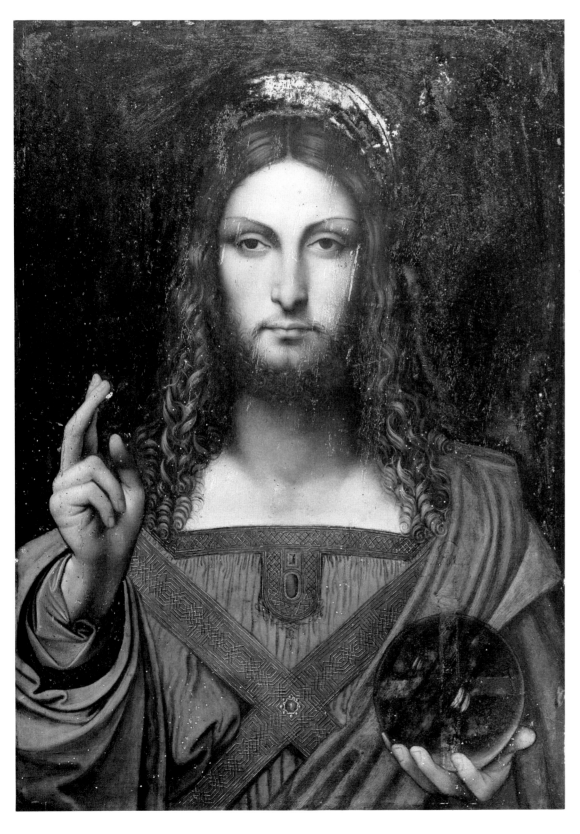

Even though a purely surface stylistic comparison between the de Ganay *Salvator Mundi* and authenticated works of Leonardo has established the Paris painting clearly within the idiom of the master, this result is evident solely within the span of normal vision. By necessity, this comparison has been augmented through examination by scientific methods available to art historians of the twentieth century, which have made manifest the ultimate correspondence between the *Salvator Mundi* and the artist's known *oeuvre* and established Leonardo's autograph in the Paris painting.

This conclusion is substantiated by the assessment of Madame Hours in regard to the scientific analyses of Leonardo's copyists of which she states:

Cesare da Sesto, Luini, Boltraffio all tried to assimilate his style, colour, grace but however well they tried, however far they succeeded, it is by very different procedures. The painting ground is thicker, less careful, and the figures are constructed by the aid of touches of white amply applied. The effect is due to a traditional technique. It is easily distinguishable from that of Leonardo, for he knew how to bestow on the materials themselves, at all stages in the process of creation, the impenetrable and mysterious character that was his.[47]

Stylistically, the de Ganay *Salvator Mundi* has pictorial elements which bespeak both visibly and invisibly of the genius of the artist. Most sublime and of the highest art is the nobility of the face of the Savior of the World in which can be seen strength and authority without harshness, charity and compassion without sentimentality —a face that only Leonardo da Vinci could have conceived and portrayed.

4 THE ICONOGRAPHIC PROGRAMME

And we have seen and testify that the Father has sent his Son as the Savior of the world.*

The late Trecento and the Quattrocento saw the rise of the usage in the West of the devotional image painted on small panels intended for private meditation and prayer, different in format and content from purely didactic art.[1] It is precisely into this idiom of personal religious imagery that the *Salvator Mundi* was adopted as an object for private devotion, as can be seen in figure 19.

Beginning with that which is both standard and readily apparent in the format of Leonardo's *Salvator Mundi* and proceeding to the more subtle and illusive, we are initially able to fit this painting into the accepted formula for that time, one which harks back indirectly to the *vera effigies* of Byzantine inspiration and more immediately to the half-length Blessing Christ and Christ in Majesty represented by the Netherlandish painters of the fifteenth century, which will be discussed in the following chapter. However, once its place in this tradition is pointed out, we must explore what religious message those earlier artists wished to transmit and in what manner that message was both initially accepted by Leonardo and then later transcended in his own representation of the *Salvator Mundi* in order to reflect the deeper underlying meaning which he found latent in this subject matter.

The iconographical schema of a portrayal of Christ that we have come to identify as a *Salvator Mundi* represents Christ, usually half-length, with His right hand raised in the act of benediction and His left hand holding or resting on the Globe of the World, or occasionally, if in a portrayal of the full-length *Salvator Mundi*, the globe is beneath His feet.[2] The globe could take three forms: (1) a solid sphere, often of gold, as represented in the central panel of the *Braque Triptych* in the Louvre by Rogier van der Weyden of about 1451 (fig. 56)[3]; (2) a globe bearing a map of the world, or *mappa mundi*, such as that to be seen in an early sixteenth-century variant of Leonardo's original *Salvator Mundi* attributed to Marco d'Oggiono (fig. 57); and (3) a crystalline orb which brings forth its own internal light, as exemplified by the de Ganay *Salvator Mundi* (fig. 55).

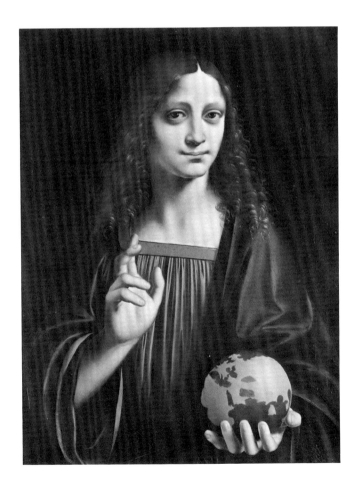

There is inherent in the globe itself a reference to Christ's imperial power and His sovereignty as ruler of the world,[4] and to His role as its creator *(Creator Mundi)*.[5] In addition, the globe may combine eucharistic as well as cosmocratic symbolism.[6]

The concept of salvation in a *Salvator Mundi* is underscored by the globe's spherical shape, a universal symbol for world without end and eternal life.[7] Of particular interest here is Leonardo's use of the crystal globe, which emphasizes the theme of eternity through salvation predicated on its symbolism as a manifestation of "the holy city Jerusalem coming down out of heaven from God, having the glory of God, its radiance like a most rare jewel, like a jasper, clear as crystal.... And the city has no need of sun or moon to shine upon it, for the glory of God is its light, and its lamp is the Lamb" (Rev. 21:10-11, 23). Salvation is also implied through the light-emitting properties of the crystal globe, recalling Christ's words "I am the Light of the World" *(Ego sum lux mundi)* in John

*1 John 4:14

8:12. The inner light of the globe is a reminder of the redemptive power of grace through Christ, and its spherical shape may be assigned a direct eucharistic symbolism with redemptive overtones in that humanity may be saved only through the inherent power of the Eucharist as a constant restatement of the awesome efficacy of His sacrifice.

The assignment of a eucharistic symbolism to the globe in a *Salvator Mundi* finds close corroboration in scenes of the *Supper at Emmaus* in which Christ is shown in an identical pose with His right hand raised in blessing but in which the globe in His left has been replaced by a round loaf of bread, clearly symbolizing the eucharistic sacrifice of the Mass and recalling Christ's words in John 6:51-52: "I am the living bread that has come down from heaven. If anyone eat of this bread, he shall live forever."[8]

The possible existence of the "Mystical Window" or "Window of Paradise," the frequent presence of which Carla Gottlieb has noted on the globe in representations of the *Salvator Mundi*, especially in Netherlandish paintings,[9] cannot clearly be determined in the de Ganay painting because of damage caused by the addition and subsequent removal of a cross that has obscured sections of the original globe.

In addition to the essential attributes of a *Salvator Mundi* schema, I would like to suggest that Leonardo's *Salvator Mundi* incorporates specific pictorial features from which an intelligible and consistent iconographical interpretation may be derived, although it is one expressed in a vocabulary which Leonardo had adapted to his own use in accordance with his unique *Weltansicht*.

As Leonardo was undoubtedly aware, that which set this particular Flemish pictorialization of Christ apart from the earlier versions of Christ the *Pantocrator* and the Christ of the Last Judgment was a certain amelioration of the facial features of the Savior, the replacement of the open Book—on which there was sometimes inscribed *Ego sum lux mundi*—or of the closed Book of Life by the Globe of the World, and, in some cases, the addition of a crossed stole to His garments.[10] However, the deepest interpretation that can reasonably be derived from this standardized representation is that the mien of Christ has been metamorphosed and His pictorialization softened from an awesome manifestation of the Godhead into one of a gentler Christ who wishes to bless rather than to condemn the world. Furthermore, in the symbolism of His wearing the Stole of Immortality, He is both assuming the priestly function[11] and making a reference, however arcane, to the immortality of the soul and the triumph over original sin and, *sub silentio*, to the victory of the New over the Old Covenant inasmuch as while vesting themselves with the stole priests of the Catholic Church pray "Restore unto me, O Lord, the Stole of Immortality which I lost through the sin of my first parents and, although unworthy to approach Thy sacred Mystery, may I nevertheless attain to joy eternal."[12]

It was not rare to see the vestments of both God the Father and Christ adorned with the crossed stole during the later Middle Ages, but gradually this portrayal declined in usage, not reappearing until the Renaissance, and the earliest representation of a *Salvator Mundi* with a crossed stole in the Quattrocento appears to be that by Hans Memling of about 1485 in the *Najera Triptych* (fig. 65).[13]

However, while the general Netherlandish type of representation of a half-length *Salvator Mundi* would have been known to Leonardo, it seems to me that an immediate impetus was provided by the three prototypes proposed earlier: (1) the illustration of *"Les élus du paradis"* from the book entitled *L'art de bien mourir* published in Paris in 1492 by Antoine Vérard (fig. 18); (2) the *Salvator Mundi* portrayed in a triptych as a private devotional image in the *Book of Hours of James IV of Scotland* (fig. 19); and (3) the figure of the Savior represented on the *Holy Host of Dijon*, to which had been credited the miraculous recovery of Louis XII (fig. 17). It is suggested that the ultimate formalization of Leonardo's *Salvator Mundi* arose out of a synthesis of these three that reflects the unique genius of Leonardo, a synthesis which the artist would have seen fit to augment by incorporating into his own version a clear manifestation of the Passion as essential to the very heart of the Christian liturgy of the Eucharist and the promise of eternal life through the intercession of Christ. The efficacy of this is determined by the fact that Christ should and must be considered not only as Priest but also as Victim on the altar, for the reason that the Savior's powers of intercession with the Father for humanity are derived from Christ's ultimate sacrifice, the pain and suffering of which are made explicit by the *stigmata* which He, the Son, underwent in compliance with the Father's wishes in order to atone for the sin of Adam.[14] Leonardo's *Salvator Mundi* seems to have been the first true representation of that theme in which reference to this concept was made.[15]

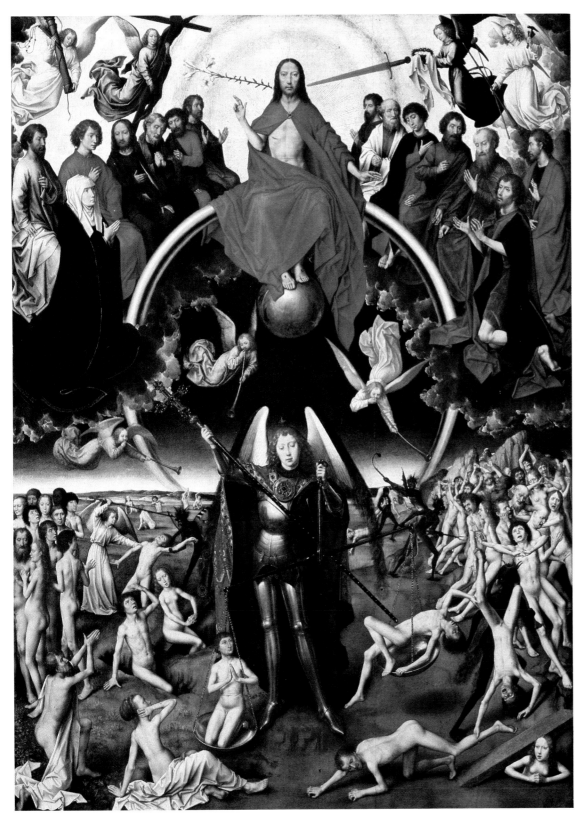

58. Hans Memling, *The Last Judgment*, center panel. 1473. Marienkirche, Danzig.

In this regard, both Leonardo's preparatory drawing Windsor 12525 and his painting of the *Salvator Mundi* incorporate in Christ's vestment a singularly shaped tuck on the right-hand side near the crossing of the stole (figs. 61 and 62). The presence of this feature in the original drawing indicates that Leonardo had initially assigned to it a particular significance, one which he later endorsed by incorporating it in his painting, necessitating that a specific iconological interpretation should be accorded to this unusual configuration of drapery. That interpretation, I believe, must be that Leonardo wished this tuck to reveal, while the garment hid, the *stigma* of the lance that had pierced the side of Christ.

The miraculous nature of the *Holy Host of Dijon*, suggested here as an important contributing factor to the formation of Leonardo's representation of the *Salvator Mundi*, arose out of the fact that when the Host was desecrated by a knife wielded by a non-believer, it was reported that real blood issued forth from the slash.[16] This information would have undoubtedly been imparted by Louis to Leonardo, and might well have provided him with the initial impetus to select a manifestation of the *coup de lance* as a symbol of the Passion in the *Salvator Mundi*. The eucharistic symbolism of the lance wound finds a liturgical source in the Byzantine rite in which "the consecrated Host is pierced on the right side by the priest, in imitation of the wound in Christ's side."[17]

Once this meaning is put forward, one can look at this tuck and visualize the indentation which would have remained after the withdrawal of the probing fingers of the doubting Saint Thomas, as portrayed in the life-size bronze statuary group made between 1465-83 by Andrea del Verrocchio and on the façade of the Church of Or San Michele in Florence (fig. 59).[18] Inasmuch as Leonardo entered the workshop of Verrocchio a few years after this commission was begun, he may well have been influenced by it.[19]

The incorporation of the lance wound in a fully dressed figure is not unknown in portrayals of Christ, and is particularly common in portrayals of Saint Francis after he had received the *stigmata*. However, in most representations of the *stigma* of the *coup de lance*, the wound is clearly represented, either because the figure of Christ is shown bare-chested, as in Hans Memling's *Last Judgment* (fig. 58), or if draped, as are all the representations of Saint Francis in which this *stigma* is shown and as is the case of Giovanni Bellini's painting of *Christ Blessing* in the Louvre (fig. 60), because the lance wound is made visible through a cut or slit in the drapery. It is completely in keeping with what we know of Leonardo's thinking processes that he would have abjured this type of representation as too obvious in much the same manner, for example, that he left out any overt symbols from his original painting of the *Virgin of the Rocks* in the Louvre, although they were later incorporated in the second version, now in the National Gallery in London, which seems to be mainly the work of Ambrogio de Predis.

59. Andrea del Verrocchio, *Doubting of Thomas*. 1465-83. Or San Michele, Florence.

60. Giovanni Bellini, *Christ Blessing*. 1460. The Louvre, Paris.

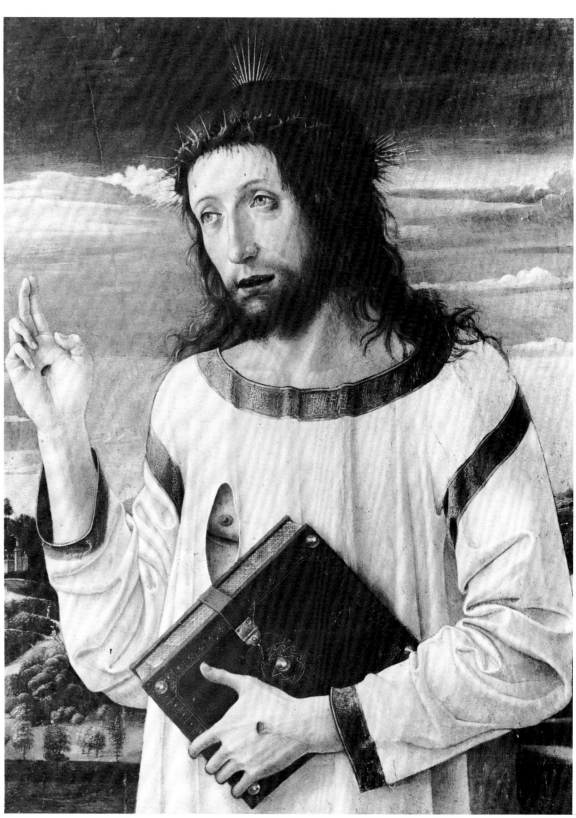

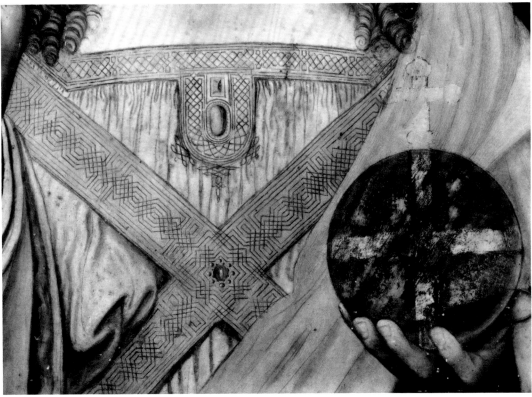

Perhaps it is not too much to read the shape of this fold of cloth in Leonardo's *Salvator Mundi* as a deliberate attempt on the part of the artist to portray the Greek letter *omega* (Ω); and, if we do, the Biblical passage is immediately brought to mind in which Christ says, "I am the Alpha and the Omega, the first and the last, the beginning and the end" (Rev. 22:13).[20]

In addition to alluding to the ideas of Christ as Victim and Priest, Leonardo has included in his *Salvator Mundi* two well-known iconographical symbols representing the Resurrection and eternity. For the first, we have but to look at the orphrey[21] of the stole to find that in it there are two series of threads, both eight in number (fig. 62). Furthermore, the jewel prominent in the crossing of the stole is surrounded by an eight-pointed embroidered star, and this star painted by Leonardo also determined the number and design of the eight pearls now surrounding it that were painted later by another hand.

In Christian iconology, the use of the number eight as a symbol of the Resurrection has been derived from two anagogical interpretations by the medieval exegetes of the Old Testament, one based on the fact that the number of persons on the ark saved from the Flood was eight and the other in Leviticus 9:1-4 where Moses declares that "on the eighth day...the Lord will appear to you." The New Testament interpretation is based on Christ's Resurrection on the eighth day after His entry into Jerusalem.

In addition to the number eight, Leonardo has chosen to incorporate the number six, a perfect number and also the number symbolizing creation, in the hexagonal pattern in the orphrey of the crossed stole and in the six-strand orphrey of the neckband bordering Christ's vestment (fig. 62). The choice of six in the context of perfection and creation, which is predicated on God's creation of the world in six days, was extolled by the medieval exegetes of the Old Testament. The former meaning is based on the unique analog that the sum of all of its parts is equal to the product,[22] encompassing the components of: (1) the number one, indicative of the single Godhead and the identity of Christ with the Father, as Christ says in John 10:30, "I and the Father are one"; (2) the number two, symbolizing the dual nature of Christ, both human and divine, which is echoed in the Eucharist in the mixture of the water and the wine, a conjunction which in itself is a reverberation of the blood and the water which issued from the wound inflicted by Longinus, showing that despite the apparent division of the dual natures of Christ, His single essence with the Father is recalled when the water and the wine are combined at the celebration of the Mass; and (3) the number three, symbolizing, of course, the Trinity or triune Godhead. We are once again reminded that, despite the apparent separation, there is but one God and *Trinitas* is the co-equal of *Unitas*. In the New Testament, the number six finds significance as Christ admonishes His twelve disciples to go forth "two by two" (Mark 6:7).

63. Andrea Mantegna, *Madonna della Vittoria*. 1493-96. The Louvre, Paris.

64. Detail of interweaving thread design in Mantegna's *Madonna della Vittoria*. The Louvre, Paris.

By employing the perfect number six in two different fashions in his representation of Christ as *Salvator Mundi* and juxtaposing it with the number eight, Leonardo is underscoring Christ's role as both Creator and Savior of the World.[23]

As an implicit statement of the concept of eternity, a close examination of the patterns of the orphreys on both the crossed stole and the neckband reveals that Leonardo has carefully portrayed within the intricate weaving a single uninterrupted thread with neither a beginning nor an end, so to that extent it is eternal.[24] In his use of an uninterrupted thread to symbolize immortality, it is suggested that Leonardo was alluding to the Grecian Fates or *Moirae* by whom the duration of a person's life was determined in the cutting of the thread of life. In the *Purgatorio*, Dante makes reference to this role of the Fates:

> *When Lachesis has no more flax,*
> *The soul is loosed from the flesh*
> *And carries with it potentially both*
> *The human and the divine faculties—*
> *All the others mute, memory,*
> *Intelligence and will in action*
> *And far keener than before.*[25]

Leonardo's predilection for the theme is evidenced in the *Sala delle Asse* in the Sforza Castle and the walls of the Old Sacristy in the Church of Sta. Maria delle Grazie in Milan, wherein da Vinci may well have been proffering a gracious conceit on the proposed longevity of the Sforza dynasty.[26]

That Leonardo consciously may have been incorporating this same theme into his religious painting about this time is borne out by extant copies of his painting of the *Madonna of the Spindle* where the reference to the Fates is implicit in the spindle itself and its reference to Christian iconology is explicit in its cruciform shape. An eyewitness account describes the original painting when it was in Leonardo's studio:

The little picture represents a Madonna seated, and at work with a spindle, while the Infant Christ, with one foot upon the basket of flax, holds it by the handle, and looks with wonder at four rays of light, which fall in the form of a cross, as if wishing for them. Smilingly, he grasps the spindle, which he seeks to withhold from his mother.[27]

The medieval anagogical interpretation of the spindle was already in use by the first half of the eleventh century based on the Apocryphal history of Mary in the *Proto-Evangelium of James* wherein Mary, the new Eve, is portrayed weaving the veil of the Temple which will be rent at the moment of her Son's crucifixion.[28] The thread would be broken then, signifying the destruction of the Old Covenant by the New: "And the curtain of the temple was torn in two, from top to bottom" (Mark 15:38).[29]

This symbolism of the unending embroidery patterns was not, of course, unique to the *oeuvre* of Leonardo but may also be seen elsewhere. In the altarpiece of the *Madonna della Vittoria* painted by Andrea Mantegna between 1493-96 and now in the Louvre, the uninterrupted thread motif (fig. 64) is placed directly above the head of the Christ Child (fig. 63). It is germane to point out that the central vertical axis of the painting begins at the bottom of the bas-relief that decorates the throne on which the Madonna is seated and which depicts the serpent in the Garden of Eden, passes through the body of the Child, and then terminates in a sixteen-pointed star surrounded by the never-ending thread design, reinforcing the concept of eternity through salvation.

Another example is to be found in Raphael's fresco of the *Disputà* painted in 1509 in the *Stanza della Segnatura* in the Vatican apartments in which the central altar, displaying the Host exposed in a monstrance, is fronted by an antependium decorated with the same type of "eternity thread" motif. The vertical axis in this painting begins with the altar frontal, ascends through the monstrance, the dove of the Holy Spirit, the figure of Christ displaying His *stigmata* and terminates in the apex of the nimbus above the head of God the Father in what is, essentially, a simple statement of salvation through Christ's sacrifice as evidenced in the Eucharist.

Further symbolic of His Passion, Christ is portrayed in Leonardo's *Salvator Mundi* wearing a flame-red robe[30] predicated on Matthew 27:27-29:

Then the soldiers of the governor took Jesus into the praetorium, and they gathered the whole battalion before him. And they stripped him and put a scarlet robe upon him, and plaiting a crown of thorns they put it on his head, and put a reed in his right hand. And kneeling before him they mocked him, saying, "Hail, King of the Jews!"

In the center of the crossed stole is a red jewel, a ruby, symbolic of the martyrdom and death inherent in Christ's Passion. There are in the central orphrey beneath the neckband of Christ's vestment two additional red stones which would seem to share the same meaning.

Across Christ's left shoulder is placed a blue mantle—like that in the *Last Supper*—symbolic of Heaven and of His ministry on earth, and it may, perhaps, also be associated with the pallium of the first century, a garment of great honor and dignity worn by teachers to signify their status.[31]

Iconographically, Leonardo's *Salvator Mundi* portrays the role of Christ as Savior of the World in terms that the artist would have chosen both for their inherent clarity of message and for their manifest beauty of representation, reminding the viewer of the believers' words: "we know that this is indeed the Savior of the world" (John 4:42).

5 THE LANGUAGE OF THE ICON

Devotional pictures are holy images, which means that to some extent the deity is thought to be present in the image or at least that the likeness partakes of the sanctity of the divine being which it impersonates.*

* Otto Pächt, "The 'Avignon Diptych' and Its Eastern Ancestry," *De Artibus Opuscula XL. Essays in Honor of Erwin Panofsky*, ed. Millard Meiss, 2 vols., New York, 1961, vol. I, p. 402.

The *Salvator Mundi* by Leonardo da Vinci is painted in the style of images of the *Mandylion* of Byzantine origin, and, like them, participates in the divinity of their prototypic representations, the *acheiropoeta*, so called as they were deemed to have come into existence without the intervention of human hands.[1] The portraits of Christ of this miraculous origin appeared in four disparate legendary forms, and all were venerated and revered as true effigies of the Redeemer.

The Mandylion of Edessa

In the early fourth century, Eusebius, Bishop of Caesarea, records correspondence between King Abgarus of Edessa and Jesus in which the King, afflicted with leprosy and hearing of Christ's miraculous powers of healing, sent a message to Him by way of Ananias, the King's footman, offering sanctuary to the Son of God and imploring Him to come to Edessa and restore his health.[2] Jesus wrote in reply that He would be unable to come then or in the future to see the ailing King, but that following the Ascension, He would send one of His disciples to effect the cure.[3]

Although Eusebius relates how the Savior's promise to Abgarus was kept when after the Ascension Saint Thomas sent Saint Jude Thaddeus, who effected the Edessan King's cure by the apotropaic quality of the earlier letter of Christ with which the Apostle rubbed Abgarus' face, he makes no mention of any image of Christ.[4] An early reference to such a portrait may be found in the writings of Saint John of Damascus (700?-759?), governor of Damascus, who relates that when Abgarus had learned that Christ had declined to come to see him, he sent a painter to portray Christ's image; however, the brilliance of the light that shone from Jesus' face prevented the artist's working.[5] Jacobus de Voragine, writing in the late thirteenth century, continues the story in his *Golden Legend*, citing John of Damascus: "But our Lord, seeing this, took the painter's linen cloth and held it to His face, and left the imprint of His countenance upon it, and sent it to King Abgar."[6] To this account, Jacobus de Voragine, continuing to rely on the work of the Damascene, appends a description of the Holy Face of Christ as it thus appeared: "He had good eyes, a strong brow, and a long face, with straight features, such as denote maturity."[7] It should be remarked that this is one of the earliest descriptions of the Savior's features which has come down to us. It is well known that the Gospel writers of the New Testament were singularly reticent in this regard. Of their silence, it has truly been said, *"On dirait qu'ils ne l'ont pas plus contemplé que Moïse n'a vu l'Éternel."*[8]

According to two other versions of the story, Abgarus was either cured by the touch of Christ's portrait brought to him by Saint Jude,[9] or by the mere sight of it after it had been brought before him by his own messenger.[10] The legend continues that Abgarus and all of his people were thereby converted to Christianity, but some time later his great-grandson lapsed into

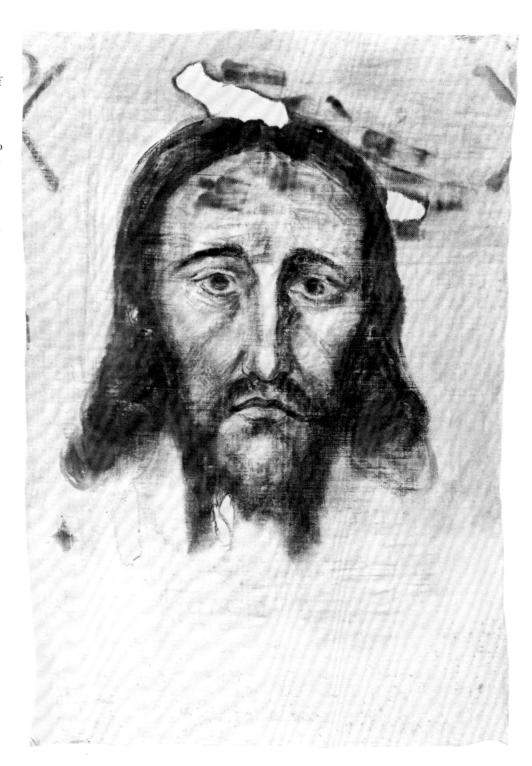

paganism, and to protect the image, it was immured by the Bishop of Edessa, who left an oil lamp burning before it.[11] There it remained sequestered until the city was besieged in 544 by the Persians, at which time the then Bishop was apprised in a dream of its location and recovered it: "Thus recovered, the miraculous portrait of Christ helped to destroy the enemy and obtained a great reputation even among the Persians."[12] Nothing further is reported of the *Mandylion* of Edessa until it was translated in 944 to Constantinople,[13] where it was to remain until it disappeared in the sack of that city during the Fourth Crusade of 1204.

A complete version of the Abgarus legend is set forth in ten small enamelled paintings which surround a portrait of Christ reported in the convent of S. Bartolommeo degli Armeni in Genoa which is purported to be the original *acheiropoeton* sent by Christ to Edessa. Although neither the painting nor its frame are now able to be seen, the central portion was sketched by Thomas Heaphy the Younger, a sketch now in the British Museum together with Heaphy's sketch of the other extant *Mandylion* (also considered as the original), which von Dobschütz reports was moved in 1870 from the Church of S. Silvestro in Capite at Rome to the private chapel of the Pope in the Vatican[14] (figs. 66, 67). It should be remarked that there is a very strong similarity between the two portrayals of the *Mandylion* by Heaphy and that of the Holy Face of Christ set within the center of the large cross in the mosaic apse decoration of S. Apollinare in Classe, Ravenna (535-549). Because of the coeval date of 544 for the rediscovery of the *Mandylion* of Edessa during the Persian siege there, one is tempted to conclude that the image of the Holy Face in S. Apollinare is a direct copy of the original *Mandylion* revered in Edessa, and may have been set in tile in the mode of the *Keramidion* that will be discussed below.

The third *Mandylion* representation which has seriously been put forward as the original was that held by Sainte-Chapelle in Paris, which was built by Louis IX (later Saint Louis) in 1252 to house relics acquired from Constantinople. Because of this direct association with the previous *locus* of the *Mandylion* alleged to have been sent by Christ to Abgarus, this icon would seem to have the best provenance of the three conflicting claimants. However, as it was destroyed in 1789 during the Revolution and no records now appear to be available concerning it, further research on this version seems impossible.[15]

The Keramidion

Necessarily associated with the legend of the *Mandylion* of Edessa is that of the *Keramidion* or "Holy Brick." In the immurement of the *Mandylion*, before closing the wall, the Bishop placed before the Holy Face a votive light. When the wall was reopened in 544, the lamp was still burning, and as a result of the light shining through the cloth, a duplicate was found to have been imprinted on a tile of the wall.[16]

67. Thomas Heaphy the Younger,
Holy Face after *Mandylion* formerly in
S. Silvestro in Capite, Rome. Mid-19th
century (?). British Museum, London.

68. School of Rostov Suzdal, *Vera
Icon*. 13th century. Suzdal Museum,
Suzdal.

69. *Holy Face*. c. 1200. Cathedral of
Laon.

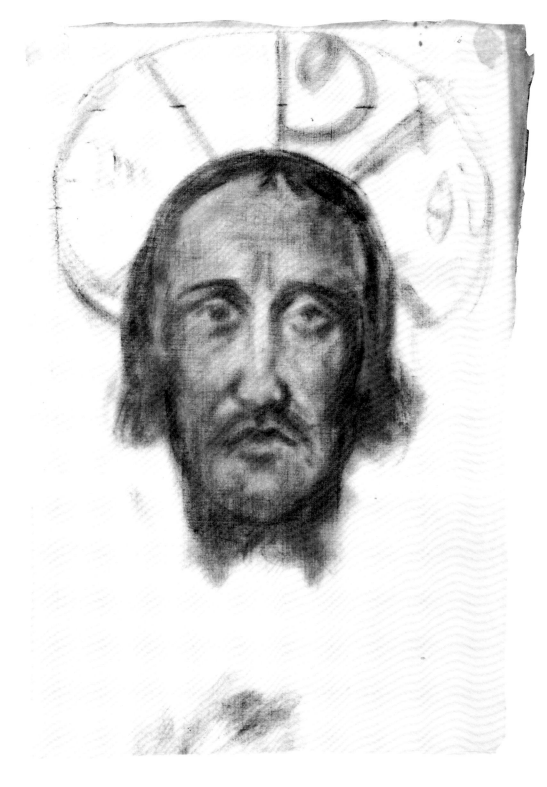

This exact duplicate, which like its prototype was a true *acheiropoeton*, was removed and venerated in Edessa until 968 when the *Keramidion*, 24 years after the *Mandylion*, was likewise translated to Constantinople and remained there until it too was lost at the time of the Fourth Crusade.[17]

The series of miniatures surrounding a copy of the *Mandylion* by Emmanuel Tzane in the Royal Collection at Buckingham Palace tells the story of the concealment and removal of the icon in three images: in the first a bishop is shown covering it in a wall by a tile; next, another bishop is removing it by means of a ladder; and in the third he is employing the light from the still-burning lamp to ignite oil with which he dispels the Persians. Although this series of miniatures, as von Dobschütz has pointed out, does not duplicate exactly that adorning the *Mandylion* at Genoa, the events are the same.[18]

Inasmuch as the *Keramidion* was an exact replica of the *Mandylion*, any representation of the one should, of necessity, be identical to the other. One of the finest examples is to be found in the treasure of the Cathedral of Laon (fig. 69), a thirteenth-century painting in encaustic, given by Jacques de Troyes, who later became Pope Urban IV.[19] Other examples of this form to be seen today are Russian copies of the twelfth to thirteenth centuries from the Schools of Suzdal (figs. 69, 80) and Novgorod.[20]

The Berenike Kerchief

The third type of portrayal of Christ "not made by human hands" is the cloth which has been associated since antiquity with a woman of the Greek name Berenike, which later became Latinized into Veronica (incorrectly derived from "*Vera Icon*"), who has often been confused with the woman in the legend of the fourth type, the Veil of Veronica, which will be discussed next.

One of the earliest accounts of the Berenike legend is to be found in the *Mors Pilati*, the "Death of Pilate" of the *Apocryphal New Testament*, which was taken from a sixth or seventh-century Syriac manuscript recording that Tiberius Caesar, suffering from a grievous illness and being aware of Jesus' healing power, dispatched his attendant, Volusianus, to Pilate ordering that Christ be sent to Rome immediately to effect a cure. When the Emperor's envoy met with Pilate, the Governor of Judea denounced Jesus as a malefactor who had been previously crucified.[21] While returning to his lodgings, Volusianus met Berenike (or Veronica) the woman who, according to the Apocryphal *Gospel of Nicodemus,* had been miraculously cured by Christ,[22] and the envoy related to her the failure of his assignment. Berenike (Veronica) said to him:
When my Lord went about preaching, and I was very unwillingly deprived of his presence, I desired to have his picture painted for me, that while I was deprived of his presence, at least the figure of his likeness might give me consolation. And when I was taking the canvas to the painter to be painted, my Lord met me and asked whither I was going. And when I had made

known to him the cause of my journey, He asked me for the canvas, and gave it back to me printed with the likeness of his venerable face. Therefore, if thy lord will devoutly look upon the sight of this, he will straightway enjoy the benefit of health.[23]

Thereupon, Berenike (Veronica) returned to Rome with Volusianus and the *acheiropoeton,* and upon gazing on the Holy Face Tiberius Caesar was immediately cured.[24]

The first document relating the history of the *Berenike* Kerchief after it arrived in Rome during the first century appeared in the first half of the twelfth century, followed by the earliest description of it by Gervase of Tilbury (d. 1211): "*Est ergo Veronica pictura Domini vera secundum carnem repraesentans effigiem a pectore superius in basilica S. Petri,*" and it may well have been illustrated about 1250 in a miniature by Matthew Paris (fig. 70).[25] Writing in his annals, he recounts a procession in 1216 from St. Peter's to the Hospital of the Holy Ghost in which Pope Innocent III carried a holy image of Christ and during which it had miraculously reversed itself; Paris identifies this *acheiropoeton* as that of Berenike (Veronica): "*Veronica tale nomen a quadam muliere . . . ad cuius petitionem ipsum fecit Christus impressionem.*"[26] The Matthew Paris miniature, known in four slightly varied versions, met with rapid circulation in copies throughout the North.[27]

Otto Pächt, in his study of the holy relic of Berenike (Veronica), states that, according to Josef Wilpert, who was allowed to examine it closely in 1917, "the original relic of the Roman *Sudarium* still exists and is kept in the Chapel of the Veronica Pillar of St. Peter's. He describes it as a square piece of cloth discolored by age and marked by two amorphous and uneven stains."[28]

The Veil of Veronica

The fourth miraculous image of Christ is known as the Veil or *Sudarium* of Veronica. This widely known representation resulted from a change in the earlier version of the story of Berenike, or Veronica, effected in the thirteenth century by Roger Argenteuil, who, influenced by the popular mysticism surrounding the Passion Cycle at that time, proposed that Christ's image had become imprinted upon Veronica's veil after she had compassionately used it to dry His face on the road to Calvary.[29] From the beginning of the fourteenth century onward, this version of the legend was associated with the account of the Bearing of the Cross in which the Veil, soon identified as one of the *Arma Christi*, usually portrayed the suffering thorn-scathed imprint of the *Imago Pietatis*.[30] This pictorial motif was much venerated and often portrayed from the time of the fourteenth century. Among others, it took the following forms: (1) Veronica, seated alone in a landscape, holding the image to the viewer, as seen in Hans Memling's panel in the National Gallery in Washington, D.C. (fig. 71); (2) the actual moment of Christ imprinting His image on the Veil; (3) the moment after the transfixing of the image; (4)

70. Matthew Paris, *Holy Face*. c. 1250.
Ms. Arundel 157, fol. 2. The British
Library, London.

71. Hans Memling, *Saint Veronica*.
c. 1470–80s. National Gallery of Art,
Washington, D.C., Samuel H. Kress
Collection.

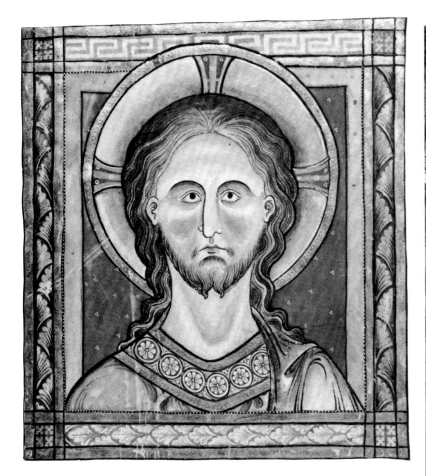

72. "Pentecost," from the *Psalter of Queen Ingeborg of Denmark*. Before 1210. Ms. 9, fol. 32v. Musée Condé, Chantilly.

73. Simone Martini, *Salvator Mundi Surrounded by Angels* (detail). c. 1340-44. Palais des Papes, Avignon.

Veronica portrayed holding the *Sudarium* with the Holy Face in a scene of the Crucifixion; (5) the representation of the *Sudarium* alone; or (6) held by angels; (7) in depictions of the miraculous *Mass of Saint Gregory*; (8) in representations of the *Arma Christi*;[31] and (9) the Veil of Veronica held by Saints Peter and Paul.[32]

However, despite its stylistic origins in Byzantine representations of the Holy Face, we need not be concerned further in this study with this version for it was not in the portrayal of the suffering Savior, but rather in that of the Christ of the *Mandylion* and *Keramidion* of Edessa and the *Berenike* Kerchief that we find the *acheiropoeta* from which the *Salvator Mundi* of Leonardo da Vinci evolved.

Although the *Salvator Mundi* schema ultimately originated in the *acheiropoeta*, in no sense was the nexus immediate. Rather, it was to be made through the intermediaries of Christ as the *Pantocrator*, the Christ in Majesty, and the Christ of the Last Judgment, which also betray their Byzantine ancestry.[33]

One of the earliest representations of a true *Salvator Mundi* portraying Christ holding the Globe of the World in His left hand and bestowing blessing with His right is to be found in an illumination associated with the School of Rheims and dated prior to 1210 from the so-called *Ingeborg Psalter* (fig. 72).[34] While this seems to herald the inauguration of the new theme, it still shows its indebtedness to Byzantine sources in its depiction of the blessing hand of Christ in the position appropriate to the iconography of the Eastern Church.

Although this representation of northern origin was to be repeated over the next century or so in small-scale works in France, the Low Countries and in England, we can look to the south and Simone Martini for what is perhaps its first appearance in a full-scale work in the *sinopia* drawn by him for a fresco for the porch of Notre-Dame-des-Doms at Avignon, dated about 1340-44 (fig. 73). Not only does this seem to be the earliest full-scale painting of a *Salvator Mundi* with the Globe of the World, it is also seemingly the first depiction of the subject by an Italian artist. That this rare *sinopia* may have announced the transition between the portrayal of a Christ in Majesty and that of a *Salvator Mundi* is suggested by the fact that a close examination reveals the artist originally intended to portray the Savior with an open book in His left hand, but either on his own or, more likely, in response to the dictates of his patron in Avignon, subsequently deleted the book and replaced it with a globe.

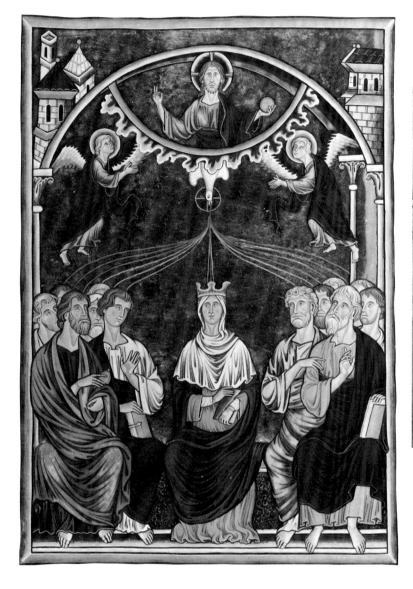

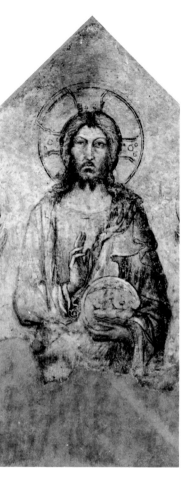

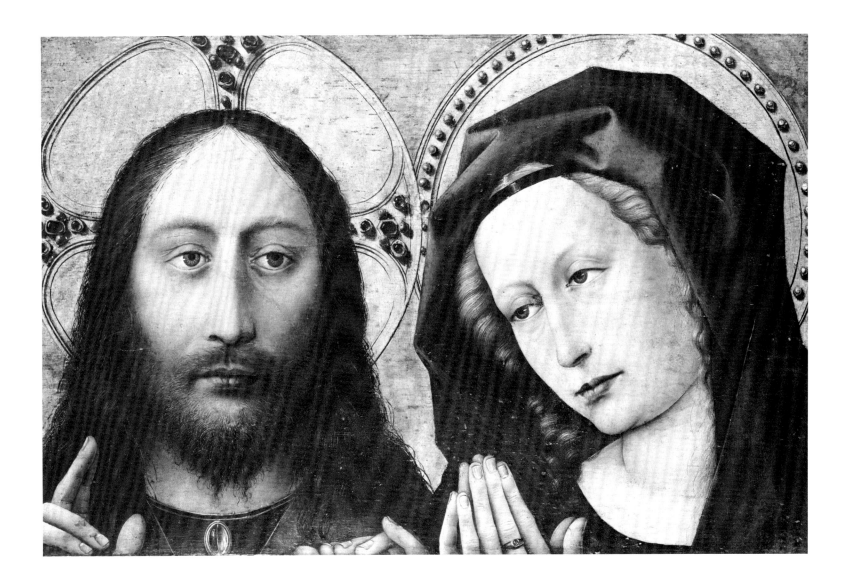

75. After Jan van Eyck, *Head of Christ*.
c. 1438-40. Stedelijke Museum,
Bruges.

76. Hans Memling, *Christ Blessing*.
1478. Private Collection, courtesy M.
Knoedler & Co., New York.

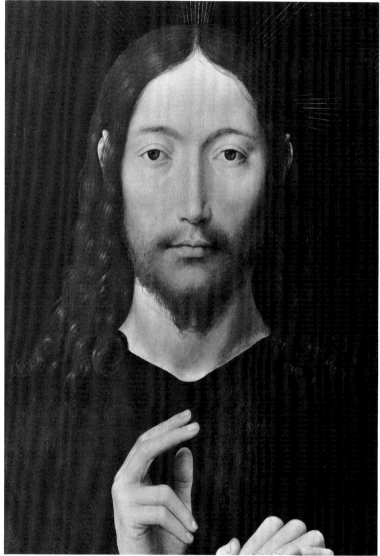

77. Antonello da Messina, *Blessing Savior*. 1465. National Gallery, London.

78. Detail of *Salvator Mundi* in van der Weyden's *Braque Triptych*. The Louvre, Paris.

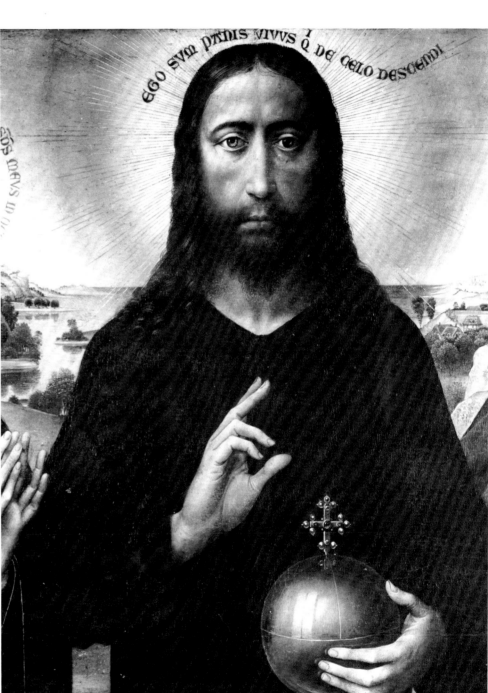

It is of interest to compare Leonardo's *Salvator Mundi* with a work of approximately the same date as Simone Martini's *sinopia*, the *Christ Blessing* by Giotto, a painting which Willhelm Suida was the first to ascribe to that painter and which he identified as the central panel of the so-called Peruzzi Altarpiece, commissioned for the Franciscan Church of Sta. Croce in Florence, dated from 1322 to the third decade of the century (fig. 79).[35] In this painting Christ is portrayed holding the Book of Life in which are written the names of the saved.[36] Although it would be incorrect to directly tie Giotto's image of Christ into the *Salvator Mundi* theme *qua* programme, one must note two distinguishing features which seem to link it and Leonardo's *Salvator Mundi*. The first is the similarity in the tightly cuffed sleeve of the blessing hand in Giotto's portrayal of Christ with that in Leonardo's preparatory drawing for a *Salvator Mundi*, Windsor 12524 (fig. 11). One is tempted to believe that Leonardo had first been inclined to follow Giotto's lead, but had later decided to abandon it for his own rendition as found in the completed painting. In the same light, we may compare Leonardo's other preparatory drawing for his *Salvator Mundi*, Windsor 12525 (fig. 12), which includes the omega tuck that simultaneously hides and suggests the lance wound, with Giotto's painting where Christ's garment is shown completely closed but in which the *coup de lance* is subtly indicated by just a slight augmentation in the density of pigment in a vertical line directly above the affected area. The uniqueness and subtlety of Giotto's representation of the lance wound can only be appreciated by comparing it with contemporary and later works in which by the baring of the chest or the large slit in the garment it is made very explicit. Here we seem to perceive Leonardo not rejecting Giotto's depiction of the *stigma in toto* but rather accepting it and altering it only slightly to conform to his own method of representation. While Giotto's representation of Christ in the Peruzzi Altarpiece was not intended to portray the *Salvator Mundi*, Leonardo seems to have found in Giotto's portrayal of the *Christ Blessing* certain details —as well as the majestic and hieratic attitude of the image of the Savior—which he either seriously considered or ultimately adapted into his *Salvator Mundi*.

79. Giotto and assistants, *Christ Blessing*, center panel of *Peruzzi Altarpiece*. c. 1322. North Carolina Museum of Art, Raleigh.

80. School of Rostov Suzdal, *Vera Icon*. 13th century. Suzdal Museum, Suzdal.

Returning to the historical development of the *Salvator Mundi* theme itself, it becomes necessary to retrace our steps and turn back to the North inasmuch as Simone Martini's early lead in the south of France appears to have had no immediate followers.[37] The evolution of panel paintings of a true *Salvator Mundi* holding the Globe of the World in which we can trace the elements found in Leonardo's *Salvator Mundi* began in the fifteenth century and seems to have been based on a representation of the *Holy Face* — echoing the type of miraculous portrait of Christ inherent in the Byzantine *vera effigies* — by Jan van Eyck datable about 1430-35, now known to us only in copies (e.g., fig. 75). The visage of Christ has been somewhat ameliorated from the stark hieratic presentation of Matthew Paris two hundred years earlier (fig. 70), and van Eyck has, like Paris, restricted himself to a depiction of only the Savior's head and shoulders.

Of approximately the same time and also to be found in the Netherlands is the portrayal of the *Christ as Savior* by Robert Campin, in which the artist has introduced the upper part of the Redeemer's blessing hand (fig. 74). Today His left hand rests on the picture edge since the painting was cut down at a later date, thus obscuring the object on which the hand was originally placed. The Virgin intercedes for humanity beside her Son, who answers her prayers with His blessing, thus introducing the idea of intercession into a "pseudo-diptych" of which Jan Bialostocki states: "In this composition, apparently hands were added to icons first represented as faces only. This may account for the somewhat awkward position of the hands."[38]

What is perhaps the initial portrayal of the Savior holding the Globe of the World in a panel painting can be traced to a composition of Rogier van der Weyden of about 1451-52: the *Braque Triptych* now in the Louvre[39] (fig. 56). It is of interest to note that this same theme appeared almost simultaneously in Italy, although not as a panel or altarpiece but rather as part of a fresco painted during the mid-1450s by Andrea del Castagno in SS. Annunziata in Florence in which a representation of Christ in the role of *Salvator Mundi* appears as a visionary image above the head of Saint Julian.

Although this theme of Christ holding the globe while blessing was not to be taken up immediately in either the Netherlands or in Italy, the theme of the Blessing Christ continued to develop in the familiar small Netherlandish panels with half-length representations that depict the Redeemer wearing a simple dark robe, His right hand raised in the act of blessing and His left resting on the lower edge of the picture frame or on a parapet. This devotional image apparently grew out of a now lost archetype by Rogier van der Weyden,[40] a composition reflected in Hans Memling's *Christ Blessing* painted about 1478 (fig. 76). While such replicas of Rogier's composition originated in the North, they ultimately were to find favor in Italy as evidenced by the *Blessing Savior*, dated 1465, by Antonello da Messina (fig. 77), who introduced this Netherlandish type into Italy.[41]

It is during the last quarter of the fifteenth century in the Netherlands that the representation which we designate as the *Salvator Mundi* became an important theme, combining definite principles of iconography from the Christ in Majesty with those of Rogier van der Weyden's *Braque Triptych* and the Blessing Christ. The Netherlandish *Salvator Mundi* image was circulated in numerous variations which are divided into two main types: (1) the type in which the Globe of the World rests *in* the left hand of Christ, as represented in the *Braque Triptych* (fig. 78); and (2) the type in which Christ is resting His hand *upon* the Globe of the World, e.g., a painting by Quentin Massys from the late fifteenth century in the National Gallery in London (fig. 81) and the *Najera Triptych*, today in the Musée Royal des Beaux-Arts, Antwerp (fig. 65).

The former type of *Salvator Mundi* in which Christ is depicted holding the Globe of the World in the palm of His hand was well known in Italy also and occurs in the Venetian paintings of the late fifteenth century that were based on an archetype by Giovanni Bellini, known now only in numerous copies and variations.[42] One of the earliest incorporating this Bellinesque formula is Vittore Carpaccio's *Salvator Mundi with the Four Evangelists* of 1490, in the Contini-Bonacassi Collection, and that it was still circulating as late as 1519, albeit as a single-figure, is evidenced by Andrea Previtali's painting of the *Salvator Mundi* theme now in the National Gallery in London (fig. 82).

82. Andrea Previtali, *Salvator Mundi.*
1519. National Gallery, London.

83. Melozzo da Forlì, *Salvator Mundi.*
c. 1490. Palazzo Ducale, Urbino.

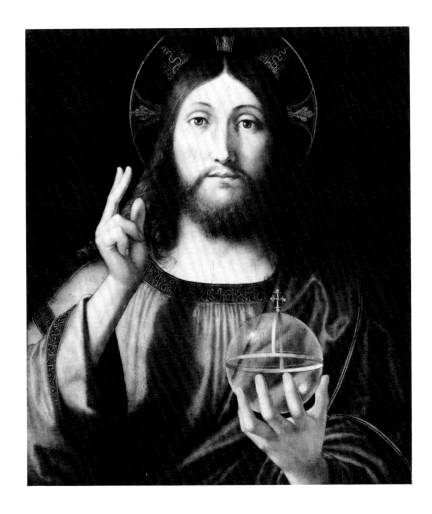

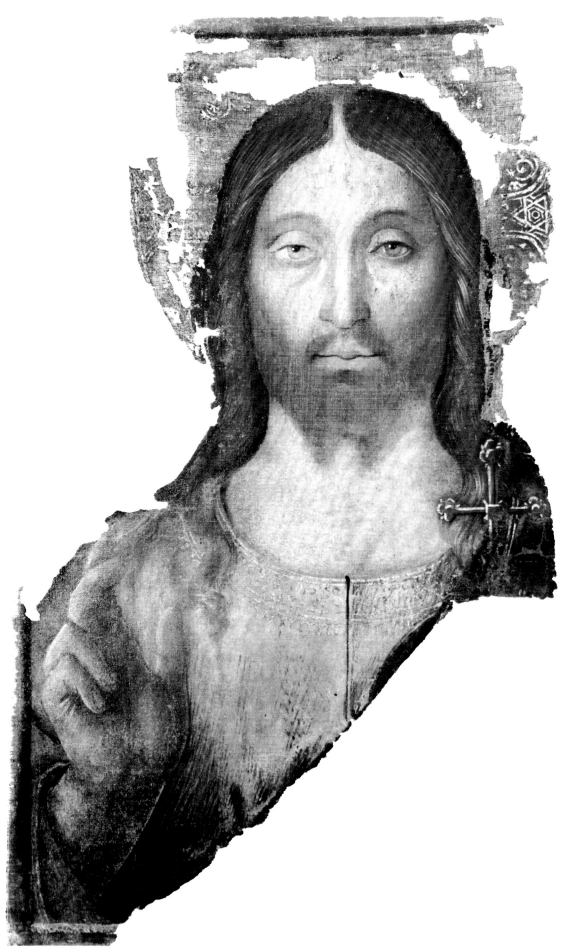

In addition there is yet another type of *Salvator Mundi* composition exemplified by Melozzo da Forlì's painting from the late fifteenth century now in the Palazzo Ducale in Urbino (fig. 83) in which the single figure of Christ is represented in a "close-up" image indicative of the private devotional usage for which the painting was intended. Sixten Ringbom, in discussing the change of format of the *Salvator Mundi* theme at this time, states: "The gesture of blessing is addressed towards the beholder, and the delicate atmosphere of the representation creates an intimacy between the beholder and the subject entirely absent in the conventional, hieratic Salvator Mundi."[43] Both types, the Venetian and da Forlì's, demonstrate their mutual dependence on a Netherlandish prototype, but da Forlì interprets the head of Christ in an iconic manner, full of majesty and grandeur that faintly echo its Byzantine ancestry, even while the Savior's visage is ameliorated by a Renaissance sense of humanity and compassion. It is the same interpretation which characterizes the *Salvator Mundi* by Leonardo da Vinci, and Heydenreich considers the painting by Melozzo da Forlì to be Leonardo's immediate stylistic prototype, noting the broad accord between them in the elongated proportions of the head and the bridge of the nose, in the portrayal of the eyes and the gaze, in the long locks of hair falling as far as the chest and in the shape of the beard.[44] However, iconographical elements not found in da Forlì's presentation have been incorporated into that of Leonardo's, as set forth previously.

This brief tracing of the development of the *Salvator Mundi* theme brings us face to face with the iconic representation by Leonardo in the collection of the Marquis de Ganay in Paris. It is an image painted in the manner of the icon and for similar purposes: the devotion and veneration of the divine person of the Savior. The language of the icon speaks to the viewer of the ineffable: through the brilliance of its color, through its symbolic imagery, and through its revelation of the realm of the Divine. It is a language, and as with all others, its vocabulary must be learned in order to fully comprehend its message.

The *Salvator Mundi* by Leonardo da Vinci is an image painted for a specific *locus* and purpose, and must be approached by the viewer with this in mind. It was not a commission for a human portrait, such as the *Mona Lisa* or the *Lady with the Ermine*, or for a mythological subject as was the *Leda*, but for a divine portrait—the Holy Face of Christ in the long iconic tradition flowing from the fountainhead of the *Mandylion* and *Keramidion* of Edessa, the *acheiropoeta*, "images not made by human hands." That Leonardo was so successful in making visible the invisible in the *Salvator Mundi* brings to mind Vasari's words in his Life of the artist:

The greatest gifts are often seen, in the course of nature, rained by celestial influences on human creatures; and sometimes, in supernatural fashion, beauty, grace, and talent are united beyond measure in one single person, in a manner that to whatever such a one turns his attention, his every action is so divine, that, surpassing all other men, it makes itself clearly known as a thing bestowed by God (as it is), and not acquired by human art. This was seen by all mankind in Leonardo da Vinci...and so great was his genius, and such its growth, that to whatever difficulties he turned his mind, he solved them with ease.[45]

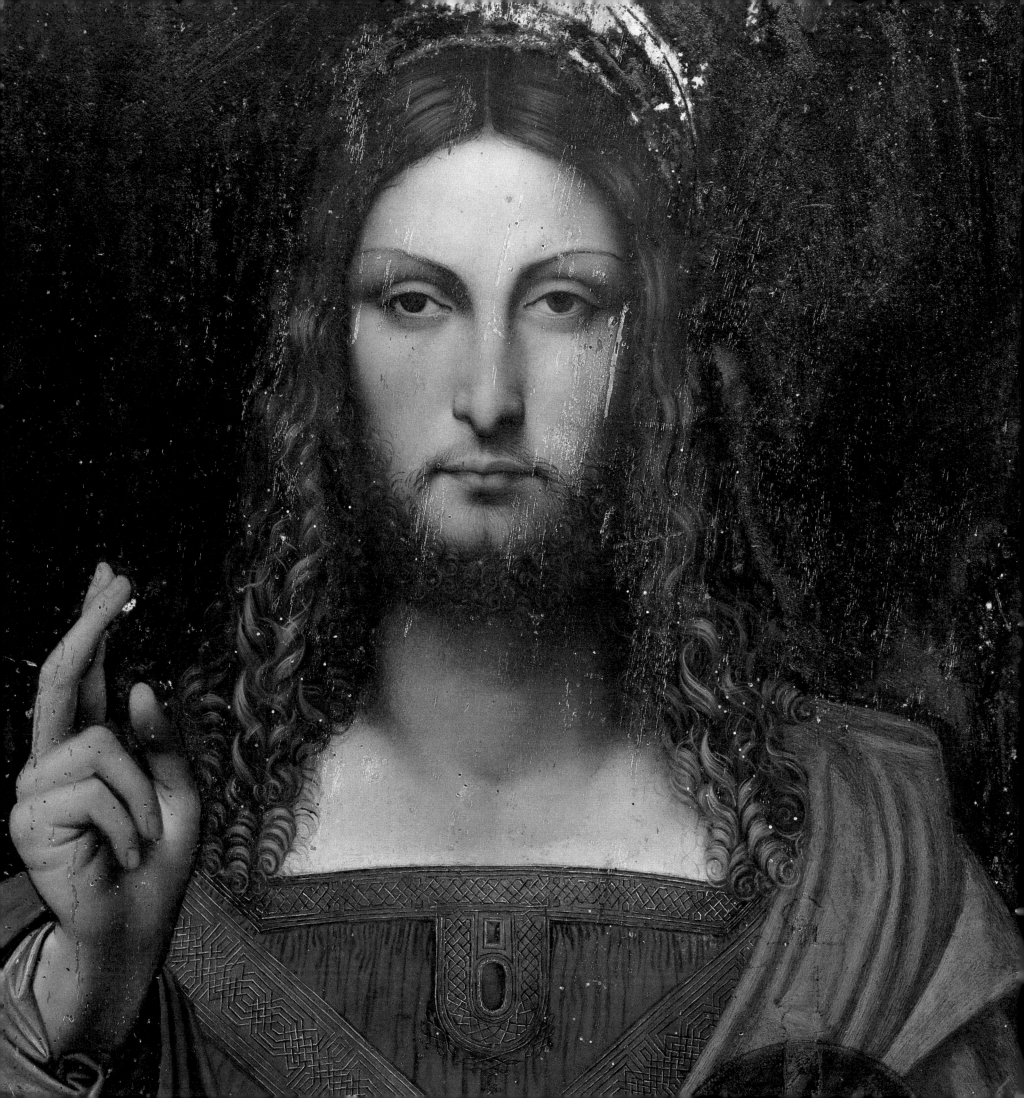

1452

Leonardo born on 15 April in Vinci, near Empoli.

c. 1468

Leonardo apprenticed to Andrea del Verrocchio, leading master in Florence.

1472

Leonardo registered in Painters' Guild but remains with Verrocchio.

1476-82

Leaves Verrocchio and becomes an independent master. Remains in Florence.

1482-99

Departs Florence to serve at court of Lodovico Sforza (Il Moro), Duke of Milan, beginning first Milanese period. Serves as court painter and military engineer.

1483

Begins *Virgin of the Rocks* now in The Louvre, Paris.

1495-97

Paints the *Last Supper* on wall in Refectory of Convent of Sta. Maria delle Grazie.

1499

Expulsion of Sforza Il Moro by Louis XII, King of France, and French army.

1500

Leonardo returns to Florence.

1502

Enters service of Cesare Borgia as military engineer.

1503

Commissioned by Signoria to paint *Battle of Anghiari* in Palazzo Vecchio; fresco never completed. Begins *Mona Lisa*.

1505

Near-fatal illness of Louis XII in Paris.

1506

Leonardo's second Milanese period begins upon return to Milan at invitation of Louis XII. Active at court of Charles d'Amboise, the French Governor of Milan.

1507

Louis XII in Milan with Jean Perréal, his court painter. Leonardo appointed painter and engineer to the King.

c. 1507-08

Commission for the *Salvator Mundi* given to Leonardo by Louis XII.

c. 1510

Preliminary drawings in red chalk on red prepared paper for a *Salvator Mundi*, now at Windsor Royal Library, begun.

1510-13

Salvator Mundi in Leonardo's studio in Milan. Copies made by pupils in various stages of completion.

1513, Spring

Salvator Mundi completed by Leonardo by order of Louis XII. Given to French general for delivery to Louis XII in France.

1513

14 September, peace treaty between French and Swiss. French forced to forfeit rights to the Duchy of Milan.

24 September, Leonardo leaves Milan for Rome for a 3-year sojourn. During Roman period, works on *Saint John the Baptist*.

1514

9 January, Anne of Brittany, beloved wife of Louis XII, dies at Blois. The King presents Leonardo's *Salvator Mundi* to a Franciscan convent of the Order of Saint Claire in Nantes as votive funerary offering for her soul. Painting remains cloistered until late 19th-early 20th century.

1515

1 January, Louis XII dies, succeeded by Francis I.

1516

Leonardo leaves Rome for France at invitation of Francis I, who appoints him "First Painter, Architect and Engineer to the King."

1519

2 May, Leonardo dies in the Château de Cloux at Amboise.

1650, Fall

Henrietta Maria, Dowager Queen of England and widow of Charles I, commissions Wenceslaus Hollar, Bohemian etcher, to copy Leonardo's *Salvator Mundi* in convent in Nantes.

late 19th-early 20th century

Salvator Mundi sold to the Baron de Lareinty of Paris by convent in Nantes upon its dissolution.

1902

The Comtesse de Béhague purchases the *Salvator Mundi* through the Paris art dealer Bourdariat from the Baron de Lareinty.

1939

Death of the Comtesse de Béhague. *Salvator Mundi* inherited by her nephew, the Marquis Hubert de Ganay.

1974

Death of the Marquis Hubert de Ganay. *Salvator Mundi* inherited by his son, the Marquis Jean Louis de Ganay, present owner of the painting.

1

1. In the holdings of the British Museum there is an impression of the uninscribed etching (BM #36646) which may be the same one referred to by Gustav Parthey in *Nachträge und Verbesserungen zum Verzeichnisse der Hollar'schen Kupferstiche* (Berlin, 1857), *sub numero*, 217, p. 631. (Hereinafter references to Parthey, *Nachträge...* will be thus: Parthey, *Nachträge, sub numero*, 217.) The partially inscribed second series of prints is represented here by fig. 2, the impression in the Royal Library, Windsor Castle. The third series of prints is known to me only from the reference in Gustav Parthey, *Wenzel Hollar. Beschreibendes Verzeichniss seiner Kupferstiche* (Berlin, 1853), *sub numero*, 217, p. 39. (Hereinafter, all references to Parthey, *Wenzel Hollar...* will be thus: Parthey, *Hollar, sub numero*, 217.) It should be mentioned that while John 14:6 is a verse suitable to a *Salvator Mundi*, it does not include the words *"Venite ad me"* ("Come unto Me"), which are found rather in Matthew 11:28. It is suggested that the reference to *"Joh. 14, v. 6"* was intentionally added by Hollar to call attention to another appropriate Biblical quotation in addition to that inscribed in full on the plate. The following explanation is offered for the three different states in which the Hollar etching appeared: the state completely without an inscription was intended for his original patron, who would neither have required nor desired a reference; the immediately subsequent and partially inscribed copies were intended for a small and knowledgeable group who, while they would have required identification of the original artist and the etcher, certainly would not have needed explication of the subject matter; and the final version was intended for general public distribution where such an exposition might have seemed desirable.

2. For a study of the significant copies connected with Leonardo's school, including a comparison between them and the Hollar etching, see Ludwig H. Heydenreich, "Leonardo's *Salvator Mundi*," *Raccolta Vinciana* 20 (1964), pp. 83-109. I am also indebted to this work for a comparison of picture sizes which supports the view of a common prototype. The sizes of the paintings in centimeters are: Zürich, 63.5 x 49.5; Detroit, 66 x 48.3; Richmond, 63.2 x 44.5; Warsaw, 63 x 50; and Worsey, 62.5 x 48.4; giving an average of 63.6 x 48.1 cm. By comparison the Paris painting measures 68.3 x 48.6 cm.

3. Heydenreich, "Salvator Mundi," p. 105, n. 33.

4. Eugène Müntz, *Leonardo da Vinci: Artist, Thinker, and Man of Science*, 2 vols. (New York, 1898), vol. 2, pp. 243-44.

5. Letter to the author from the Detroit Institute of Arts, dated 26 January 1972.

6. W. R. Valentiner and William E. Suida, *Leonardo da Vinci Loan Exhibition*, Los Angeles County Museum, Los Angeles, 1949, pp. 24, 85-86.

7. Wilhelm Suida, *Leonardo und sein Kreis* (Munich, 1929), p. 293.

8. In addition to the above views on the Detroit painting, I am indebted to Mr. Burton B. Fredericksen, Curator of Paintings of the J. Paul Getty Museum in Malibu, who has conducted extensive research on it, for conveying his present opinions: 1) the painting referred to in the inventory of Père Dan is not the Detroit painting but rather is a painting at Nancy (inv. 28); 2) the artist of the Detroit painting is more likely an "as yet unidentifiable member of Leonardo's circle active very early in the sixteenth century. He would seem to have been Italian, probably Milanese" (Letter to the author dated 26 April 1982).

9. Kenneth Clark, *Leonardo da Vinci, An Account of his Development as an Artist*, 2nd ed. rev. (Middlesex, 1967), pp. 139-42.

10. Kenneth Clark, *The Drawings of Leonardo da Vinci in the Collection of Her Majesty the Queen at Windsor Castle*, 2nd ed. rev. with the assistance of Carlo Pedretti, 3 vols. (London, 1968-69), *sub numero*, 12524. (Hereinafter, "Clark, *Windsor Catalogue*.")

11. Heydenreich, "Salvator Mundi," pp. 99, 109.

12. *Ibid.*, p. 98, translation mine.

13. *Ibid.* When writing these words in 1964 Professor Heydenreich had not yet had the opportunity of viewing the de Ganay *Salvator Mundi*. After doing so and noting the similarity between the omega tucks in Windsor 12525 and that painting, he reassessed his opinion and expressed to me his conclusion that the Hollar etching and the Worsey *Salvator Mundi* were based on the same original painting but that the Worsey artist had borrowed heavily not only from Windsor 12524 but also from a more detailed drawing, if not a complete cartoon now lost to us, which Leonardo had prepared for his *Salvator Mundi*, a cartoon which found its ultimate expression in the de Ganay painting.

14. Clark, *Windsor Catalogue, sub numero*, 12525.

15. Ernst H. Gombrich, *Art and Illusion* (Princeton, 1969), p. 334. For various possible interpretations of armorial bearings, see Vicente de Cadenas y Vincent, *Diccionario Heraldico* (Madrid, 1954), pp. 210, 268.

16. Heydenreich, "Salvator Mundi," p. 102, after studying these copies suggests the *"Stilphase des zweiten Mailänder Aufenthaltes (1507-1513)."* Wilhelm Suida, in *Leonardo und sein Kreis*, pp. 139-40, discusses the young blessing Christ holding a globe now at the Borghese, a variant of the more mature versions of the *Salvator Mundi*, and suggests for it a date *"zwischen dem Damenporträt mit dem Hermelin (Krakau) und dem Engel (nur in Kopien als Johannes der Täufer erhalten) und Johannes dem Täufer (Louvre) mitten inne steht, ohne in äusserlicher Weise von einem der uns bekannten Werke abhängig zu sein,"* and later in the same paragraph points out that the copy of Leonardo's *Salvator Mundi* in the Galerie Czernin in Vienna is itself dated 1511.

Chapter 1 cont.

17. Cf. Jean Porcher, *Anne de Bretagne et son Temps*, Musée Dobrée, Nantes, 1961, pl. 21, cat. no. 64, and description p. 36.

18. Jean Godefroy, ed., *Lettres du Roy Louis XII et du Cardinal George d'Amboise*, 4 vols. (Brussels, 1712), vol. l, p. 3.

19. Pierre L. Roederer, *Louis XII et François Ier, ou mémoires pour servir à une nouvelle histoire de leur règne*, 3 vols. (Paris, 1825-33), vol. l, p. 383. Cf. François Fénelon, *Oeuvres de Fénelon-Dialogues des Morts LXI. Louis XI et Louis XII* (Paris, 1826), pp. 286-389.

20. See François Gebelin, *La Sainte-Chapelle et la Conciergerie* (Paris, n.d.), pp. 12-31 for mention of the trumeau statue (now restored) and a lengthy description of the major remodelling of Sainte-Chapelle under Louis XII, including the construction of a large staircase leading directly from the courtyard to the upper level where, *"Un Christ Benissant, tenant un globe de la main gauche, decorait le trumeau."*

21. For a discussion of the interior decorations see *ibid.*, pp. 34 ff.

22. Jacques du Bruel, *Théâtre de Antiquitez de Paris* (Paris, 1639), pp. 393-94. Cf. Jean d'Auton, *Chroniques de Louis XII*, 4 vols. (Paris, 1891), vol. 2, pp. 219-28, 398-99.

23. L. Merlet and M. de Gombert, *Recit des funerailles d'Anne de Bretagne* (Chartres, 1858), p. xxvi, n. 1, state: *"Pour récompenser les dames d'une conduite irréprochable, elle introduisit à la cour de France l'ordre de la Cordelière, fondée par la duchesse Marguerite, première femme de François II, en mémoire des cordes dont Jésus-Christ fut lié dans sa Passion."* (Hereinafter, "Merlet-de Gombert, *Recit*.") Cf. du Bruel, *Théâtre de Antiquitez*, p. 399.

24. du Bruel, *Théâtre de Antiquitez*, p. 399. Cf. Porcher, *Anne de Bretagne*, pl. 15, cat. no. 52, and description on p. 31. It is interesting to note the correspondence between this cord motif and that employed by Leonardo in the decorative embroidery on the crossed stole worn by Christ in the *Salvator Mundi*.

25. Pierre de Bourdeille Brantôme, *Vies des Dames Illustres, Françoises et Etrangères*, ed. Louis Moland (Paris, 1868), p. 9.

26. Merlet-de Gombert, *Recit*, pp. 30, 34.

27. Porcher, *Anne de Bretagne*, pl. 1, cat. no. 47, p. 53, and description on pp. 27-28.

28. Merlet-de Gombert, *Recit*, p. 29, n. 3: *"Sur le destre estoit le sceptre, et sur le senestre la main de justice ou de miséricorde, comme on la vouldra nommer."* Cf. Porcher, *Anne de Bretagne*, description on p. 25.

29. Rüdiger R. Beer, *Einhorn, Fabelwelt und Wirklichkeit* (Munich, 1972), p. 120; or *idem, Unicorn: Myth and Reality*, trans. Charles M. Stern (New York, 1977), pp. 139-40.

30. Jürgen W. Einhorn, *Spiritalis Unicornis: Das Einhorn als Bedeutungsträger in Literatur und Kunst des Mittelalters* (Munich, 1976), *passim*.

31. Marie Thérèse Barrelet, Gérard Hubert and Pierre Rosenberg, eds., *The Louvre Museum, General Guide*, trans. Heather Greig (Paris, n.d.), p. 124.

32. Cyprien Monget, *La Chartreuse de Dijon, d'après les documents des archives de Bourgogne*, 3 vols. (Montreuil-sur-mer, 1901), vol. 2, pp. 206-07. For a complete description of manuscripts, works, and paintings referring to the Miraculous Host, see Pierre Quarré, *La Sainte-Chapelle de Dijon* (Dijon, 1962), p. 10, cat. nos. 69, 72, 105, 106, 116-24, pp. 35-54 *passim*, and pls. 4-7.

33. Godefroy, *Lettres*, p. 43. For a complete account of this meeting, see *ibid.*, pp. 43-51, and for a further account of Louis XII's illness, see d'Auton, *Chroniques*, vol. 4, pp. 1 *et seq.*

34. That Louis XII was completely aware of the disaster he had averted is evidenced by a letter from him to the Sieur de Chievres dated 31 May 1506 and printed in its entirety in Roederer, *Louis XII et Françoise Ier*, vol. 1, pp. 435-37. For the background feud which was responsible for the original engagement of Claude and Charles, see Louis Batiffol, *Le Siècle de la Renaissance* (Paris, 1909), pp. 30-32.

35. Heydenreich, "Salvator Mundi," p. 84.

36. For examples, see *The Très Riches Heures of Jean, Duke of Berry, Musée Condé*, Chantilly, trans. Victoria Benedict (New York and Paris, 1969), pls. 34, 37, 59, 92, 102, and in particular, pl. 130.

37. See the portion of the letter of Giovanni Valla, the agent of Ercole I d'Este, Milan, 24 December [September] 1501, as translated by Ludwig Goldscheider in *Leonardo da Vinci the Artist* (London and New York, 1944), p. 17. Cf. Luca Beltrami, *Documenti e memorie riguardanti la vita e le opere di Leonardo da Vinci in ordine cronologico* (Milan, 1919), no. 112.

38. d'Auton, *Chroniques*, vol. 4, p. 293, n. 1. Cf. M. Cermenati, "Le roi qui voulait emporter en France, la Cène de Léonard de Vinci," *Nouvelle Revue d'Italie* (Rome, 1919).

39. Letter of Fra Pietro de Novellara to Marchesa Isabella d'Este, 4 April 1501, in Goldscheider, *Leonardo the Artist*, p. 19. Cf. Beltrami, *Documenti*, no. 108.

40. Ludwig H. Heydenreich, *Leonardo da Vinci*, 2 vols. (New York, 1954), vol. 1, pp. 13-15.

41. For a translation of the entire text of this letter, see Goldscheider, *Leonardo the Artist*, pp. 19-20. Cf. Beltrami, *Documenti*, no. 183.

42. Etienne Delécluze, *Saggio intorno a Leonardo da Vinci* (Siena, 1844), p. 127. Cf. Beltrami, *Documenti*, no. 184.

43. Delécluze, *Saggio*, p. 128. Cf. Beltrami, *Documenti*, no. 189.

44. Beltrami, *Documenti*, no. 189. Cf. Francesco Savorgnan di Brazzà, *Gli Scienziati Italiani in Francia* (Rome, 1920), p. 19.

45. Jean Paul Richter, *The Literary Works of Leonardo da Vinci*, 2 vols. (London, 1883), vol. 1, *sub numero*, 1349. Cf. Gerolamo Calvi, *I manoscritti di Leonardo da Vinci dal punto di vista cronologico, storico e biografico* (Bologna, 1925), pp. 264 ff.

46. Richter, *Literary Works*, vol. 2, *sub numero*, 1529. Cf. Beltrami, *Documenti*, no. 207, indicating that Leonardo was both conscious and appreciative of the rewards which he had received at the hands of the King when he wrote during this period 1510-11, *"Questo Sua Maestà sa che quel dà a me ei lo toglie a sè."*

47. d'Auton, *Chroniques*, vol. 2, p. 386 and n. 3, p. 386. Cf. Beltrami, *Documenti*, no. 206.

48. Carlo Amoretti, *Memorie Storiche di Leonardo da Vinci* (Milan, 1804), pp. 96-98. Cf. Richter, *Literary Works*, vol. 2, *sub numero*, 1566, for a copy of Leonardo's entire will.

49. For an extensive eyewitness account of this event, see d'Auton, *Chroniques*, vol. 4, pp. 283-94.

50. For a discussion of this Book of Hours by Gerard Horenbout, see Friedrich Winkler, "Neuentdeckte Altniederländer II," *Pantheon* 31 (March, 1943), pp. 55-64.

51. Notable here is the fact that for the exhibition of the Leonardo Collection of the late Comtesse de Béhague held at the Henry Art Gallery at the University of Washington in Seattle from 6 November 1982 to 16 January 1983, a replica to scale of the triptych and altar seen in the illumination of King James IV were made to display Leonardo's *Salvator Mundi* in its original context. It was considered paramount for the viewer of the exhibition to be able to see the *Salvator Mundi* in the artistic and religious milieu for which it was originally commissioned. The carving of the triptych and the dual coat-of-arms of Louis XII and Anne of Brittany (in place of that of the Scottish King) on the altar frontal was made by Roberto Tacchi, a native Florentine carver living in Seattle. The altar was constructed by Albert Baab and Ransom-Baab Co., also of Seattle.

52. Leslie Stephen, ed., *Dictionary of National Biography*, 66 vols. (New York, 1885-1901), vol. 10, pp. 588-89. Cf. Merlet-de Gombert, *Recit*, p. 107.

53. That Louis must have anticipated serious problems with the Swiss as early as June 1512 is amply borne out by the fact that according to a contemporary account, the fortifications of Dijon in Burgundy were reinforced *"pour soy en ayder et servir en cas de nécessité et éminent peril"* (Monget, *La Chartreuse de Dijon*, p.208). Louis' problems in this area were brought on by a concatenation of unfortunate circumstances. His leading general, Gaston de Foix, was killed at Ravenna, the Holy Roman Emperor Maximillian deprived the French King of the continued use of German mercenary troops, and the Swiss introduced 18,000 new men into the fight against him. See Mark J. Zucker, "Raphael and the Beard of Pope Julius II," *The Art Bulletin* 59, no. 4 (Dec., 1977), p. 530.

54. It is of interest to note that exactly two years later to the day, the French forces under Louis' successor, Francis I, triumphed over the Swiss forces at the Battle of Marignano and regained the Duchy of Milan. For an eyewitness record of this battle, see my "Pasquier Le Moyne's 1515 Account of Art and War in Northern Italy: A Translation of His Diary from *Le couronnement*," *Studies in Iconography* 5 (1979), pp. 208-19.

55. Richter, *Literary Works*, vol. 2, *sub numero*, 1465. For a brief account of this period in French history, see Monget, *La Chartreuse de Dijon*, pp. 208-14 and Batiffol, *Renaissance*, pp. 33-37.

56. Batiffol, *Renaissance*, pp. 40-41; and Nathaniel William Wraxall, *The History of France Under the Kings of the Race of Valois*... (London, 1785), pp. 179-82; both stress the complete dissolution of Louis XII on the death of his wife after her illness of only ten days. The King's grief was so deep and long-lasting that even at the marriage of his daughter, Claude, to the future Francis I on 18 May 1514, more than five months after Anne's death, not only the attendants but also both the bride and groom were dressed in black. Although Louis XII remarried on 9 October 1514, because of his desire for an heir, the nuptials were celebrated without any ostentation and the King died less than three months later on 1 January 1515, his health ruined by the unconsolable grief for the loss of Anne.

57. Etienne Catta, *La Visitation Sainte-Marie de Nantes, 1630-1792* (Paris, 1954), pp. 23-26.

58. Merlet-de Gombert, *Recit*, p. ix.

59. *Ibid.*, p. xxiii.

60. The history of the disposition of Anne's heart commences over three months after her death when it was placed on Sunday the 13th of March in the middle of the choir of the church of the Charterhouse in Nantes atop the tomb of her great-uncle Arthur III, Duke of Brittany, who had immediately preceded her father in the dukedom. It remained there in state and was afforded many honors until the 19th of the month when it was translated with due ceremony to the choir of the Cathedral of Nantes, the walls of which were draped in black velvet, where it was placed in the Royal Funerary Chapel. Among the decorations of this area were included double crowns of gold signifying her dual queenship of France (as bride of both Charles VIII and later of Louis XII) that were linked by the knot of the Cordelière, the order which she had introduced to the Court. In addition there appeared two arms clad in gold, one of which held the scepter and the other the *Main de Justice*. After Mass had been said, a sermon preached and a plea made for the salvation of her soul, her heart was taken down into the crypt beneath the Royal Funerary Chapel and was placed between the lead coffins of her mother and father. It remained there until 1792 when the gold reliquary which had housed it was destined for the melting pot—only to be spared and placed in storage in the Bibliothèque Royale of the city of Nantes in 1819 (Merlet-de Gombert, *Recit*, pp. 93-106. Cf. Porcher, *Anne de Bretagne*, pp. 27-28).

61. Merlet-de Gombert, *Recit*, p. 110: *Et le landemain, Messeigneurs les frères de la frarye de la Véronnique, de laquelle frarye estoit la dicte dame, en laquelle frarye n'est receu femme de quelque estat qu'elle soit, sinon leur princesse et dame souveraine du pays.... Et estoit l'esglise, chappelle ardant, le tout paré comme les jours précédans. Et dist la messe le dict arcevesque de Dol, et n'y trouvé aucune différence, sauf que les torches de la frarye estoient armoyées d'une Véronne et face de Jhésu-Crist, et aussi d'un escu aux armes de la dicte dame.*

For the important connection between the Veronica and the *Salvator Mundi* image type, see Chapter 5, *infra*.

62. Heydenreich, "Salvator Mundi," p. 104.

63. Parthey, *Hollar, sub numero*, 1604, 1609.

64. *Ibid., sub numero*, 1771.

65. Heydenreich, "Salvator Mundi," p. 104. For commentary on the Arundel Collection, see Lionel Cust, "Notes on the Collections Formed by Thomas Howard, Earl of Arundel and Surrey, K.G.," *The Burlington Magazine* 19, no. 101 (August, 1911), pp. 278-86 and addendum, pp. 323-25; vol. 20, no. 106 (Jan., 1912), pp. 233-36; vol. 20, no. 108 (Mar., 1912), pp. 341-43; vol. 21, no. 113 (Aug., 1912), pp. 256-58. Cf. Mary Hervey, *The Life, Correspondence and Collections of Thomas Howard, Earl of Arundel* (London, 1921).

1. Hollar's proposed trip to Italy to participate in the celebration of the Jubilee Year of 1650 in Rome is outside the scope of the present study, but the documentary evidence is in preparation for future publication.

2. Ms. Aubrey 6, fol. 26. Mr. D.S. Porter, the Senior Assistant Librarian in the Department of Western Manuscripts of the Bodleian Library, Oxford, has kindly researched this manuscript at my request and confirmed the date as 1649 rather than 1652, which at times has been cited in error.

3. For this view, which even hints at a diplomatic role for Hollar, and for a suggested bibliography covering the period of Hollar's working life (including information outside the scope of this study), see Katherine S. Van Eerde, *Wenceslaus Hollar—Delineator of His Time* (Charlottesville, 1970), especially pp. 41-42 and 111-15.

4. Keith Brown, in "The Artist of the *Leviathan* Title Page," *British Library Journal* 4 (1978), pp. 29-30, states: *[It] is of interest that for a period running at least from the execution of Charles I to his son's defeat at Worcester, Hollar is thought to have been consciously courting the favour of the Prince. Although he had made his home in Holland during the Civil War years, it has been asserted that he joined the Royalists in the Channel Islands for awhile around 1650, and the most recently published study of his work accepts that there are reasons for suspecting that when he later returned to England he did so as a clandestine Royalist courtier. Hollar, in touch with Royalist circles, thus may have passed through France at a suitable time, and Hobbes could in any case have easily enough made contact with him even when in Holland, either by a personal visit or via intermediaries. For although Hobbes himself was living among the English exiles in Paris, his admirer Sorbière, for example, seems to have brought out editions of his master's work indifferently in Holland or Paris as convenience served, and there was always ample communication between the English Royalists in both countries. In short, there seems to be no practical obstacle to postulating that Hobbes was making use of Hollar's services some time around 1650-1, and it appears that Hollar would have had reasons of his own for taking particular interest at that time in any commission destined for the young Charles II. He would also have been well placed, had Hobbes so wished, to borrow the features of the young Prince for his representation of the Moral God. The presentation copy is today in the British Library.*

5. John Aubrey, *Letters Written by Eminent Persons in the Seventeenth and Eighteenth Centuries*... (London, 1813), no. 2, part 2, pp. 400-02, transcribing Aubrey's short biography of Hollar.

6. John Evelyn, *Sculptura; or, the History and Art of Chalcography, and Engraving in Copper*... 2nd ed. (London, 1755), pp. 78-79.

7. John Evelyn, *The Diary of John Evelyn*, ed. E. S. de Beer (London, 1959), pp. 17-18.

2

8. Samuel Pepys, *The Diary of Samuel Pepys...*, ed. Henry B. Wheatley, 10 vols. (London, 1924), vol. 2, p. 106, n. 2; vol. 6, p. 68, and ns. 1 and 2, p. 334 and n. 1.

9. George Vertue, *A Description of the Works of the Ingenious Delineator and Engraver Wenceslaus Hollar, Disposed into Classes of Different Sorts; with Some Account of His Life*, 2nd ed. (London, 1759).

10. *Ibid.*, p. 144.

11. Vertue, *Wenceslaus Hollar*, pp. 144-45, which provides a rather free English translation of this subscription. Cf. Gustav Parthey, *Wenzel Hollar. Beschreibendes Verzeichniss seiner Kupferstiche* (Berlin, 1853), *sub numero*, 1419.

12. Vertue, *Wenceslaus Hollar*, p. 145.

13. Horace Walpole, *Anecdotes of Painting in England; with Some Account of the Principal Artists; and Incidental Notes on Other Arts...*, 4 vols. (London, 1762-71).

14. Horace Walpole, *Anecdotes of Painting in England; with some Account of the Principal Artists...with Additions by the Rev. James Dallaway; A New Edition, Revised, with Additional Notes by Ralph N. Wornum*, 3 vols. (London, 1849), vol. 3, p. 888.

15. Parthey, *Hollar*, pp. vi, vii.

16. Parthey, *Hollar, sub numero*, 610-13. This series is represented by several states, the first of which was apparently prepared for the British market, as no. 610 bears English subtitles and the notation *W. Hollar inventor et fecit Londini A. 1641*, but no printer's or publisher's name. As these plates were after original drawings by Hollar himself, they would have been his property; and it is possible that when he fled England in the next year that he took them with him and kept them in his possession until he finally found a publisher in France.

17. Parthey, *Hollar, sub numero*, 172.

18. Parthey, *Hollar, sub numero*, 2041-52. That this series found popular success on the continental market is evidenced by the fact that a copy of it was published in Augsburg by Jeremiah Wolff.

19. Parthey, *Hollar, sub numero*, 1346. The first state dated 1647 apparently was not widely published as it bears no printer's mark; Hollar may well have retained the plate himself and altered it for the French market.

20. Parthey, *Hollar, sub numero*, 1418, 1420 (d). The former bears the subscription *"A Paris chez Odieuvre"* and would appear to be the fourth state of Hollar's copy after Holbein's self-portrait. The first was incorporated in an edition of Erasmus' *In Praise of Folly;* the second, dated 1647, bears no printer's mark, but has the notation *"ex Collec: Arundel";* the third has a notation that it was printed by "F. de Wit." The date of 1647 on the second state establishes a *terminus post quem* and as the third state indicates some lapse of time before the Paris printing of the fourth state, it does not seem unreasonable to assign the latter a date of around 1650.
Number 1420 (d), having the same Parisian provenance, is one of eight states of Hollar's own self-portrait, one of which, state (f), is dated and which bears the same date of 1647 as does the second state of number 1418, Hollar's copy after Holbein. For a suggested dating to 1650 of the Paris printing of a Hollar self-portrait from another original, see n. 21 *infra*.

21. Parthey, *Hollar, sub numero*, 233-62; Vertue, *Wenceslaus Hollar*, pls. 12-41. Vertue states "Abr. a Diepenbecke inv. the Decorations and Borders" and assigns the date of 1651. While this may be true of the ultimate printing, I prefer a date of 1650 for the initial state "before the initials of Holbein and of Hollar," (cf. Gustav Parthey, *Nachträge und Verbesserungen zum Verzeichnisse der Hollar'schen Kupferstiche* (Berlin, 1857), *sub numero*, 233-62) which found its way into the collection of the Duke of Buckingham. Inasmuch as the young George Villiers was in Paris at this time, he could easily have acquired it there then. That Hollar's self-portrait, published by Odieuvre, was intended as a frontispiece for Holbein's *Dance of Death* is suggested by the statement in a note to Parthey, *Hollar, sub numero*, 1420, that a copy of this etching exists bearing the inscription *"The Dance of Death painted by H. Holbein and engraved by W. Hollar."*

22. Parthey, *Nachträge, sub numero*, 1354, 1367, 1408, 1442, 1455, 1463. Plates were usually scraped and re-used at this time rather than kept, as the copper in the plates was worth far more than the etcher's work on them. Aubrey, *Eminent Persons*, p. 401-02, mentions a fee of sixpence a print for Hollar where elsewhere a price of from two to three pounds is quoted as the cost of a plate.

23. Parthey, *Nachträge, sub numero*, 1367, 1408, 1455.

24. Parthey, *Nachträge, sub numero*, 1442.

25. Parthey, *Hollar, sub numero*, 1354 and *idem.*, *Nachträge, sub numero*, 1354. While I have been unable to place the Countess of Arundel in Paris at this time or find any record of Matthew, it is known that one of her sons was in that city in 1650.

26. Parthey, *Hollar, sub numero*, 1463. The only linkage I can find between this portrait and Hollar would be his conversion to Catholicism in Antwerp, which may have been influenced by his reading of Malderus' texts. Hollar may have taken the plate to Paris with him for personal reasons or it may have reached there by another route. To say more at this time would be pure guesswork.

27. Parthey, *Hollar, sub numero*, 1396.

28. Leslie Stephen and Sidney Lee, eds., *Dictionary of National Biography*, 22 vols. (Oxford, 1973), vol. 6, p. 651.

29. Edward Nicholas, *The Nicholas Papers*, 4 vols. (New York, 1865), vol. 1 pp. 190-91.

30. *Ibid.*, p. 190.

31. I am deeply indebted to the Duke of Northumberland, owner of this painting, for graciously arranging to have this photograph made especially for reproduction in this publication.

32. Nicholas, *Papers*, vol. 1, pp. 198-200.

33. Etienne Catta, *La Visitation Sainte-Marie de Nantes, 1630-1792* (Paris, 1954), p. 216 and n. 4, p. 216.

34. *Ibid.*, p. 16.

35. *Ibid.*, p. 216.

36. *Ibid.*, pp. 25-26.

37. *Ibid.*, p. 23.

38. That no special dispensation for a visit to a convent of the Clairician Order would have been required in any case is suggested by a sojourn made at a convent of that order in Bosleduc by John Evelyn on 17 September 1641 (John Evelyn, *Diary*, pp. 33-34).

3

1. For a full discussion of the scientific analysis of paintings, see Madeleine Hours, *Les secrets des chefs-d'oeuvre* (Paris, 1964), published in English as *The Secrets of the Great Masters* (Paris, 1964); *idem., Conservation and Scientific Analysis of Painting*, trans. Anne G. Ward (New York, 1976); and Jacques Maroger, *The Secret Formulas and Techniques of the Masters*, trans. Eleanor Beckham (New York and London, 1948).

2. Cf. Hours, *Conservation*, p. 29.

3. *Ibid*, p. 55.

4. See Madeleine Hours, "Études analytique des tableaux de Léonard de Vinci au laboratoire du Musée du Louvre," *Leonardo: saggi e ricerche*, Libraria dello Stato (Rome, 1954), pp. 16-21, figs. 1, 3, 11. Cf. Jack Wasserman, *Leonardo* (New York, 1980), figs. 39, 42.

5. For a technical analysis of X-radiography examination, see S.J. Fleming, "Physico-chemical Approaches to Authentication," *Authentication in the Visual Arts: A Multidisciplinary Symposium, Amsterdam, 12th March 1977*, eds. H.L.C. Jaffé, J. Storm van Leeuwen, and L.H. van der Tweel (Amsterdam, 1979), pp. 114-25.

6. In her writings, Hours has referred to the support for *Saint John the Baptist* as *"bois fruitier"* (Hours, "Etudes," p. 21).

7. *Ibid., passim*. The *La Belle Ferronnière* at the Louvre is on oak *(bois du chêne) (ibid., p. 22).*

8. Further evidence of the woods usually employed by Italian painters for panels may be found in two references, one prior and the other subsequent to the date of Leonardo's *Salvator Mundi*. Cennino Cennini, writing about 1430, begins: "Now we are really going to paint pictures. In the first place, a panel must be prepared of the wood of the poplar, which is very good *(ben gentile)* or lime tree, or willow" *(The Book of the Art of Cennino Cennini*, trans. Christina J. Herringham (London, 1899), chap. 113, p. 93. Cf. p. 228). Vasari, over a century later, adds in his Lives of the Bellini: "…the last-named picture was painted on canvas, as it has been almost always the custom to do in that city, where they rarely paint, as is done elsewhere, on panels of the wood of that tree that is called by many *oppio* [poplar] and by some *gattice* [white poplar]. This wood, which grows mostly beside rivers or other waters, is very soft, and admirable for painting on, for it holds very firmly when joined together with carpenters' glue" (Giorgio Vasari, *Lives of the Most Eminent Painters, Sculptors and Architects*, trans. Gaston Du C. De Vere, 10 vols. (London, 1912-14), vol. 2, p. 174). It may be repeated here that the panels of both the Louvre *Saint John the Baptist* and the de Ganay *Salvator Mundi* are composed of a single piece of wood and have no need of the joints mentioned by Vasari.

9. Jean d'Auton, *Chroniques de Louis XII*, 4 vols. (Paris, 1891-95), vol. 4, p. 176, n. 1; Jean-Paul Richter, *The Literary Works of Leonardo da Vinci*, 2 vols. (London, 1883), vol. 1, *sub numero*, 1379. Cf. Jean Porcher, *Anne de Bretagne et son Temps*, Musée Dobrée, Nantes, 1961, pp. 5-6.

10. See Ludwig Goldscheider, *Leonardo da Vinci the Artist* (London and New York, 1944), document XVI, p. 20, "The Visit of the Cardinal, Luigi d'Aragona, paid to Leonardo on 10 October 1517…" in which the Cardinal relates his seeing a "youthful *St. John the Baptist*" in Leonardo's studio at Amboise. Cf. Luca Beltrami, *Documenti e memorie riguardanti la vita e le opere di Leonardo da Vinci in ordine cronologico* (Milan, 1919), no. 238. Kenneth Clark, *Leonardo da Vinci, an Account of his Development as an Artist* 2nd rev. ed. (Middlesex, 1967), p. 153, assigns a tentative date to the completion of this painting when he says: "In the same years—1514-15—I would place Leonardo's last surviving picture, the Louvre *St. John….* It is usually said, on no evidence, to have been painted in France, but if this were the case we could hardly account for the numerous contemporary Italian copies. No doubt Leonardo had been working on the subject for years and the actual date of its execution as a picture can never be established." See also Kenneth Clark, *The Drawings of Leonardo da Vinci in the Collection of Her Majesty the Queen at Windsor Castle*, 2nd. ed. rev. with the assistance of Carlo Pedretti, 3 vols. (London, 1968-69), vol. 1, p. liii, in which a date of about 1509 is suggested for the commencement of the Louvre *Saint John*, which would make it contemporary with the date proposed for the de Ganay *Salvator Mundi*.

11. For the penchant for the diptych as "a devotional form especially popular in France," see Colin Eisler's book review, *The Art Bulletin* 63, no. 2 (June, 1981), p. 332.

12. Hours, "Etudes," p. 20.

13. Ludwig H. Heydenreich, "Leonardo's *Salvator Mundi*," *Raccolta Vinciana* 20, pp. 108-09.

14. Hours, "Etudes," p. 21.

15. In Hours, "Etudes," p. 21, she states: "The photograph of a detail of the face of St. John (photo 17) adduces evidence of the extraordinary subtlety of the transitions between light and shade. No trace of the brush stroke is visible in this ultimate accomplishment of Leonardo, which is affected as much by the utmost *délicatesse* of the pictorial layer that includes only a few pigments having any color as by its subtle play of shadow and light" (translation mine).

16. Hours, *Secrets; idem, Les secrets*, p. 18 in both editions.

17. Hours, *Secrets*, pp. 202-03; *idem, Les secrets*, p. 203. In *A la Découverte de la Peinture par les méthodes physiques* (Paris, 1957), p. 110, Hours states: "*Mais cette immatérialité même de Léonard est une signature, qu'aucun de ses imitateurs ou élèves n'a pu atteindre.*"

18. Hours, "Etudes," p. 21, translation mine.

19. For discussions of the technical aspects of the cleaning of paintings, with differing opinions, see Cesare Brandi, "The Cleaning of Pictures in Relation to Patina, Varnish, and Glazes," *The Burlington Magazine* 91, no. 556 (July, 1949), pp. 183-88; Neil Maclaren and Anthony Werner, "Some Factual Observations about Varnishes and Glazes," *The Burlington Magazine* 92, no. 568 (July, 1950), pp. 189-92; and Cesare Brandi, *Teoria del Restauro* (Turin, 1977), pp. 99-121.

20. SYLVAINE BRANS
[signature of]

RAPPORT

ETAT DU TABLEAU:

Vernis très épais et jaune, panneau ayant des galeries de vers, nombreux trous qui étaient repeints et qui peuvent réapparaitre à l'allègement du vernis. Le fond noir semble être un repeint sur toute la surface. Accident au-dessus de la tête du Christ, pouvant être la justification du repeint noir du fond. On discerne cependant une trace d'auréole dorée. Le vêtement bleu serait peut-être un repeint, il semble tout au moins postérieur à l'ensemble de la peinture.

INTERVENTIONS:

Refixage des parties fragiles. Le soulèvement de ces endroits a pu être réduit, mais en raison du manque de place pour les remettre bord à bord en position parfaitement plane, nous n'avons pu que les indurer, aussi la surface présente-t-elle, en de nombreux endroits, des crêtes de pellicule picturale originale. Le dessin est très visible. Allègement du vernis fait entièrement sous microscope. Aucune matière originale n'a pu ainsi être touchée, nous sommes restés à la limite entre le vernis jaune et la patine naturelle. Des repeints, particulièrement au-dessus de la tête du Christ, ont été enlevés avec l'allègement. Seul un vernis à retoucher a été posé après l'allègement du vernis ancien pour permettre une meilleure lecture de la surface picturale. Il peut être enlevé à tout moment.

21. These additions would have to have taken place sometime after the date of Hollar's etching since it does not evidence such features, nor do any of the known painted copies.

22. For commentaries on the colors of the *Last Supper* after restoration, see Arturo Bovi, "La visione del colore e della luce nella Cena," *Raccolta Vinciana* 17 (1954), p. 315; F. Wittgens, "Il restauro del Cenacolo di Leonardo," *Atti del convegno di studi Vinciani* (Florence, 1953), p. 39; John Shearman, "Leonardo's Colour and Chiaroscuro," *Zeitschrift für Kunstgeschichte* 25 (1962), p. 32, ns. 50-56; and Ludwig H. Heydenreich, *Leonardo: The Last Supper* (New York, 1974), pp. 66-67.

23. Heydenreich, *Last Supper*, p. 66.

24. Jack Wasserman, *Leonardo* (New York, 1980), p. 126.

25. That Leonardo was not alone in this area and that there is today a clear directive for a re-evaluation of the Renaissance palette is borne out by the cleaning in progress of Michelangelo's Sistine Ceiling which has revealed this contemporary of Leonardo, despite a widely-held belief to the contrary, also to be a brilliant and bold colorist. This concept is best expressed by the words of Dr. Gianluigi Colalucci, presently chief conservator of paintings at the Vatican: "Michelangelo was in control of a dazzling palette."
To point out the problem of scientifically revealing heretofore unknown characteristics of a major artist and, at the same time, obtaining popular acceptance of them, Professor Carlo Pietrangeli, director general of the Vatican Museum, feels that, in regard to the Sistine Ceiling, "…the radical restoration can be made palatable only if it is done in small doses" (Patricia Corbett, "After Centuries of Grime," *Connoisseur* (May, 1982), pp. 68-75).

26. Anna Maria Brizio, "Leonardo: The Painter," *Leonardo: The Artist* (New York, 1980), p. 58. For a discussion of a "Book on Colors" that Leonardo had intended writing sometime after 1505, see Carlo Pedretti, *Commentary on the Literary Works of Leonardo da Vinci Compiled and Edited from the Original Manuscripts by Jean Paul Richter*, 2 vols. (Oxford, 1977), vol. 1, pp. 203-22.

27. Heydenreich, *Last Supper*, pp. 66-67.

28. Shearman, "Leonardo's Colour," p. 32.

29. See Chapter 1, *supra*.

4

30. Heydenreich, "*Salvator Mundi,*" p. 96, n. 24, translation mine. I am indebted to Professor Heydenreich for stressing to me in person the similarity of the hair in the de Ganay *Salvator Mundi* to not only these other works of Leonardo but to the Hollar etching as well.

31. Richter, *Literary Works,* vol. 1, *sub numero*, 389.

32. These passages were transcribed by Francesco Melzi into the Codex Urbinas Latinus 1270 (now in the Vatican Library) around the 1550s (see, e.g., Ladislao Reti, ed., *The Unknown Leonardo* (New York, 1974), pp. 222-23).

33. *Ibid.,* p. 223. For the suggestion that Leonardo was the first to systematically examine shadow projection in relation to painting, see Thomas Da Costa Kaufmann, "The Perspective of Shadows: The History of the Theory of Shadow Projection," *Journal of the Warburg and Courtauld Institutes* 38 (1975), pp. 267-73.

34. Vasari, *Lives,* vol. 4, pp. 100-01.

35. For a discussion of the light source in the *Mona Lisa,* see Z. Zaremba Filipczak, "New Light on Mona Lisa: Leonardo's Optical Knowledge and His Choice of Lighting," *The Art Bulletin* 59, no. 4 (December, 1977), pp. 518-23.

36. As to the anatomical structure of this hand, it might be of interest to note that it was analyzed, at my request, by Dr. John W. Madden, a world-renowned hand specialist, who concluded that the blessing hand and also the hand holding the globe are both "anatomically correct," and further stated that "The position of the metacarpophalangeal joints of the small and ring finger plus the lengths of the phalanges in these two fingers seem entirely appropriate." In regard to the fingernails on both hands, he stated: "I think they are really quite accurate" (Letter to the author dated 4 April 1979).

37. Vasari, *Lives,* vol. 4, p. 92.

38. *Ibid.,* p. 91.

39. For commentaries on these knot designs, see Willi Kurth, ed., *The Complete Woodcuts of Albrecht Dürer* (1927; reprint ed., New York, 1963), p. 28; Moriz Thausing, *Albert Dürer, sa vie et ses oeuvres* (Paris, 1878), pp. 279-80; Richter, *Literary Works,* vol. 1, *sub numero,* 680, and n. 9; and Pedretti, *Commentary,* vol. 1, pp. 388, 398, 399 and pl. 32.

40. I.e., Ms. 2038, folio 34 verso, and Ms. H. folio 3 recto, in the Bibliothèque Nationale, Paris; in Oxford, Christ Church College; and Windsor 12351 verso in the Royal Library, Windsor Castle. In addition to his usage of the theme in knot designs, Leonardo also has shown a predilection for the employment of a continuous filament both in the verdure of the ceiling of the *Sala delle Asse* in the Sforza Castle in Milan and in the voussoirs and the penetrations on the wall of the sacristy of Sta. Maria delle Grazie in that city.

41. This folio also contains a bird in a cage which is conjoined to various unfinished knot designs. The representation of a bird encaged is, of course, often interpreted as the soul imprisoned in the body. However, the bird may also be read as a symbol of Hope, all that remained after Pandora had opened the box. For a discussion of this interpretation, see Dora and Erwin Panofsky, *Pandora's Box: The Changing Aspects of a Mythical Symbol* (1962; reprint ed., Princeton, 1978), pp. 29-33. For a different provenance of the bird cage found on Leonardo's folio, see Carlo Pedretti, "Eccetera: perché la minestra si fredda," *Lettura Vinciana* 15 (Florence, 1975), p. 22, figs. 22, 23.

42. Richter, *Literary Works,* vol. 1, *sub numero,* 390.

43. *Ibid., sub numero,* 391.

44. *Ibid., sub numero,* 392. For Leonardo's illustration of this and his other comments on draperies, see *ibid.,* pls. 26, 28 and 30.

45. Vasari, *Lives,* vol. 4, p. 90.

46. For color reproductions of all four of these drapery studies, see *Leonardo's Return to Vinci: The Countess de Béhague Collection,* Catalogue by Alessandro Vezzosi (New York, 1981), pls. 1, 2, 3 and 4.

47. Hours, *Secrets,* p. 203.

1. For the development of images intended for private devotions, see Sixten Ringbom, "Devotional Images and Imaginative Devotions," *Gazette des Beaux-Arts* 73, ser. 6 (March, 1969), pp. 159-70; *idem.,* "Icon to Narrative: The Rise of the Dramatic Close-up in Fifteenth-Century Devotional Painting," *Acta Academiae Åboensis,* ser. A., 31, no. 2 (Åbo, 1965), pp. 1-233, *passim.* Cf. Erwin Panofsky, "'Imago Pietatis': Ein Beitrag zur Typengeschichte des 'Schmerzensmanns' und der 'Maria Mediatrix'," *Festschrift für Max J. Friedländer zum 60. Geburtstage* (Leipzig, 1927), pp. 261-308, *passim.;* Otto Pächt, "The 'Avignon Diptych' and Its Eastern Ancestry," *De Artibus Opuscula XL, Essays in Honor of Erwin Panofsky,* ed. Millard Meiss, 2 vols. (New York, 1961), vol. 1, pp. 402-04; and Rona Goffen, "Icon and Vision: Giovanni Bellini's Half-Length Madonnas," *The Art Bulletin* 52, no. 4 (Dec., 1975), pp. 487-518, *passim.* For a commentary on the private devotional worship of images in the Early Christian Church before the Iconoclastic crisis of the eighth century, see Ernst Kitzinger, "The Cult of Images in the Age Before Iconoclasm," *Dumbarton Oaks Papers,* no. 8 (Cambridge, Mass., 1954), pp. 85-100.

2. For discussions of the iconography of the *Salvator Mundi* theme, see Ludwig H. Heydenreich, "Leonardo's *Salvator Mundi,*" *Raccolta Vinciana* 20 (1964), pp. 83-96; Carla Gottlieb, "The Mystical Window in Paintings of the Salvator Mundi," *Gazette des Beaux-Arts* 56, ser. 6 (Dec., 1960), pp. 313-32; Ringbom, "Icon to Narrative," pp. 69 ff., 171-78; Anna Jameson and Lady Eastlake, *The History of Our Lord,* 2 vols. (London, 1864), vol. 2, pp. 374-75; and Irving Lavin, "Bernini's Death," *The Art Bulletin* 54, no. 2 (June, 1972), p. 181. Cf. Jan Bialostocki, "Fifteenth Century Pictures of the Blessing Christ, Based on Rogier van der Weyden," *Gesta* 15, nos. 1 and 2 (1976), pp. 313-20, *passim.;* and Engelbert Kirschbaum, ed., *Lexikon der christlichen Ikonographie* (Freiburg, 1968), cols. 423-24.

3. For a discussion of the central panel of this altarpiece with the suggestion that it is similar to a *Deësis,* see Erwin Panofsky, *Early Netherlandish Painting: Its Origins and Character,* 2 vols. (Cambridge, Mass., 1953), vol. 1, pp. 275-76. Cf. Barbara G. Lane, "Early Italian Sources for the Braque Triptych," *The Art Bulletin* 62, no. 2 (June, 1980), pp. 281-84.

4. For a discussion of the origin of the representations of Christ as sovereign, see André Grabar, *Christian Iconography: A Study of Its Origins* (Princeton, 1968), pp. 60-86.

5. For a thirteenth-century representation of Christ as *Creator Mundi* with the attributes of a *Salvator Mundi,* see Alphonse N. Didron, *Christian Iconography: The History of Christian Art in the Middle Ages,* trans. E. J. Millington, 2 vols. (New York, 1965), vol. 1, fig. 65 and pp. 240-41. For the role of Christ in the creation, see Adelheid Heimann, "Trinitas Creator Mundi," *Journal of the Warburg and Courtauld Institutes* 2, no. 1 (July, 1938), pp. 42-52, pls. 1-9.

6. See Meyer Schapiro, "Two Romanesque Drawings in Auxerre and Some Iconographic Problems," *Studies in Art and Literature for Belle da Costa Greene,* ed. Dorothy Miner (Princeton, 1954), pp. 341-45.

7. "...the ball in this context represents the entirety of God's creation in the sense of Nicholas of Cusa and at the same time the perfection of the geometric figure in the sense of the "Divine Proportions" of his [Leonardo's] friend Luca Pacioli, concepts which the palace scholars of Urbino and Milan knew well" (Heydenreich, "*Salvator Mundi,*" pp. 92-94, translation mine). Cf. Pierre Speziali, "Léonard de Vinci et la 'Divina Proportione' de Luca Pacioli," *Bibliothèque d'Humanisme et Renaissance* 15 (1953), pp. 295-305; and Fra Luca Pacioli, *Divina Proportione,* ed. Constantin Winterberg (Vienna, 1889), *passim.*

8. Several examples of the Supper at Emmaus scene in this idiom are those by the school of Giovanni Bellini in the Church of S. Salvatore in Venice, by Titian in the Louvre, and by Caravaggio in the Brera. See Heydenreich, "*Salvator Mundi,*" pp. 89-90; and Charles Scribner, III, "*In Alia Effigie:* Caravaggio's London Supper at Emmaus," *The Art Bulletin* 59, no. 3 (Sept., 1977), pp. 380-82. In addition to this theme, it is of interest to note the similarity to a *Salvator Mundi* of a mid-eleventh century illumination of the Echternach School in the *Golden Gospels of Heinrich III* of "The Feeding of the Multitudes" in which Christ is portrayed standing in the center with His right hand raised in the act of benediction and His left hand resting on a large round loaf that is supported by one of His disciples who is helping to distribute the bread. See Gertrud Schiller, *Iconography of Christian Art,* trans. Janet Seligman, 2 vols. (Greenwich, Conn., 1971), vol. 1, p. 211 and fig. 485. This same correspondence to the *Salvator Mundi* theme is evident in a wall painting of 1037-56 in the Hagia Sophia, Ochrid, in a portrayal of the "Communion of the Apostles" in which Christ stands behind an altar blessing with His right hand and holding a large circular Host in His left. See *ibid.,* vol. 2, p. 30 and fig. 62. Shapiro has commented upon the Host itself sometimes acquiring an imperial connotation at this time and the deliberate artistic creation of an ambiguous form "in order to evoke the double aspect of Christ as ruler and sacramental body" (Schapiro, "Two Romanesque Drawings," pp. 344-45). For several early commentaries on Christ as "The Bread of Life" in the liturgy of the Roman Church, see André Hamman, ed., *The Mass: Ancient Liturgies and Patristic Texts* (New York, 1967), pp. 125-30, 216-20, 233-39. Cf. Gregory Dix, *The Shape of the Liturgy* (1945; reprint ed., London, 1970), pp. 48-102.

9. Gottlieb, "Mystical Window," *passim*.

10. The crossed stole, symbolizing the yoke of Christ and immortality, must be worn by the clergy of the Roman Catholic Church when administering any of the Sacraments, a practice originating in the seventh century. For the development of the stole, see the *Catholic Encyclopedia*, 15 vols. (New York, 1907-12), vol. 8, p. 874 and vol. 13, p. 720; and Herbert Norris, *Church Vestments: Their Origin and Development* (New York, 1950), pp. 88-91.

11. For commentaries on the role of Christ as Priest in the Roman Church as postulated in the Epistle to the Hebrews, see Josef A. Jungmann, *The Early Liturgy to the Time of Gregory the Great*, trans. Francis A. Brunner (South Bend, Ind., 1959), pp. 297-98; *idem., Liturgical Worship*, trans. by a monk of St. John's Abbey (New York and Cincinnati, 1941), pp. 31-35; and Thomas Merton, *The Living Bread* (New York, n.d.), pp. 22-26, 81-83.

12. Joseph F. Stedman, ed., *My Lenten Missal* (New York, 1942), p. 3.

13. Heydenreich, *"Salvator Mundi,"* p. 94, n. 23.

14. Hebrews 9:11-15 and Romans 5:12-21. For a discussion of the Catholic doctrine of the sacrifice of Christ inherent in the Eucharist, see Josef A. Jungmann, *The Mass of the Roman Rite: Its Origins and Development*, trans. Rev. and abr. in 1 vol. (Westminster, Md., 1959), pp. 137-47; *idem., The Mass: An Historical, Theological and Pastoral Survey*, trans. Julian Fernandes (Collegeville, Minn., 1975), pp. 87-121; Dix, *Liturgy*, pp. 238-67; Hamman, *The Mass*, pp. 89-136, 171-85, 233-39; John O'Connell, *The Celebration of Mass* (Milwaukee, 1941), pp. 346-69; Thomas Merton, *The Living Bread*, pp. 95-109; and Yrjö Hirn, *The Sacred Shrine: A Study of the Poetry and Art of the Catholic Church* (London, 1912), pp. 76-88, 111-36.

15. A fragment of the altarpiece for Frechilla (c. 1480-1500) attributed to Pedro Berruguete includes a pseudo-*Salvator Mundi* in which there is revealed the lance wound in the side of Christ, who is portrayed wearing a loincloth and an open mantle and has His right hand raised in blessing. However, as a large globe surmounted by a tall cross with a Resurrection banner is cradled in His left arm, this work is based on and is much closer in concept to the representation of the Risen Christ with *stigmata* than a true *Salvator Mundi*. For reproductions and a discussion of this Spanish painting, see Gottlieb, "Mystical Window," pp. 325-326, figs. 15 and 16. For a commentary on Leonardo's Christian iconography throughout his *oeuvre*, see Hans Ost, *Leonardo-Studien* (Berlin and New York, 1975), pp. 80-93.

16. See Cyprien Monget, *La Chartreuse de Dijon, d'après les documents de Bourgogne* (Montreuil-sur-mer, 1901), pp. 206-07.

17. Barbara G. Lane, "Rogier's Saint John and Miraflores Altarpieces Reconsidered," *The Art Bulletin* 60, no. 4 (Dec., 1978), p. 665. Of the symbolism of the wound in Christ's side, St. Jerome wrote in *Commentariorum in Isaiam Prophetam* 13, chap. 48: "...the side, wounded by the lance, flowed with water and blood, sanctifying baptism and martyrdom for us" (Quoted in *ibid.*, p. 669).

18. In this regard, it is of interest to note the instructions given to the worshipper when meditating on the "Incredulity of St. Thomas" and the importance of the *stigmata* of Christ as stated in the influential late thirteenth-century Franciscan text of the *Meditations on the Life of Christ*: *Therefore, observe Him diligently and consider His customary goodness, humility, and fervent love as He shows Thomas and the other disciples His wounds in order to remove all doubt from their hearts, for their profit and ours. The Lord preserved the scars of the wounds for three reasons especially: that He might give the apostles faith in His Resurrection; that He might show them to the Father when He wishes to appease Him and intercede for us, for He is our advocate; and that He might show them to the wicked on the day of Judgment.* (Isa Ragusa and Rosalie B. Green, eds., *Meditations on the Life of Christ*, trans. Isa Ragusa (Princeton, 1961), pp. 370-71.)

19. For a discussion of this period in Leonardo's career, see W. R. Valentiner, "Leonardo as Verrocchio's Coworker," *The Art Bulletin* 12, no. 1 (March, 1930), pp. 43-89; and Ludwig H. Heydenreich, *Leonardo da Vinci*, 2 vols. (New York, 1954), vol. 1, p. 11.

20. For two examples of twelfth-century representations of Christ in Majesty with the *alpha* and the *omega* shown on either side of Christ's head, see George Zarnecki, *Romanesque Art* (New York, 1971), figs. 149 and 150.

21. A name derived from the Latin *auri-frigium*, meaning gold embroidery, used since the eleventh century to decorate all clerical vestments, with the exception of the amice and alb. See Norris, *Church Vestments*, pp. 18, 64-70 for the development and illustrations of various designs of the orphreys.

22. I.e., $1+2+3=6$ and also $1 \times 2 \times 3 = 6$. For an account of the perfection of the number six, see Cedric E. Pickford, ed., *The Song of Songs: A Twelfth-Century French Version* (London, 1974), v. 3347-60. Cf. Isidore of Seville, *Etymologiarum*, in J.-P. Migne, *Patrologia Latina ...cursus completus*, 162 vols. (Paris, 1841-93), vol. 82, cols. 157-58.

23. In the interior of the early fourteenth-century Swinburne pyx in the Victoria and Albert Museum can be seen the face of Christ set within diapered hexalobes. See Marie-Madeleine Gauthier, *Émaux du moyen âge occidental* (Paris, 1972), fig. 210.

24. For commentaries on Leonardo's knot designs see Ananda K. Coomaraswamy, "The Iconography of Durer's 'Knots' and Leonardo's 'Concatenation'," *The Art Quarterly* 7, no. 2 (Spring, 1944), pp. 109-28; Marcel Brion, *Génié et destinée: Léonard de Vinci* (Paris, 1952), pp. 183-214; *idem.*, "Les 'Nœuds' de Léonard de Vinci et leur signification," *(Comm. Congrès int. Val de Loire, 1952) Etudes d'art* (Paris, 1953), nos. 8-10, pp. 69-81; and Giuseppina Fumagalli, *Leonardo: ieri e oggi* (Pisa, 1959), pp. 49-62, pls. 1 and 2.

25. Dante Alighieri, *The Divine Comedy of Dante Alighieri*, trans. John D. Sinclair (New York, 1968), *Purgatorio*, canto 25, lines 79-84:
Quando Lachèsis non ha più del lino,/ solvesi dalla carne, ed in virtute/ne porta seco e l'umano e 'l divino:/l'altre potenze tutte quante mute,/memoria, intelligenza e volontade/in atto molto più che prima agute.
For Ficino's commentary on the Grecian Fates, see Marsilio Ficino, *Opera Omnia*, 2 vols. (Turin, 1959), vol. 2, book 2, p. 1891.

26. These interweaving knot designs occur also in Leonardo's notebooks as discussed in Chapter 3 *supra*. Also see fig. 50.

27. Letter of Fra Pietro da Novellara to Marchesa Isabella d'Este, 4 April 1501, Goldscheider, *Leonardo the Artist* (London and New York, 1944), p. 19.

28. William Hone, ed., *The Lost Books of the Bible*, trans. Jeremiah Jones and William Wake (1926; reprint ed., New York, 1979), chap. 9, v. 6. For typological references to Eve holding a distaff and winding thread on her spindle and Mary at the time of the *Annunciation* "sitting on a throne and spinning red silk," see the Appendix "Byzantine Guide to Painting," in Didron, *Christian Iconography*, vol. 2, pp. 267, 352.

29. For a suggested parallel between the veil of the Temple and the body of Christ, see Tadeusz Dobrzeniecki, "The Toruń Quinity in the National Museum in Warsaw," *The Art Bulletin* 46, no. 3 (Sept., 1964), pp. 384-85. For an interpretation of one of the Sibylline Oracles correlating the tearing of the veil and the Redemption of the Just of the Old Covenant at Christ's descent into Limbo, see Schiller, *Iconography*, vol. 2, p. 114 and n. 48.

30. As previously stated, the same scarlet color was used earlier by Leonardo for the robe of Christ in the *Last Supper*.

31. For the development and illustrations of the pallium from its original usage into a liturgical vestment, see Norris, *Church Vestments*, pp. 22-37.

1. For a discussion of this specific designation for certain portrayals of Christ, see Lionel Cust and Ernst von Dobschütz, "The Likeness of Christ," *The Burlington Magazine* 5, no. 18 (Sept., 1904), pp. 517-28; John Stuart, *Ikons* (London, 1975), pp. 31-32; Otto Pächt, "The 'Avignon Diptych' and Its Eastern Ancestry," *De Artibus Opuscula XL, Essays in Honor of Erwin Panofsky*, ed. Millard Meiss, 2 vols. (New York, 1961), vol. 1, pp. 402-10; Konrad Onasch, *Russian Icons*, trans. I. Grafe (Oxford and New York, 1977), p. 6; Gertrud Schiller, *Iconography of Christian Art*, trans. Janet Seligman, 2 vols. (Greenwich, Conn., 1972), vol. 2, *passim*; Jean A. Keim, "La Préhistoire chrétienne de la photographie," *Gazette des Beaux-Arts* 73, ser. 6 (May-June, 1969), pp. 363-66; André Grabar, *Christian Iconography: A Study of Its Origins* (Princeton, 1968), pp. 78-79; Ludwig H. Heydenreich, "Leonardo's Salvator Mundi," *Raccolta Vinciana* 20 (1964), pp. 84-86; Georgiana Goddard King, "Iconographical Notes on the Passion," *The Art Bulletin* 16, no. 3 (Sept., 1934), pp. 302-03, figs. 9-12; Rona Goffen, "Icon and Vision: Giovanni Bellini's Half-Length Madonnas," *The Art Bulletin* 52, no. 4 (Dec., 1975), p. 498; Louis Réau, *Iconographie de l'Art Chrétien*, 3 vols. (Paris, 1957), vol. 2, pp. 17-19; Paul Perdrizet, "De la Véronique et de Sainte Véronique," *Seminarium Kondakovianum* (Prague, 1932), vol. 5, pp. 1-15, figs. 1-5; Ernst Kitzinger, "The Cult of Images in the Age Before Iconoclasm," *Dumbarton Oaks Papers*, no. 8 (Cambridge, Mass., 1954), pp. 85-128, *passim;* and Ernst von Dobschütz, *Christusbilder: Untersuchungen zur Christlichen Legende*, 3 vols. (Leipzig, 1899), vol. 1, pp. 40 ff.

Chapter 5 cont.

2. William Hone, ed., *The Lost Books of the Bible*, trans. Jeremiah Jones and William Wake (1926; reprint ed., New York, 1979), pp. 62-63:
Abgarus, king of Edessa, to Jesus the good Saviour, who appears at Jerusalem, greeting.

1 I have been informed concerning you and your cures, which are performed without the use of medicines and herbs.

2 For it is reported, that you cause the blind to see, the lame to walk, do both cleanse lepers, and cast out unclean spirits and devils, and restore them to health who have been long diseased, and raisest up the dead;

4 All which when I heard, I was persuaded of one of these two, viz.: either that you are God himself descended from heaven, who do these things, or the son of God.

5 On this account therefore I have wrote to you, earnestly to desire you would take the trouble of a journey hither, and cure a disease which I am under.

6 For I hear the Jews ridicule you, and intend you mischief.

7 My city is indeed small, but neat, and large enough for us both.
Cf. J.-P. Migne, *Patrologiae Latina…cursus completus*, 221 vols. (Paris, 1841-93), vol. 98, cols. 1202-03.

3. Hone, *Lost Books of the Bible*, p. 63, Jesus' letter to Abgarus:
Abgarus, you are happy, forasmuch as you have believed on me, whom ye have not seen.

2 For it is written concerning me, that those who have seen me should not believe on me, that they who have not seen might believe and live.

3 As to that part of your letter, which relates to my giving you a visit, I must inform you, that I must fulfil all the ends of my mission in this country, and after that be received up again to him who sent me.

4 But after my ascension I will send one of my disciples, who will cure your disease, and give life to you, and all that are with you.
Cf. Migne, *Pat. Lat.*, vol. 98, cols. 1202-03.

For the suggestion that the apocryphal letter of Christ to Abgarus was used as an apotropaic incantation, see Meyer Schapiro, *Late Antique, Early Christian and Mediaeval Art* (New York, 1979), p. 195, n. 137. In this regard, it is interesting to read the comments of the editor of *The Lost Books of the Bible*: "The Rev. Jeremiah Jones observes, that the common people in England have this Epistle in their houses, in many places, fixed in a frame, with the picture of Christ before it; and that they generally, with much honesty and devotion, regard it as the word of God, and the genuine Epistle of Christ" (p. 62). Jacobus de Voragine, in *The Golden Legend*, (trans. Granger Ryan and Helmut Ripperger (New York, 1969), p. 635) writes: "The letter of Our Lord possessed such virtue, that no heretic or pagan was able to live in the city of Edessa, nor did any tyrant dare to attack it. For if at any time an armed force arose against the city, some child would stand upon the gate, and would read the letter, and in that very day the enemy would either flee in terror, or would make peace." See also Kitzinger, "The Cult of Images," pp. 100-12.

4. de Voragine, *The Golden Legend*, pp. 634-35.

5. *Ibid.* Cf. J.-P. Migne, *Patrologiae Graecae…cursus completus*, 161 vols. (1857-1886; reprint ed., Turnholti, Belgium, 1967), vol. 95, col 351. For the attribution to Euagrius, a Syrian of the sixth century, as the author of the earliest mention of the portrait icon sent to Abgarus, see Perdrizet, "De la Véronique," vol. 5, p. 2, n. 9; von Dobschütz, *Christusbilder*, vol. 2, p. 70; and Kitzinger, "The Cult of Images," p. 114 and no. 124.

6. de Voragine, *The Golden Legend*, pp. 634-35. Cf. Migne, *Pat. Graec.*, vol. 95, col. 351.

7. de Voragine, *The Golden Legend*, pp. 634-35. Cf. Migne, *Pat. Graec.*, vol. 95, col. 351.

8. Louis Hourticq, *La vie des Images* (Paris, 1927), p. 47 as cited in Réau, *Iconographie*, vol. 2, p. 36. For the development of the Christian cult of images and the Early Christians' original aversion to the visual representation of Christ, see Kitzinger, "The Cult of Images," pp. 88-95.

9. Réau, *Iconographie*, vol. 2, p. 18. Cf. Migne, *Pat. Graec.*, vol. 95, col. 351.

10. Keim, "La Préhistoire chrétienne," p. 363.

11. *Ibid.* Cf. Migne, *Pat. Graec.*, vol. 95, col. 351.

12. Cust and von Dobschütz, "The Likeness of Christ," p. 518. Cf. Réau, *Iconographie*, vol. 2, p. 18; and Keim, "La Préhistoire chrétienne," p. 363. Also, cf. Migne, *Pat. Graec.*, vol. 95, col. 351; and Kitzinger, "The Cult of Images," pp. 103-04.

13. Cust and von Dobschütz, "The Likeness of Christ," pp. 518-19, describe this translation:
The conveyance of this relic from Edessa to the capital was a notable event to the whole empire. Splendid was its reception in the town, the entire royal court taking part in the magnificent procession which conducted the Lord's portrait from the Golden Gate by the usual via triumphalis to the Hagia Sophia and afterwards to the palace chapel. We owe the minute description of these facts to a sermon which the learned Emperor Constantine Porphyrogennetos himself delivered, probably on August 16, 945 A.D., the next anniversary of the entrance of the holy portrait.
Cf. Perdrizet, "De la Véronique," p. 2.

14. Cust and von Dobschütz, "The Likeness of Christ," pp. 517-28 *passim* and pls. 1-3. The ten individual scenes on the frame are discussed in detail and are compared to those known from an oil painting attributed to a Greek priest, Emmanuel Tzane, dated c. 1640 which was in the collection of His Majesty King Edward VII and hung outside the Royal Chapel at Buckingham Palace and to two Greek manuscripts in Paris, one of the eleventh century and the other of the twelfth century.

15. *Ibid.*, p. 521. For a discussion of the image of Camuliano, a type of *acheiropoeton* different from that of Abgarus, inasmuch as the former was believed to have had a celestial rather than an earthly provenance, see Kitzinger, "The Cult of Images," pp. 113-15, 120-21, 124-25, 142-44; and von Dobschütz, *Christusbilder*, vol. 1, pp. 40-60.

16. Keim, "La Préhistoire chrétienne," pp. 363-64. For a slightly different version of this legend, see Réau, *Iconographie*, vol. 2, p. 18. For the early Christian practice of placing candles or lamps before holy images, see Kitzinger, "The Cult of Images," pp. 91-92, 96-98. Cf. Perdrizet, "De la Véronique," p. 3, n 22.

17. Keim, "La Préhistoire chrétienne," p. 363.

18. Cust and von Dobschütz, "The Likeness of Christ," p. 527, sum up the similarities and differences between these two:
From this comparison we must conclude that the picture at Buckingham Palace is a western copy of an Old Byzantine Mandilion, of the type of the Genoese picture, if not of this very painting itself. The differences, however apparent, do not disprove this conclusion. It is not a copy in the true sense of the word, but a reproduction of what in the copyist's mind was to be represented. The seventeenth-century men had not the historical sense of our time, which aims at exactness; they were always inclined to embellish according to their own taste.
Cf. note 14, *supra*.

19. Perdrizet, "De la Véronique," pp. 3-4. For a complete discussion of this *Mandylion*, see André Grabar, "La Sainte Face de Laon. Le Mandylion dans l'Art Orthodoxe," *Zographika*, (Prague, 1931), vol. 3.

20. An example of the Novgorod School from the Tretyakov Gallery, Moscow, is reproduced in Onasch, *Russian Icons*, fig. 6.

21. Hone, *Lost Books of the Bible*, pp. 269, 279-81.

22. *Ibid.*, p. 70, relates: "And a certain woman named Veronica, said, 'I was afflicted with an issue of blood twelve years, and I touched the hem of his garments, and presently the issue of my blood stopped.'"

23. *Ibid.*, pp. 280-81.

24. *Ibid.* Cf. de Voragine, *The Golden Legend*, p. 215. The story of the emperor's cure is also recounted in de Voragine, *The Golden Legend*, p. 214, under "The Passion of Our Lord," similar in most details except that, in regard to the transmission of the Holy Image, Veronica says: "And the Lord …pressed the cloth against His face, and left His image upon it." Cf. Kitzinger, "The Cult of Images," p. 114, n. 123; and Perdrizet, "De la Véronique," pp. 7-9. For a detailed discussion of the Berenike (Veronica) legend, see Alfred Maury, "Sur L'étymologie du nom de Véronique," *Revue Archéologique*, 7 (Paris, 1851), pp. 484-495.

25. Pächt, "The 'Avignon Diptych'," pp. 405, 408. Cf. Schiller, *Iconography,* vol. 2, p. 173; and Perdrizet, "De la Véronique," pp. 6-7

26. Pächt, "The 'Avignon Diptych'," p. 405.

27. *Ibid.,* p. 405, n. 15. It should be mentioned here in this regard that one of the important avenues for the dissemination of the *acheiropoeton* image throughout Europe was by way of the return of the pilgrim from Rome wearing the emblem portraying the Holy Face. An example of this practice is to be found in the *Triumph of the Church* fresco in the Spanish Chapel of Santa Maria Novella in Florence, painted by Andrea da Firenze in the mid-fourteenth century. In the center foreground are portrayed three pilgrims, each wearing the insignia designating the site of their pilgrimage. On the hat of the old man on the left can be clearly recognized an emblem with a depiction of the Holy Face, denoting his pilgrimage to Rome. A slightly earlier example of the wearing of the Veronica image, in this instance as indicative of being present at the Crucifixion, is to be found in Ambrogio Lorenzetti's Sta. Petronilla altarpiece painted in the 1330s, now in the Pinacoteca in Siena, in which Mary Magdalen is portrayed wearing the Holy Face on her chest (Alistair Smart, *The Dawn of Italian Painting,1250-1400* (Ithaca, 1978), p. 102, pl. 120).

28. Pächt, "The 'Avignon Diptych'," p. 405, n. 19. For further discussions, see von Dobschütz, *Christusbilder,* vol. 1, pp. 197-262; and Josef Wilpert, *Die römischen mosaiken und malereien* (Freiburg, 1917), vol. 2, pp. 1123 ff. Cf. Maury, "Sur l'etymologie," pp. 484-95.

29. Schiller, *Iconography,* vol. 2, p. 78. For a variation on this theme which seems to also combine elements from the Berenike legend that is recounted in a manuscript dated 1380 based on the *Meditations on the Life of Christ* and which was translated into French for the Duke of Berry, see Millard Meiss and Elizabeth H. Beatson, eds., *La Vie de Nostre Benoit Sauveur Ihesuscrist & La Saincte vie de Nostre Dame* (New York, 1977) p. 92. Veronica, suffering from leprosy in this version, has sought Jesus to be healed and arrives as He is being crucified. Distraught that she has arrived too late to be cured, Mary assures her that she will aid her and takes the towel that Veronica is wearing on her head and touches Jesus' face with it, and *"La face de Ih[es]uscrist y fut apparoissa[n]te, com[m]e qui l'y eust painte."* Immediately upon touching the towel, Veronica is healed, and the account concludes, *"Ceste touaille est a Romme, et la monstre l'en aux pelerins."* In the introduction, Millard Meiss states the influence of this French manuscript on the subject matter of artists of the period, which is readily demonstrated by various scenes of the Crucifixion in which Veronica is portrayed showing the miracle of the Holy Face to the mob, as related in this version of the legend.

It should be remarked that while the woman identified as Veronica was venerated as a saint in various localities and the Mass and the Office were celebrated in her honor, her name does not appear in either any of the earlier or in the present Roman Martyrology (*The New Catholic Encyclopedia,* 15 vols. (Washington, D.C., 1967), vol. 14, p. 625).

30. Erwin Panofsky, "'Imago Pietatis': Ein Beitrag zur Typengeschichte des 'Schmerzensmanns' und der 'Maria Mediatrix'," *Festschrift für Max J. Friedländer zum 60. Geburtstage* (Leipzig, 1927), pp. 261-308; Sixten Ringbom, "Icon to Narrative: The Rise of the Dramatic Close-up in Fifteenth-Century Devotional Painting," *Acta Academiae Åboensis,* ser. A., 31, no. 2 (Åbo, 1965), pp. 147-55; and Schiller, *Iconography,* vol. 2, pp. 79, 184-197, figs. 657, 665, 716, 735, 750, 755, 774, 806, and 807.

31. For reproductions illustrating these eight modes of representation of the Veil of Veronica, see James H. Marrow, *Passion Iconography in Northern European Art of the Late Middle Ages and Early Renaissance* (Brussels, 1979), figs. 15, 16, 66, 89, 90, 94, 96, 99, 100, 101, 107, 128; and Schiller, *Iconography,* vol. 2, figs. 293, 522, 657-665, 716, 735, 750, 756, 774, 806 and 807.

32. For a discussion of this unusual iconographic programme, see Edith Warren Hoffman, "Some Engravings Executed by the Master E. S. for the Benedictine Monastery at Einsiedeln," *The Art Bulletin* 43, no. 3 (Sept., 1961), pp. 236-37, fig. 4.

33. David Talbot Rice, *Byzantine Art* (Middlesex and Baltimore, 1968), figs. 106, 132, 166, 175, 185, 186, 190, 191, 201, 208, 388; Kurt Weitzmann, *The Icon: Holy Images — Sixth to Fourteenth Century* (New York, 1978), pls. 1, 3, 11, 23; and Stuart, *Ikons,* pl. A.

34. See Andrew Martindale, *Gothic Art* (New York, 1967), p. 69, for a discussion of this new genre of devotional manual, lavishly decorated, intended for private meditation.

35. Wilhelm Suida, "A Giotto Altarpiece," *The Burlington Magazine* 59, no. 343 (Oct., 1931), pp. 188-93, figs. A, B. Cf. Fern R. Shapley, *Paintings from the Samuel H. Kress Collection: Italian Schools: XIII-XV Century* (London, n.d.), pp. 21-22, figs. 43-47; and *The Samuel H. Kress Collection,* North Carolina Museum of Art, Raleigh, 1960, p. 30, fig. on p. 31. It is of interest to note that in the modern reassembly of this penta-partite altarpiece Mary has been placed to the right of the Savior and John the Baptist to His left in a *Deësis* arrangement while the subordinate saints, John the Evangelist and Francis of Assisi are relegated to the periphery.

36. Schiller, *Iconography,* vol. 2, p. 187. The Apocalyptic connotation is stressed in the portrayal of Saint John the Evangelist in this same altarpiece in which he carries an identical book.

37. An early fifteenth-century Northern example is to be found in a Flemish manuscript in the Bibliothèque Royale in Brussels (Ms. 11041), illustrating an unusual representation of Christ in the role of *Salvator Mundi* entitled "The Sermon on the Mount" in which Christ is shown with His right hand raised in blessing and holding a globe surmounted by a cross in His left, and seated on a hill, as if it were a throne, with a community of followers seated at His feet. For an illustration of this rare iconographical schema, see Erwin Panofsky, *Early Netherlandish Painting, Its Origins and Character,* 2 vols. (Cambridge, Mass., 1953), vol. 2, pl. 66, fig 141.

38. Jan Bialostocki, "Fifteenth-Century Pictures of the Blessing Christ, Based on Rogier van der Weyden," *Gesta* 15, nos. 1 and 2 (1976), p. 314. For further commentaries on these early Netherlandish works, see Max J. Friedländer, *Early Netherlandish Painting,* 14 vols. (Leyden, 1967), vol. 2, pp. 15, 19-20, 65-66, 88, pls. 46-48, 126, and Panofsky, *Early Netherlandish Painting,* vol. 1, pp. 187, 275-76, and p. 430, n. 1, vol. 2, pls. 127, 187, 195.

39. Heydenreich, "*Salvator Mundi,*" p. 88.

40. Bialostocki, "Blessing Christ," pp. 313-20.

41. Heydenreich, "*Salvator Mundi,*" p. 85.

42. *Ibid.,* p. 86.

43. *Ibid.,* pp. 88-90

44. Ringbom, "Icon to Narrative," p. 177.

45. Heydenreich, "*Salvator Mundi,*" pp. 90-92. Because of the poor state of preservation of the Urbino painting, it is impossible to see the globe in Christ's left hand, but its presence is indicated by the top of the cross which originally surmounted it.

46. Giorgio Vasari, *Lives of the Most Eminent Painters, Sculptors and Architects,* trans. Gaston Du C. de Vere, 10 vols. (London, 1912-14), vol. 4, p. 89.

BIBLIOGRAPHY

Selected sources pertaining to the
Salvator Mundi of Leonardo da Vinci.

Aubrey, John. *Letters Written by Eminent Persons in the Seventeenth and Eighteenth Centuries...* London, 1813.

Beltrami, Luca. *Documenti e memorie riguardanti la vita e le opere di Leonardo da Vinci in ordine cronologico.* Milan, 1919.

Bialostocki, Jan. "Fifteenth-Century Pictures of the Blessing Christ, Based on Rogier van der Weyden." *Gesta* 15, nos. 1 and 2 (1976), pp. 313-20.

Brown, Keith. "The Artist of the *Leviathan* Title Page." *British Library Journal* 4 (1978), pp. 24-36.

Calvi, Gerolamo. *I manoscritti di Leonardo da Vinci dal punto di vista cronologico, storico e biografico.* Bologna, 1925.

Clark, Kenneth. *The Drawings of Leonardo da Vinci in the Collection of Her Majesty the Queen at Windsor Castle.* 2nd ed., rev. with the assistance of Carlo Pedretti. 3 vols. London, 1968-69.
_____. *Leonardo da Vinci, An Account of his Development as an Artist.* 2nd ed., rev. Middlesex, 1967.

Cust, Lionel, and von Dobschütz, Ernst. "The Likeness of Christ." *The Burlington Magazine* 5, no. 18 (Sept., 1904), pp. 517-28.

D'Auton, Jean. *Chroniques de Louis XII.* 4 vols. Paris, 1889-95.

De Voragine, Jacobus. *The Golden Legend.* Translated by Granger Ryan and Helmut Ripperger. New York, 1969.

Dix, Gregory. *The Shape of the Liturgy.* 1945. Reprint. London, 1970.

Evelyn, John. *The Diary of John Evelyn.* Edited by E.S. de Beer. London, 1959.

Fleming, S.J. "Physico-chemical Approaches to Authentication." In *Authentication in the Visual Arts: A Multi-disciplinary Symposium, Amsterdam, 12th March 1977,* edited by H.L.C. Jaffé, J. Storm van Leeuwen, L.H. van der Tweel. Amsterdam, 1979.

Friedländer, Max J. *Early Netherlandish Painting.* 14 vols. Leyden, 1967.

Goffen, Rona. "Icon and Vision: Giovanni Bellini's Half-Length Madonnas." *The Art Bulletin* 52, no. 4 (Dec., 1975), pp. 487-518.

Goldscheider, Ludwig. *Leonardo da Vinci the Artist.* London and New York, 1944.

Gottlieb, Carla. "The Mystical Window in Paintings of the Salvator Mundi." *Gazette des Beaux-Arts* 56, ser. 6 (Dec., 1960), pp. 313-32.

Grabar, André. *Christian Iconography: A Study of Its Origins.* Princeton, 1968.

Hamman, André, ed. *The Mass: Ancient Liturgies and Patristic Texts.* New York, 1967.

Heydenreich, Ludwig H. *Leonardo da Vinci.* 2 vols. New York, 1954.
_____. "Leonardo's *Salvator Mundi*." *Raccolta Vinciana* 20 (1964), pp. 83-109.
_____. *Leonardo: The Last Supper.* New York, 1974.

Hirn, Yrjö. *The Sacred Shrine: A Study of the Poetry and Art of the Catholic Church.* London, 1912.

Hone, William, ed. *The Lost Books of the Bible.* Translated by Jeremiah Jones and William Wake. 1926. Reprint. New York, 1979.

Hours, Madeleine. "Études analytique des tableux de Léonard de Vinci au Laboratoire de Musée du Louvre." *Leonardo: Saggie e richerce.* Libraria dello Stato, Rome, 1954.
_____. *Les Secrets des chefs-d'oeuvre.* Paris, 1964.
_____. *The Secrets of the Great Masters.* Paris, 1964.

_____. *Conservation and Scientific Analysis of Painting.* Translated by Anne G. Ward. New York, 1976.

Jungmann, Josef A. *The Mass of the Roman Rite: Its Origins and Development.* Translated by Francis A. Brunner. Rev. and abr. in 1 vol. Westminster, Md., 1959.

Keim, Jean A. "La Préhistoire chrétienne de la photographie." *Gazette des Beaux-Arts* 73, ser. 6 (May-June, 1969), pp. 364-66.

Kitzinger, Ernst. "The Cult of the Images in the Age Before Iconoclasm." *Dumbarton Oaks Papers,* no. 8. Cambridge, Mass., 1954.

Merlet, L., and de Gombert, M. *Recit des funerailles d'Anne de Bretagne.* Chartres, 1858.

Onasch, Konrad. *Russian Icons.* Translated by I. Grafe. Oxford and New York, 1977.

Pächt, Otto. "The 'Avignon Diptych' and Its Eastern Ancestry." *De Artibus Opuscula XL, Essays in Honor of Erwin Panofsky.* Edited by Millard Meiss. 2 vols. New York, 1961. vol. 1, pp. 401-10.

Panofsky, Erwin. *Early Netherlandish Painting, Its Origins and Character.* Cambridge, Mass., 1953.

Parthey, Gustav. *Wenzel Hollar. Beschreibendes Verzeichniss seiner Kupferstiche.* Berlin, 1853.
_____. *Nachträge und Verbesserungen zum Verzeichnisse der Hollar'schen Kupferstiche.* Berlin, 1857.

Perdizet, Paul. "De la Véronique et de Sainte Véronique." *Seminarium Kondakovianum,* vol. 5. Prague, 1932.

Porcher, Jean. *Anne de Bretagne et son Temps.* Musée Dobrée, Nantes, 1961.

Ragusa, Isa, and Green, Rosalie B., eds. *Meditations on the Life of Christ.* Translated by Isa Ragusa. Princeton, 1961.

Réau, Louis. *Iconographie de l'Art Chrétien.* 3 vols. Paris, 1957.

Reti, Ladislao, ed. *The Unknown Leonardo.* New York, 1974.

Rice, David Talbot. *Byzantine Art.* Middlesex and Baltimore, 1968.

Richter, Jean-Paul. *The Literary Works of Leonardo da Vinci.* 2 vols. London, 1883.

Ringbom, Sixten. "Icon to Narrative: The Rise of the Dramatic Close-up in Fifteenth-Century Devotional Painting." *Acta Academiae Åboensis,* ser. A., vol. 31, no. 2. Åbo, 1965.
_____. "Devotional Images and Imaginative Devotions." *Gazette des Beaux-Arts* 73, ser. 6 (March, 1969), pp. 159-70.

Schiller, Gertrud. *Iconography of Christian Art.* Translated by Janet Seligman. 2 vols. Greenwich, Conn., 1972.

Shearman, John. "Leonardo's Colour and Chiaroscuro." *Zeitschrift für Kunstgeschichte* 25 (1962), pp. 13-47.

Stuart, John. *Ikons.* London, 1975.

Van Eerde, Katherine S. *Wenceslaus Hollar—Delineator of His Time.* Charlottesville, 1970.

Vasari, Giorgio. *Lives of the Most Eminent Painters, Sculptors and Architects.* Translated by Gaston Du C. De Vere. 10 vols. London, 1912-14.

Vertue, George. *A Description of the Works of the Ingenious Delineator and Engraver Wenceslaus Hollar, Disposed into Classes of Different Sorts; with Some Account of His Life.* 2nd ed. London, 1759.

Wasserman, Jack. *Leonardo.* New York, 1980.

LIST OF ILLUSTRATIONS

Diamond indicates color illustration.

Designed by Douglas Wadden

Photograph Credits

The author and publisher would especially like to thank the Research Laboratory of the Museums of France, the Trustees of The British Museum and the Trustees of The National Gallery for providing and granting permission to reproduce many of the photographs necessary for this volume.

AGRACI, Paris, front cover, 6, 13, 45, 46, 49, 51, 52, 55, 79; Alinari/EPA, New York, 51, 60; Austrian National Library, Vienna, 24; Benjamin Blackwell, University Art Museum, Berkeley, 53; Biblioteca Ambrosiana, Milan, 52; Biblioteca Nacional, Madrid, 45; Bibliothèque Nationale, Paris, 20, 22; Binenbaum, Fontainebleau, 67; British Library, London, 21, 69; British Museum, London, 27, 29, 30, 54, 66, 67, back cover; Bulloz, Paris, 18, 19; Detroit Institute of the Arts, 15; Duke of Northumberland, Syon House, 26; Gabinetto Photografico Nazionale, Rome, 57; German National Museum, Nuremberg, 54; Giraudon, Paris, 70; Koninklijk Museum, Antwerp, 64; M. Knoedler & Co., New York, 72; Museo d'arte antica, Milan/Ed Dull, Portland, 16, 17; Musées Nationaux, Paris, 47, 49, 56, 60, 62, 73; National Gallery of Art, Washington, D.C., 69; The National Gallery, London, 73, 76, 77; National Museum, Warsaw, 14; North Carolina Museum of Art, Raleigh, 74; Palazzo Ducale, Urbino, 77; Philadelphia Museum of Art, 71; Research Laboratory of the Museums of France, Paris, 36, 37, 39, 41, 61; Royal Library, Windsor Castle, 12, 17, 32, 44, 45, 61; Rusconi Editore, Milan, 34, 43; Scala/EPA, New York, 10, 50, 59, 62; Stedelijke Museum, Bruges, 72; Steve Morgan, Portland, 20; Suzdal Museum, Suzdal, 67, 74

Colophon

Type set in New Baskerville and Baskerville Old Style by Paul O. Giesey/Adcrafters, Portland, Oregon. Separations and lithography by Graphic Arts Center, Portland, Oregon. Printed on 100 lb. Karma Matte Text and Kromekote Cover laminated to boards with Strathmore Grandee Toro Black endsheets. Binding by Lincoln & Allen, Portland, Oregon. Edition: 5000.